THE URBAN PRAIRIE

CURATOR

DAN RING

ESSAYS

DAN RING

GUY VANDERHAEGHE

GEORGE MELNYK

MENDEL ART GALLERY

FIFTH HOUSE PUBLISHERS

SASKATOON CANADA

Co-published to accompany the exhibition, *The Urban Prairie,* by the Mendel Art Gallery and Fifth House Limited. The Mendel Art Gallery is a nonprofit organization supported by donations and grants from the City of Saskatoon, Saskatchewan Lotteries, the Saskatchewan Arts Board, The Canada Council, and the Museum Assistance Program of the Department of Communications. Fifth House Limited receives support from The Canada Council, Communications Canada, and the Saskatchewan Arts Board. Both organizations gratefully acknowledge these sources.

Canadian Cataloguing in Publication Data

Ring, Dan

 The urban prairie

 Co-published by: Mendel Art Gallery.
 ISBN 1-895618-28-2 (bound) -- 1-895618-30-4 (pbk.)

1. Cities and towns in art. 2. Prairie Provinces in art. 3. Cities and towns - Prairie Provinces - History - Pictorial works. 4. Cities and towns - Prairie Provinces - History. 5. Art, Canadian - Prairie Provinces. 6. Art, Modern - Prairie Provinces. I. Vanderhaeghe, Guy. II. Melnyk, George. III. Mendel Art Gallery. IV. Title.

NX650.C66R5 1993 704.9'44712'09712 C93-098118-9

Funding for the production and circulation of the exhibition, *The Urban Prairie,* and this book was provided by the Museum Assistance Program, Department of Communications, Ottawa, and Northern Telecom.

I T I N E R A R Y

Mendel Art Gallery
Saskatoon, Saskatchewan
29 October 1993 to 2 January 1994

Winnipeg Art Gallery
Winnipeg, Manitoba
9 April to 19 June 1994

Dunlop Art Gallery
Regina, Saskatchewan
17 September to 23 October 1994

Edmonton Art Gallery
Edmonton, Alberta
19 November 1994 to 15 January 1995

Glenbow
Calgary, Alberta
11 February to 9 April l995

Mendel Art Gallery
950 Spadina Crescent East
P.O. Box 569
Saskatoon, Saskatchewan
Canada S7K 3L6
Ph: (306) 975-7610

Fifth House Publishers
620 Duchess Street
Saskatoon, Saskatchewan
Canada S7K 0R1
Ph: (306) 242-4936

CONTENTS

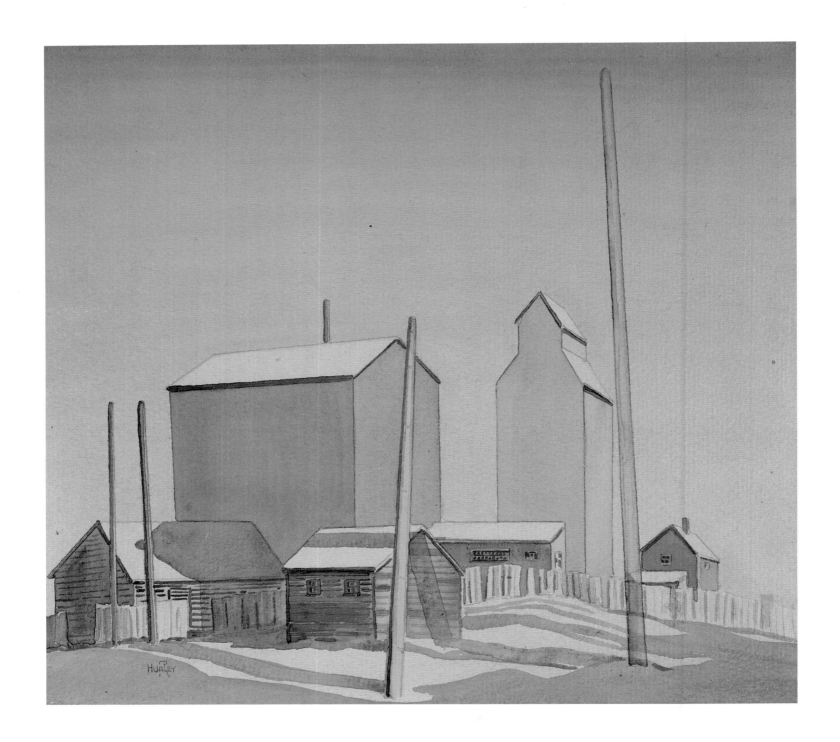

82. Robert Newton Hurley, *Untitled* (prairie town), c. 1937

FOREWORD

The landscape is typically seen as the overriding image and metaphor of western Canada. But however fundamental the land is to life in the West, a distinctive urban culture has evolved on the Prairies since the late 19th century. It is the representation of this urban culture—images of the cities and small towns on the Canadian Prairie from 1880 to 1960—that is the subject of the exhibition and the essays in this book, *The Urban Prairie*.

The Urban Prairie is a unique venture for the Mendel Art Gallery in that it is both a major exhibition and our first co-published book, undertaken in co-operation with Fifth House Publishers, Saskatoon. As an exhibition it has depended on many for its realization. The exhibition was conceived and initiated by my predecessor Peter White, and by Mendel Art Gallery assistant curator Dan Ring. They planned the exhibition as a multifaceted installation that would represent urban life as manifest in paintings, sculptures, drawings, photographs, architectural renderings, advertisements, postcards, maps and other material from this period. This vision has been successfully realized. Dan Ring has selected and gathered together material from a vast archive that stretches from coast to coast, and the resulting exhibition offers an astounding image of utopian dreaming, catastrophic transformation, wild boosterism, rational planning and modern idealism.

In this book, three essays that address the urban prairie and its history have been contributed by Dan Ring, Guy Vanderhaeghe and George Melnyk. On behalf of the Mendel Art Gallery, I extend our thanks to them. They have provided a historical and cultural context for the exhibition and have encouraged us to build a unique understanding of this time and place. Thanks are also due to the staffs of Fifth House Publishers and the Mendel Art Gallery for their many contributions, and to Mendel Art Gallery curator Bruce Grenville, who has supervised the project as a whole.

The Mendel Art Gallery is extremely grateful to all the lenders to the exhibition, both public and private, who agreed to participate in this important project. Such an undertaking would not be possible without their generous co-operation. We gratefully acknowledge support from the Museum Assistance Program of the Department of Communications, which provided a generous grant to prepare and present the exhibition and to allow for its tour to Winnipeg, Calgary, Edmonton and Regina.

Terry Fenton
Director
Mendel Art Gallery

Alberta Foundation for the Arts,
Edmonton, Alberta

Art Gallery of Ontario, Toronto, Ontario

British Columbia Archives and Records Service,
Victoria, British Columbia

Bowness Senior Citizens' Club,
Calgary, Alberta

City of Calgary, Alberta

Canadian Architectural Archives, University of
Calgary Libraries, Calgary, Alberta

Canadian Pacific Limited, Montréal, Québec

Centre Canadien d'Architecture/Canadian Centre
for Architecture, Montréal, Québec

Concordia University, Leonard & Bina Ellen
Art Gallery, Montréal, Québec

The Edmonton Art Gallery,
Edmonton, Alberta

Glenbow, Calgary, Alberta

Leighton Foundation, Calgary, Alberta

City of Lethbridge, Alberta

MacKenzie Art Gallery, Regina, Saskatchewan

Manitoba Provincial Archives,
Winnipeg, Manitoba

Medicine Hat Museum and Art Gallery,
Medicine Hat, Alberta

Mendel Art Gallery, Saskatoon, Saskatchewan

Moose Jaw Art Museum,
Moose Jaw, Saskatchewan

National Archives of Canada, Ottawa, Ontario

National Gallery of Canada, Ottawa, Ontario

Provincial Archives of Alberta,
Edmonton, Alberta

City of Regina, Saskatchewan

Regina Plains Museum, Regina, Saskatchewan

Regina Public Library, Regina, Saskatchewan

Province of Saskatchewan

Saskatchewan Archives Board,
Regina, Saskatchewan

Saskatchewan Western Development Museum,
Saskatoon, Saskatchewan

Saskatoon Board of Education,
Saskatoon, Saskatchewan

Saskatoon Public Library,
Saskatoon, Saskatchewan

SaskTel, Regina, Saskatchewan

Seagrams of Canada, Montréal, Québec

University of Alberta, Edmonton, Alberta

The University of Lethbridge,
Lethbridge, Alberta

University of Saskatchewan,
Saskatoon, Saskatchewan

University of Winnipeg, Winnipeg, Manitoba

City of Winnipeg, Manitoba

Winnipeg Art Gallery, Winnipeg, Manitoba

Caven Atkins, Southfield, Michigan, USA

Mr. and Mrs. H.E.J. Bergman,
Winnipeg, Manitoba

Cecilia Côté, Saskatoon, Saskatchewan

John P. Crabb, Winnipeg, Manitoba

Ir. E. Hendrik Grolle, Regina, Saskatchewan

Robert and Margaret Hucal,
Winnipeg, Manitoba

Dorothy Knowles, Saskatoon, Saskatchewan

Lynn and Ken Martens, Calgary, Alberta

Matthew Petley-Jones,
Vancouver, British Columbia

Private collection, Edmonton, Alberta

Neil Richards, Saskatoon, Saskatchewan

Jack Severson, Regina, Saskatchewan

John Snow, Calgary, Alberta

Robert Stacey, Toronto, Ontario

Matthew Teitelbaum, Toronto, Ontario

George T. Williams, Winnipeg, Manitoba

ACKNOWLEDGEMENTS

This exhibition has evolved over a number of years and in a number of places; in its stops and starts, dead ends and discoveries, it resembles the growth of the prairie cities which are its subject. The initial concept—an examination of the response of artists working on the Canadian Prairie between 1880 and 1960 to their towns and cities—originated with Peter White. After he became director of the Mendel Art Gallery in 1991, our conversations led to the organization of this exhibition and this book. While I realize that one could never gather together all the material documenting the prairie city, it is my hope that *The Urban Prairie* will enrich an awareness of place in our lives. This approach has always been important to Peter and for this he has my unreserved thanks.

My conversations with many individuals profoundly affected the exhibition. The largest portion of thanks must go to the lenders to the exhibition, private and institutional; without them, projects like this could never be realized. Many archivists, curators and registrars answered endless questions and went out of their way to help me locate works. I would especially like to thank in Edmonton: Helen Collinson of the University of Alberta Museum and Collections Services; Mark Joslin, formerly with The Edmonton Art Gallery; Brock Silversides of the Provincial Archives of Alberta; and the staff of the Alberta Foundation for the Arts. In Calgary: Doug Maclean of the Canadian Art Galleries; Kathy Zimon and the staff of the Canadian Architectural Archives at the University of Calgary; Bonnie Murdock, City of Calgary; Patricia Ainslie, Chris Jackson, and Lisa Christensen of the Glenbow Museum and Lynette Walton, Len Gottselig and Lindsay Moir of the Glenbow Archives. In Lethbridge: Victoria Baster of the University of Lethbridge Art Gallery. In Medicine Hat: Linda Carney of the Medicine Hat Museum and Art Gallery. In Saskatoon: Ruth Millar of the Saskatoon Public Library, Local History Room. In Regina: Tim Long of the MacKenzie Art Gallery; and Tim Novak of the Saskatchewan Archives Board. In Moose Jaw: Norma Lang of the Moose Jaw Art Museum. In Winnipeg: Elizabeth Blight of the Manitoba Provincial Archives; Thora Cooke of the Western Canadian Pictorial Index; Sara McKinnon of the University of Winnipeg; Margo Rousset of the Winnipeg Art Gallery; Karin Woods of the Great-West Life Assurance Company. And finally, in Montreal: Stanley Triggs of the Notman Archives of the McCord Museum; and Ludek Stipl of the CPR Corporate Archives; and in Toronto: Linda Scott of the Imperial Oil Archives.

My conversations with co-authors Guy Vanderhaeghe and George Melnyk in the early stages of the project helped me focus on issues explored in the exhibition, as did suggestions from Rosemary Donegan, Don Kerr, John O'Brian, and Matthew Teitelbaum. To all these, my wholehearted thanks.

I am grateful to all the staff at the Mendel Art Gallery, many of whom invested a disproportionate amount of time and effort towards the realization of this exhibition. I would especially like to thank Gary Boehm, Karen Eckhart, Bruce Grenville, Christopher Lefler, Perry Opheim, Linda Sawchyn, Adele Suveges and Sylvia Tritthardt.

Dan Ring

I wish to dedicate this exhibition to the memory of Trevor (Skip) Darke, with whom I discovered the prairie city of my youth. D.R.

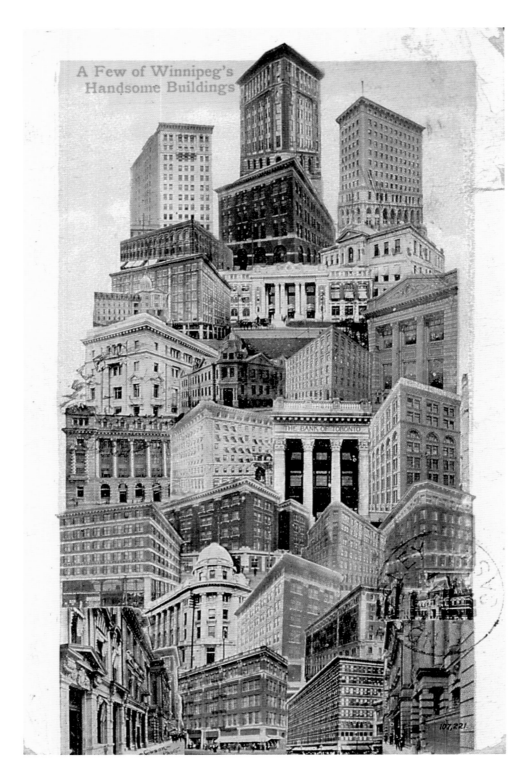

A Few of Winnipeg's
Handsome Buildings

THE BANK OF TORONTO

107,221.

Above: 282. *A Few of Winnipeg's Handsome Buildings*, 1912 Opposite: 143. Roland Keevil, *Untitled* (Saskatoon), c. 1955

THE
URBAN
PRAIRIE

1880 TO 1960

DAN RING

The representation of urbanism in the Canadian West embodies both a mythology of progress and the reality of a collective imagination. In any time or culture, the history of the city forms a complex and elusive tale, like a chimera, that fabulous mythological beast composed of many parts. Such a phantasmic aura surrounds the formation of the prairie city. Despite the sheer volume of its representation in paintings, photographs and commercial images, our idea of the city remains fragmented and incomplete, shadowed by that which has been effaced or unspoken.

Accordingly, the exhibition and this accompanying book, *The Urban Prairie*, examine some of the cities of the Canadian Prairie in the context of their most visionary and imaginative forms, as well as their more mundane and accidental ones, and explore the complexity of the idea of the prairie city we hold in our memories and dreams, a complexity both imaginative and pragmatic, intrinsic to its origins and vital for its future.

INDIAN CAMP, BLACKFOOT RESERVE.

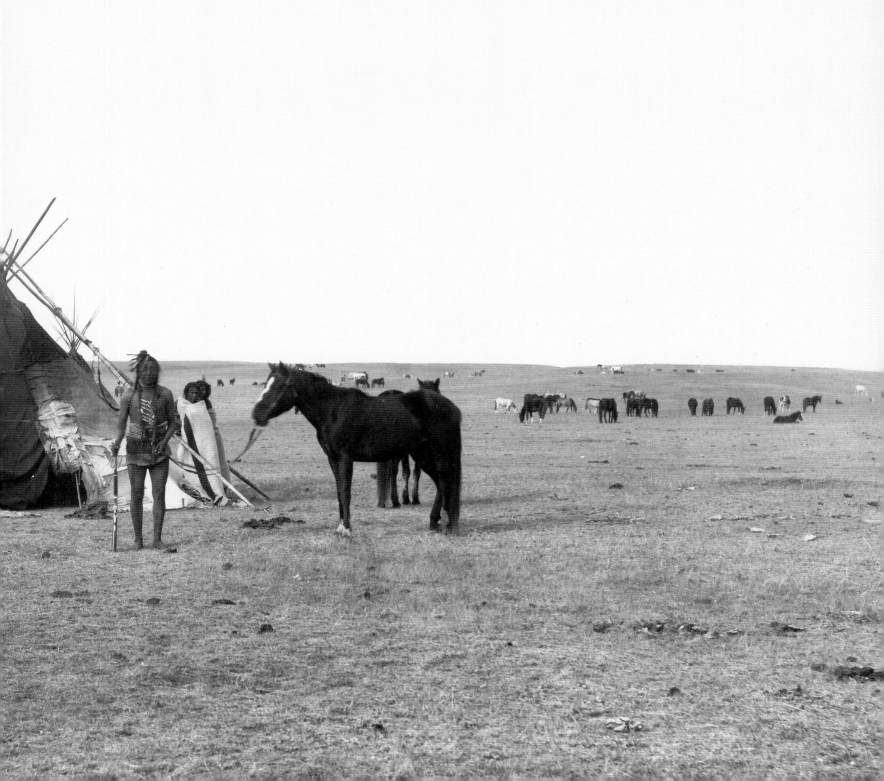

Above: 229. *The Canadian Pacific Railway. Traversing the Great Wheat Region of the Canadian Northwest*, c. 1883. Collection of Canadian Pacific Limited. GR874A

Opposite: 166. William McFarlane Notman, *Calgary, NWT*, 1884

THE
CITIES OF THE
RAIL

In 1812, thirty-six Scottish and Irish laborers, under the leadership of Miles Macdonnell, newly appointed governor of the western Canadian territory of Assiniboia, established the first permanent European agricultural settlement in western Canada. It would become known as the Red River Colony and later would form part of the city of Winnipeg. Before this time, apart from the gathering of nomadic aboriginal peoples for religious or hunting events, the forts of the Hudson's Bay and North West companies were the only settlements in the prairie region. By 1881, Winnipeg had a population of 7,985[1] and small towns elsewhere on the Prairies were about to experience explosive growth. This would be a result, in the main, of the speculation surrounding the building of the Canadian Pacific transcontinental rail line, completed in November of 1885. The railway carried wealth to and from the Prairies, creating markets for agricultural and manufactured goods, markets stimulated by the influx of immigrants occupying the empty sections of the grid and the emerging towns. The railway was the tangible symbol of both eastern Canadian and European capital and of the Canadian nationalist agenda in the West. The cities it created shared in a speculative, competitive and utopian venture, one which turned a wilderness into a new source of capital.

The CPR also carried the photographers and artists who would make images of the newly created towns and settlements. One of these was William McFarlane Notman whose father operated a prosperous photographic studio in Montréal. William McFarlane Notman's first trip to western Canada was in 1884, the result of an agreement made by his father and William Cornelius Van Horne, the general manager of the CPR.[2] Notman photographed the instant settlements created by the railway: Portage la Prairie, Brandon, Moose Jaw, and Medicine Hat, and, occasionally, the Indian settlements which these cities would soon eclipse (cats. 163, 165, illus., 160, & 162, illus.). Notman's urban views are emblematic of the displacement of peoples; they document a fractured culture and a changing landscape.

Van Horne and the CPR worked hand-in-hand with the Canadian government to encourage massive immigration to the West which would repay the enormous cost of completing the railway while consolidating Ottawa's federalist project.[3] Together they organized an advertising campaign and promotional scheme to attract world attention to the opening of the North-West, thereby stimulating both immigration and tourism, as well as providing employment for a growing industry of artists and photographers who would represent the new West. Van Horne's shrewd promotion of the West utilized commissioned paintings and photographs in pamphlets, investment reports and posters, which were widely circulated and prominently displayed in CPR offices in Europe and America (cat. 229, illus.). These advertisements embody that curious mixture of Anglo-Saxon aesthetic, utopianism and relentless boosterism which characterized the representation of the prairie city and landscape well into the 20th century. Van Horne was a major patron of the arts, as were many of the railway barons and entrepreneurs of The Gilded Age. An artist himself, he counted such prominent Canadian artists as William Brymner, Lucius O'Brien and Horatio Walker as his friends and sketching companions.[4] His influence on the Royal Canadian Academy was extensive, as was his control over the selection and hanging of Canadian paintings in overseas exhibitions, such as the Colonial and Indian Exhibition in London in 1886.[5]

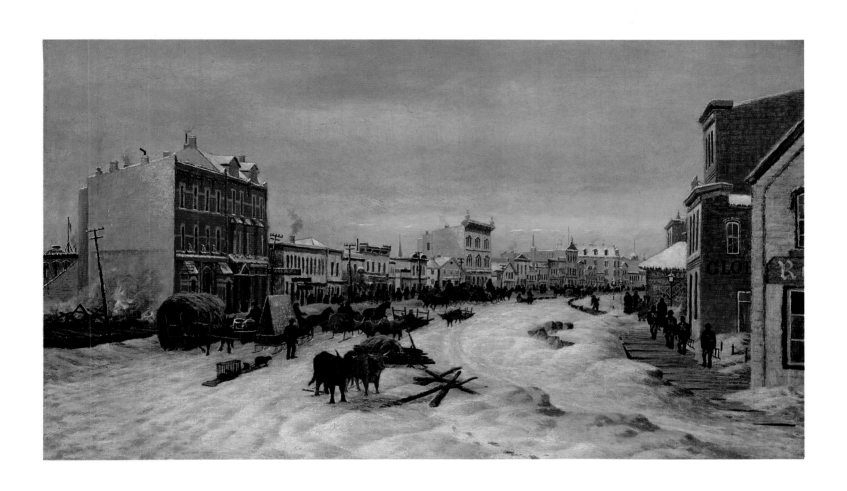

3. D. Macdonald, *Winnipeg's Main Street*, 1882

The CPR was a patron of the Notman family for more than twenty-five years and covered much of the expense of their photographic ventures in western Canada.[6] Many other artists received only free passage on the railway, but that was encouragement enough to travel to the West in the hope of selling their work when they returned to eastern Canada. Most of the artists commissioned by Van Horne painted the landscape, especially the Rocky Mountains, to lure tourists and settlers to the North-West. Because settlements west of Winnipeg were barely more than station houses and a few shacks, they were not usually deemed a suitable subject by artists. As a result, images of future prairie cities, other than Winnipeg, are sparse before 1900 and are found more in photographs than in paintings and drawings. One of these is by the English artist,

163. William McFarlane Notman, *Assiniboine Flour Mill and Elevator, Portage la Prairie, Manitoba,* 1884

Melton Prior, whose *View of Calgary, Alberta,* c.1887 (cat. 5, illus.) emphasizes the importance of the rail line to that emerging city. Prior (1845–1910) was a correspondent for *The Illustrated London News,* one of many artists who worked for this journal or similar mass circulation publications, like *The London Graphic* or *Harper's Weekly,* which were an important source of visual information on western Canada for readers in England, America and eastern Canada. Few Canadian artists, in fact, depicted the new West; for example, four-fifths of the more than five hundred engravings in *Picturesque Canada,* a deluxe two-volume book of Canadian scenes published in 1882, were based on paintings and drawings by American artists. One of the most prominent of these was Frederick B. Schell (1839–1902), who contributed more than two hundred

images.[7] His *Winnipeg from Saint Boniface,* 1881 (cat. 2, illus., see also cat. 228), uses the genre of the dock scene, so common to English and Dutch painting from the 16th century on, to look at commercial activities near Winnipeg. Interestingly, the river was the main commercial link of pre-railroad Winnipeg, and this image reflects the changing face of this city.

On November 8, 1873, by royal assent, the "fur trade station known as the Forks and a part of the Red River Colony merged to form the new City of Winnipeg."[8] Winnipeg would soon become the first great industrial city of the Canadian Prairies. By 1881, the CPR had built the main line through the city, and, with rail lines from it to St. Paul, Minnesota, and the western territories, Winnipeg became a major hub for both the CPR and the agricultural and manufacturing industry in the West. When Van Horne took up residence in Winnipeg, the real estate boom of 1881–82 was in full swing. D. Macdonald's painting *Winnipeg's Main Street*, 1882 (cat. 3, illus.) and William Notman's photograph of *Main Street, Winnipeg, Manitoba,* 1884 (cat. 159, illus.), are evidence of the well-established commercial activity that resulted from the railway. This is evident also in a bird's-eye-view map of Winnipeg of 1884 (cat. 294, illus.) showing the completion of two bridges across the Red River and industrial development around the railroad yards; on the border of the map are images of major public and industrial buildings. This connection between industry and civic identity is a leit-motif of the promotional brochures of this period, the cementing of the image of the city to the personalities of the business élite. Interestingly, the insert showing the population growth grossly exaggerates the figure at 30,000, when in fact it was only 17,000 in 1884.[9] Nevertheless, the growth of population resulting from immigration led to the surveying of townsites along the rail line, which in turn provided real estate profits for the CPR and other speculators in a boom economy. Instant towns and overnight profits, determined by the placement of the line, encouraged intense civic pride and promotional boosterism among the emerging cities.[10] This tendency to hyperbole and an obsession with the quantification of the city in maps and pamphlets, visually expressed through the repetition of images of streets and buildings, would become the hallmark of most of the promotional imagery surrounding the city in the following century.

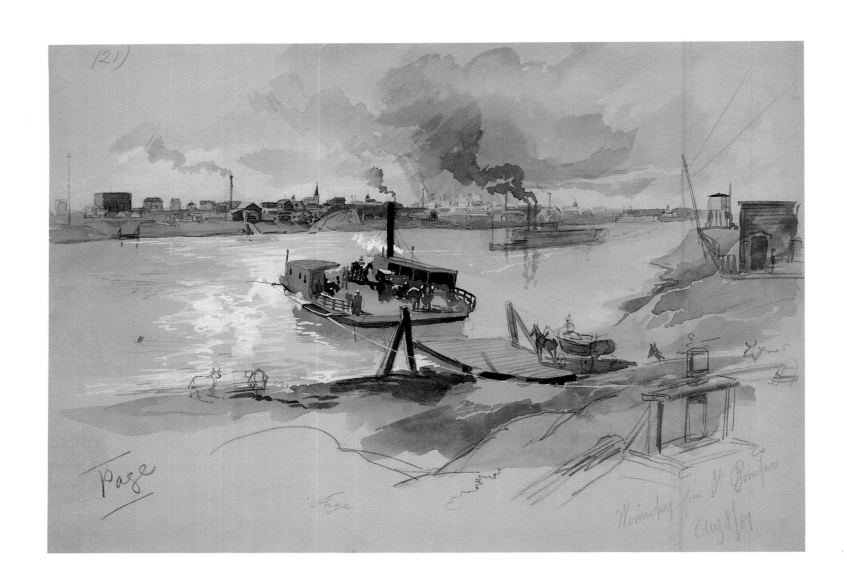

2. Frederick B. Schell, *Winnipeg from Saint Boniface*, 1881. Collection of the National Archives of Canada

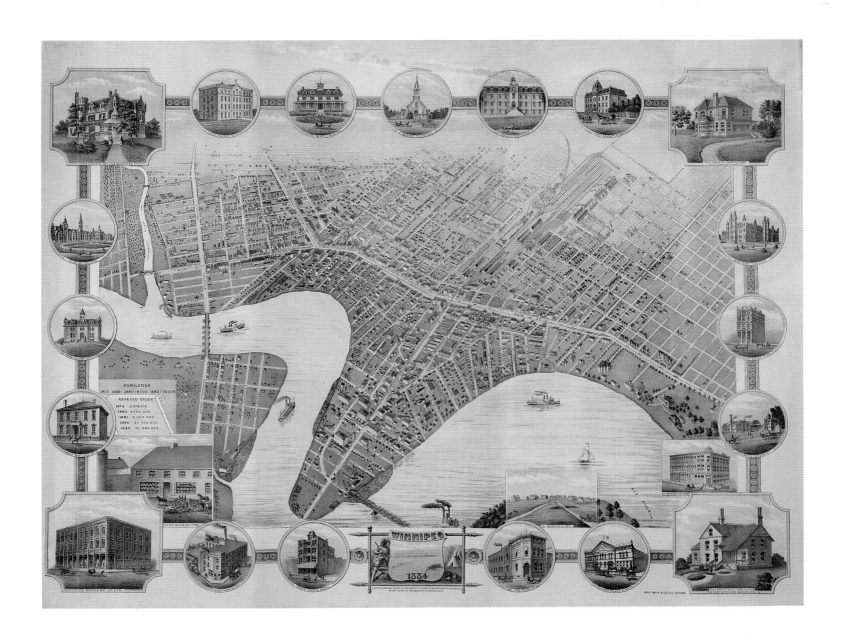

294. *Bird's-Eye View of Winnipeg, 1884.* Glenbow Collection

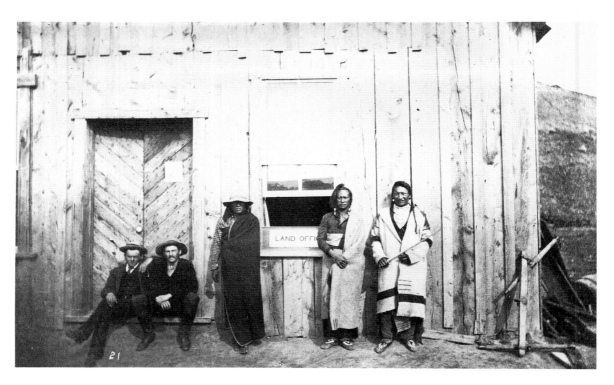

Top: 173. Anonymous, *Calgary, Alberta, in 1890—A Business Block on Stephen Avenue*, 1890

Bottom: 168. William Pearce, *Blood Indians and Whites at the North-West Company Land Title Office, Lethbridge, Alberta*, 1885

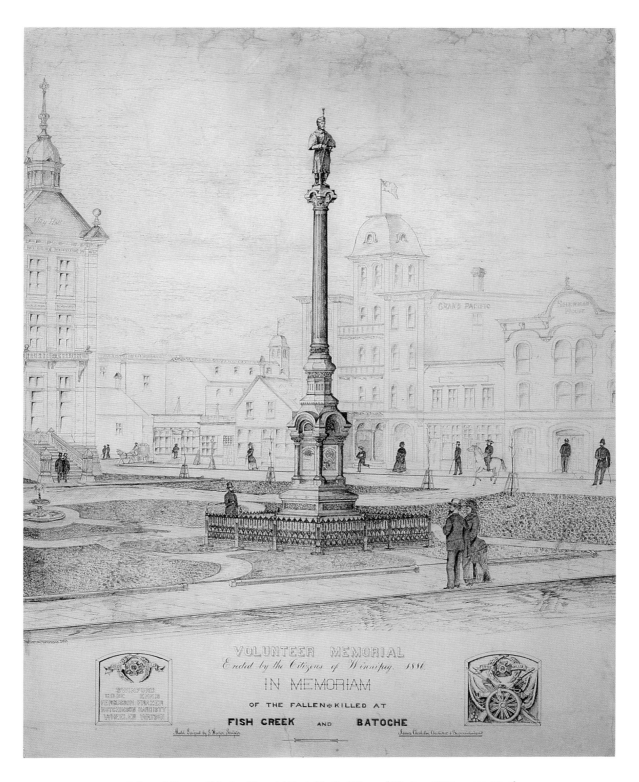

4. Samuel Hooper, *Volunteer Memorial Erected by the Citizens of Winnipeg 1886 in memoriam of the Fallen and Killed at Fish Creek and Batoche*, 1886. Collection of the National Archives of Canada

5. Melton Prior, *View of Calgary, Alberta*, c. 1887. Glenbow Collection

162. William McFarlane Notman, *Medicine Hat, NWT*, 1884

Above: 22. Reinhold Gundlach, *The Path of Progress,* 1913 Opposite: 241. Detail of *Calgary Alberta,* 1911. Glenbow Collection

THE EMPIRE
OF THE WEST

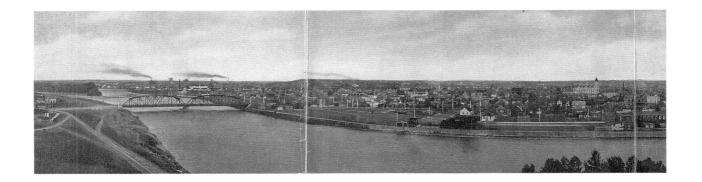

BOOSTERISM

By the first decade of the 20th century, the stage was set for the dramatic growth of the city in the West. Soaring prices for wheat and escalating government and business boosterism fueled massive immigration which, in turn, stimulated manufacturing and real estate, making western Canada one of the most profitable investment areas in the world. What the railway had started was completed by the consolidation of the North-West and Assiniboia territories into full provinces within the Dominion of Canada by 1905.

The visual material representing the city between 1900 and 1920 is largely characterized by the phenomenon of boosterism and is extensive. The proliferation of this material reflected the speculative frenzy of the period, especially up to the end of the 1912 boom, in its promotion of the prairie city as a viable

place to invest and live. The notion of repetition and the radical techniques of photographic montage, which juxtaposed imagery and text, are crucial to the genre of boosterism, mirroring the bewildering growth of the cities represented and reflecting the source of this growth in a modern economy of mass production and distribution. The level of hyperbole and inventiveness in this imagery was high, as seen in the newspaper advertisements for Saskatoon's proposed industrial Magic City, Factoria, which was heavily promoted (cats. 247, 255 & 256, illus.). The tone of these tracts suggests that if you will a thing, however

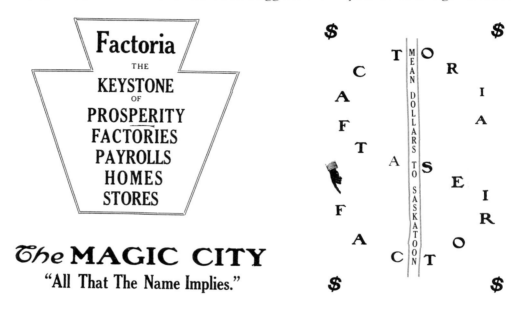

256. *Factoria: The Keystone of Prosperity*, 1913 247. *Factoria: Means Dollars*, 1912

fantastic, it will come into existence. This was an essential characteristic of the promotion of the prairie city until 1912; shortly after, Factoria, like so many other urban projects in the Empire of the West, was abandoned with the sudden collapse of prosperity. Paralleling the false front, that typical sign of the frontier town, the mass imagery of boosterism promoted both real growth as well as a façade of civilization, which, by the end of 1913, appeared to be more and more a hollow promise than the reality of unlimited prosperity in the West.

Boosterist images were intended for a mass audience and employed the modern processes of photography and offset lithography in the promotion of the city. By

1910, most prairie cities had one or more photographic studios catering to this promotional market in the popular press. Photographers also assumed the traditional role of the artist in an expanding market for portraits of family and home. These photographers, such as John W. Gibson in Saskatoon, William J. Oliver in Calgary, Frederick G. McDermid in Edmonton, Lewis B. Foote in Winnipeg, Edgar Rossie in Regina and William John James in Prince Albert, extensively documented the urban scene. They had few pretensions to artistic interpretations of the city, as did some of their famous European counterparts,

255. *Factoria: (nuf sed)*, 1913

Atget, for example, who used the city as a source of poetic imagery. The poetry of the prairie photographers' work seems almost accidental, complicit as it was with the grid of streets and buildings which formed the background to the varied activities of the new cities, their poetry more a product of our contemporary nostalgia for what has vanished than artistic purpose. Most of the studio photographers used the Kodak Circuit camera to produce panoramic photographs for urban promotional material. These photographs were structurally suited to boosterism because of the exaggerations of scale and sense of limitless space that the image conveyed (cats. 179, 182, 184, 187, 221 & 241, illus.). There is a remarkable similarity to these images, as if the photographers were the same

249. *Calgary Brewing and Malting Company, c. 1912. Glenbow Collection*

person looking, often from a bird's-eye point of view, at almost the same city and enumerating the same rivers, bridges, floods, rail yards, warehouses and office buildings. It was also typical of boosterist tracts to present images of factories or office buildings paired with their owners' residences in a display of unembarrassed braggadocio and optimism. These pamphlets, newspapers and fold-out postcards familiarized the city to its new or potential inhabitants, colonizing its newness and strangeness for those who lived or would live there (cat. 282, illus.). The consolidation of the visible world in the 19th century by photographers went hand in hand with colonial expansion.[11] The mania for documentation inherent in boosterism may be construed as a variant of this process where the representation of the city becomes a token of the colonization of the Prairie and its former inhabitants, the Indians, whose settlements were quite often documented in the early settlement period but become less visible in representation over time.

It is difficult now to imagine the almost oppressive sense of space, the vastness and hostility of the land which must have confronted the first generation of settlers on the Prairie. This horror vacuii is evident in two fold-out brochures of Main Street, Winnipeg, 1881 and 1892 (cats. 227 & 231), where the engraved image of every building on the street is reproduced in a handy, pocket-sized pamphlet replacing the reality of the physical street itself. What may have been obscured by the optimism of this image, and of boosterism in general, as manifested in the obsession with objectifying the city through the exaggerated and endlessly repeated images of the urbanscape, was likely a fear of the featureless and empty void of the Prairie itself (cats. 31 & 182, illus.).

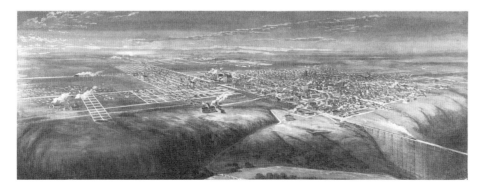

31. Anonymous, *City of Lethbridge,* c. 1915

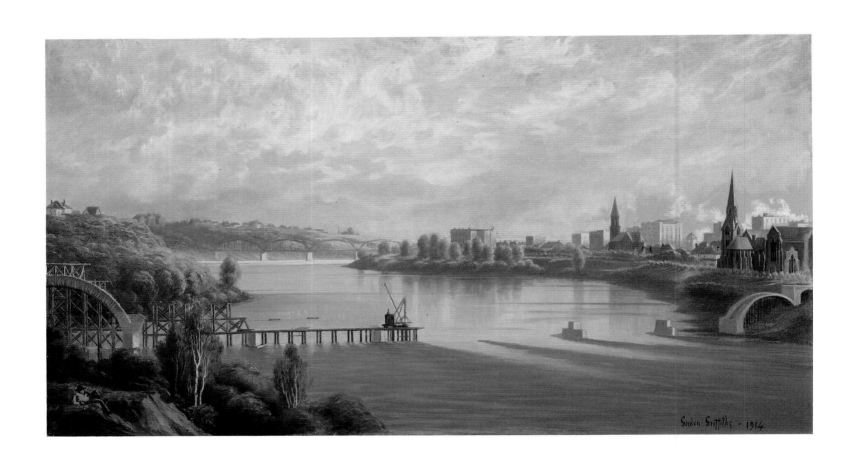

28. William G. Griffiths, *Saskatoon in 1914*

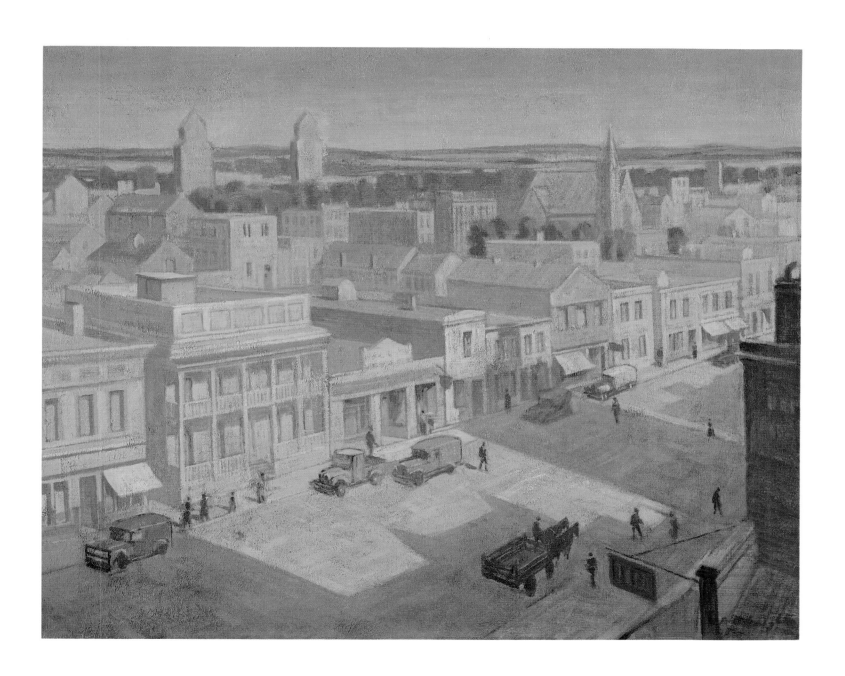

153. A.C. Leighton, *City Buildings*, n.d.

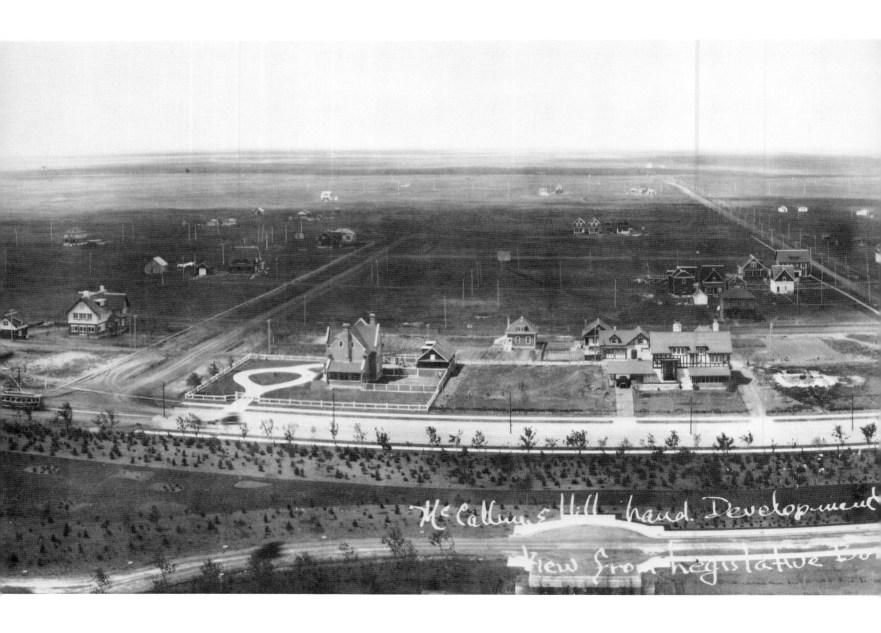

McCallum & Hill Land Development

View from Legislative Bo...

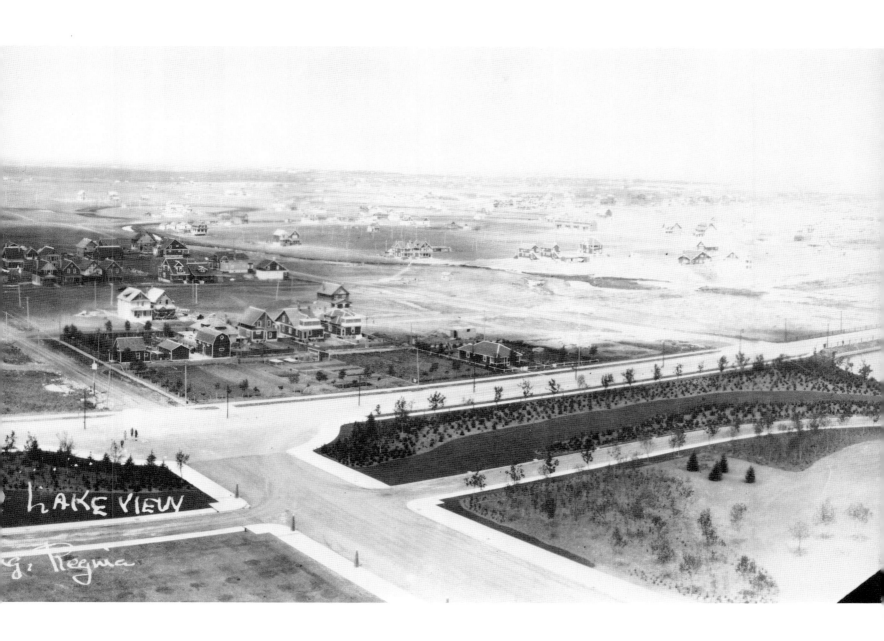

LAKE VIEW

G. Regina

182. Edgar Rossie, Detail of *McCallum & Hill Development of Lakeview. View from Legislative Building, Regina*, c. 1910

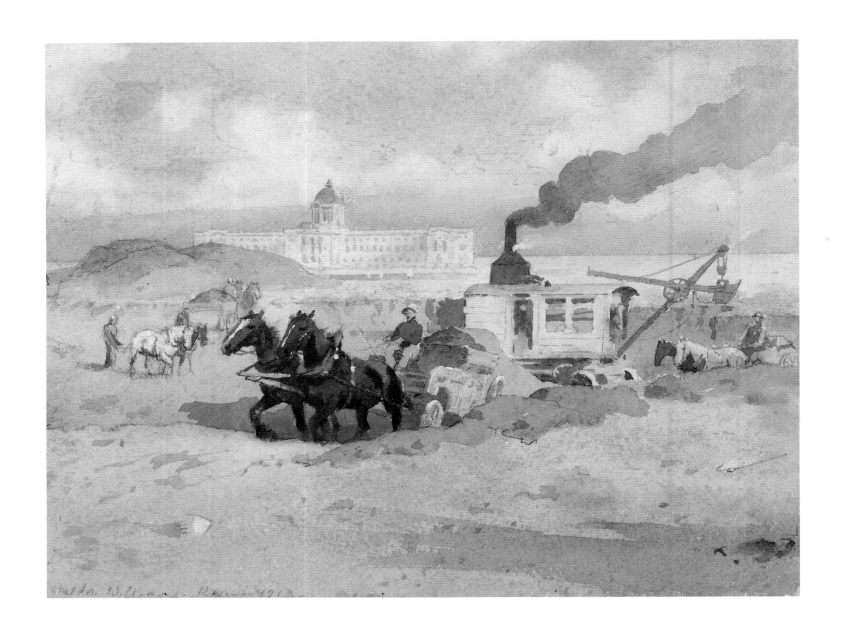

20. Inglis Sheldon-Williams, *Construction of Parliament Buildings, Regina*, 1913

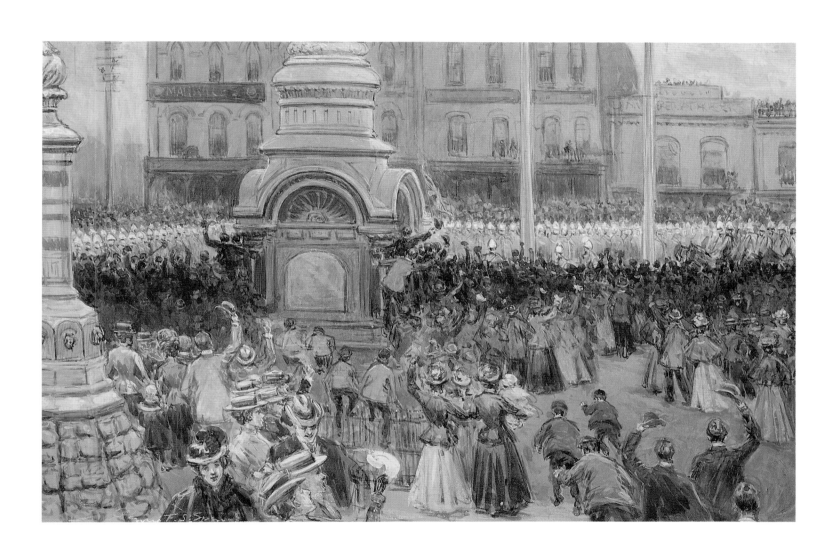

7. Percy F.S. Spence, *The Manitoba Volunteers being addressed by the Mayor of Winnipeg before leaving for the South African War*, 1899. Glenbow Collection

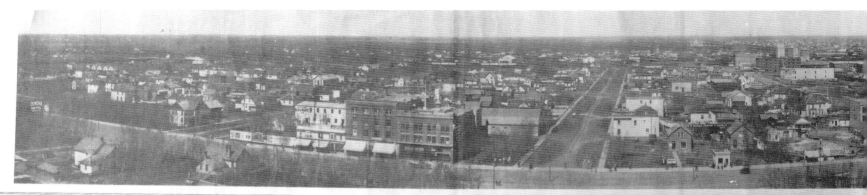

PHONE 24621 FOR A FREE COPY

Panoramic View of
OLD~EDMONTON 1909

HAMLY PRESS Ltd.

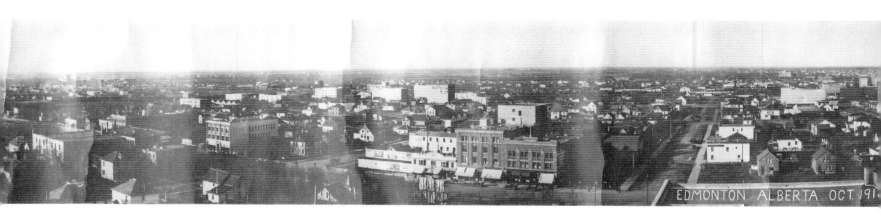

EDMONTON ALBERTA OCT. 191

Top: 179. Hamly Press Ltd., *Panoramic View of Old-Edmonton, 1909*

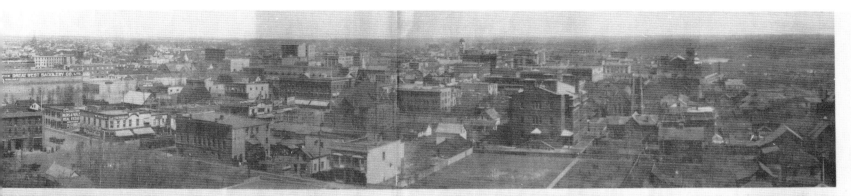

Panoramic View of OLD~EDMONTON — *for* ART & ORIGINALITY *in* PRINTING *Call The* HAMLY PRESS *Ltd.*

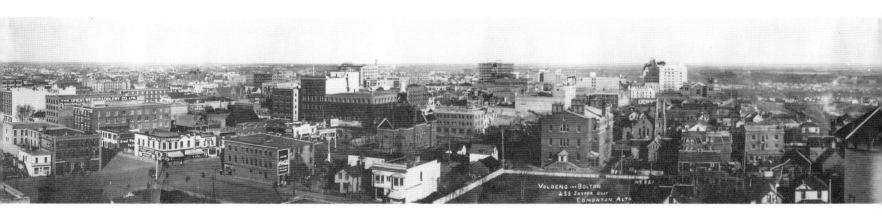

Bottom: 187. Ole Voldeng and Eric Bolton, *Edmonton, Alberta, October, 1913*

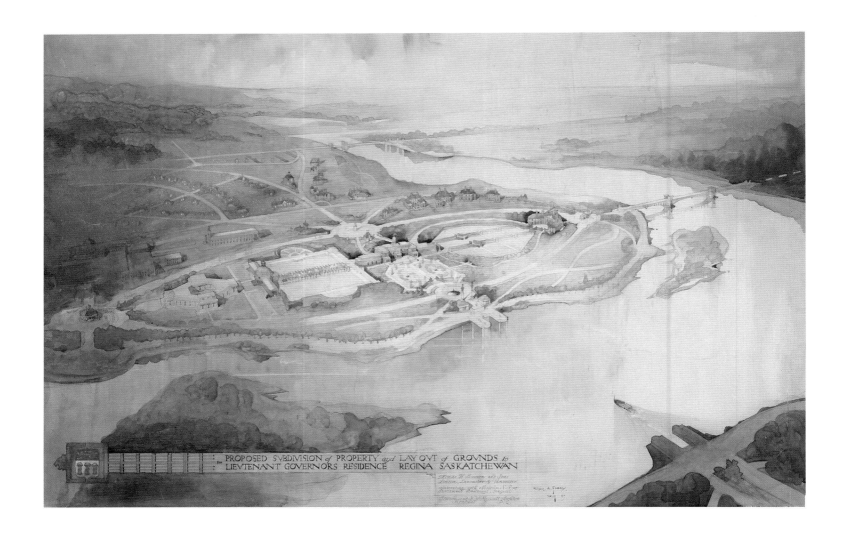

Above: 23. Thomas H. Mawson, *Proposed Subdivision of Property and Lay-Out of Grounds for Lieutenant-Governor's Residence, Regina, Saskatchewan,* 1913

Opposite: 15. Thomas H. Mawson, Detail of *City of Calgary, Preliminary Town Planning Scheme,* Section of City Hall, c. 1912

THE CITY BEAUTIFUL

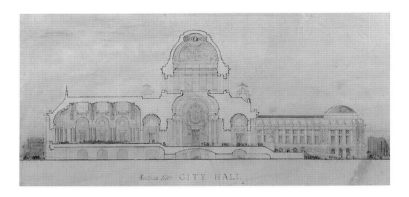

Section thro CITY HALL.

The populations of the rapidly growing prairie cities were of predominantly Anglo-Saxon descent from Great Britain, eastern Canada and the United States. In Calgary, for example, the Dominion Census of 1911 recorded that "over 70% of the total population of the city were of British descent."[12] This group also largely formed the business, political and cultural élite of these cities. As a result, taste ran to things British, pervaded by a nostalgia for the values and institutions of the waning British Empire.

The obsession with the physical signs of progress, of a mechanized and modern utopia inherent in boosterism, coexisted with an Edwardian aesthetic which fostered a notion of "social progress through civic art."[13] This was embodied in the City Beautiful Movement which had originated in Great Britain as a remedy for the urban blight created by the Industrial Revolution.[14] The movement promoted a belief in the efficacy of beautification to improve urban living conditions. It was, in fact, a profoundly middle-class philosophy which "held dear the values of property, family, profit, social status, Christian values and the status quo,"[15] while sometimes avoiding issues of labor and race underlying urban poverty.[16] The zeal to beautify the landscape of the Prairies also had other sources, including the quasi-religious ideas behind Arbor Day and more scientific theories which linked rainfall to ground cover.[17] The treeless, exposed landscape of the nascent prairie city and the inflexible grid which determined its plan were well suited to improvement by town planners influenced by the City Beautiful Movement, planners who advocated an aesthetically unified urban plan where parks and wide, tree-lined boulevards and streets would complement public architecture.

Opposite: 190. Lewis B. Foote, *Recruiting Drive, Trenches at Main Street and Water Avenue*, 1916 Above: 199. Anonymous, *War Memorial in Prince Albert Saskatchewan*, c. 1920

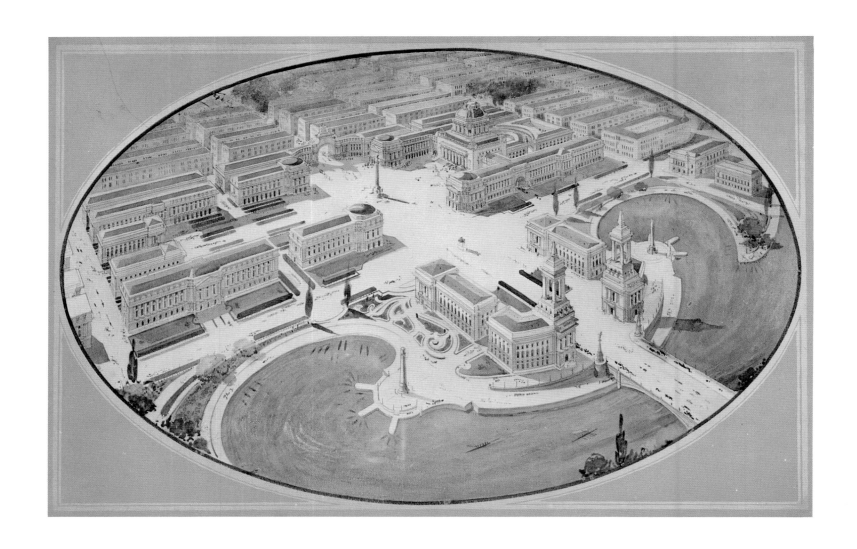

244. Thomas H. Mawson, Frontispiece for *Calgary, Past, Present and Future*, 1912. Glenbow Collection

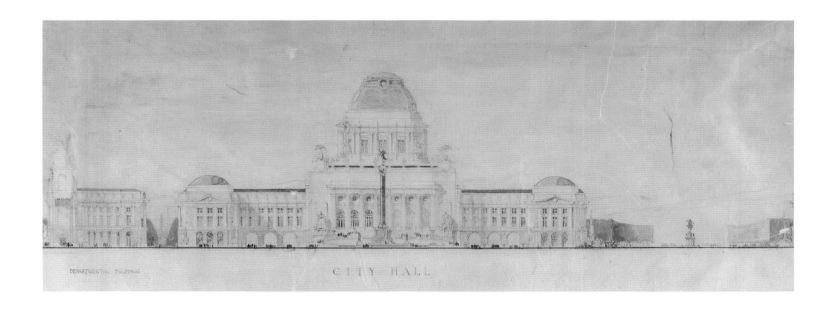

DEPARTMENTAL BUILDINGS

CITY HALL

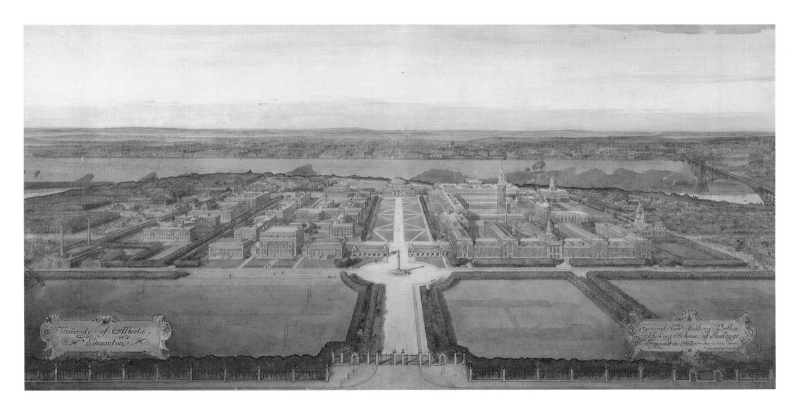

University of Alberta at Edmonton

General View Looking North Showing Scheme of Buildings Proposed in 1912

Top: 15. Thomas H. Mawson, Detail of *City of Calgary, Preliminary Town Planning Scheme.* Elevation of City Hall and Departmental Buildings, c. 1912

Bottom: 30. Percy Erskine Nobbs and Frank Darling, *University of Alberta, Edmonton, General View, Looking North Showing Scheme of Buildings Proposed in 1912, Revised* 1915.
Collection of the University of Alberta Archives

Perhaps the most important of these landscape architects and town planners to work in western Canada was the Englishman Thomas H. Mawson (1861–1933). His 1912 plan for Calgary, if implemented, would have radically changed that city. Calgary in 1900 had 4,000 people; by 1911, the population had reached 44,000.[18] Calgary city councillors and the business community realized that uncontrolled growth would cause serious problems and in 1912 formed the City Planning Commission and advertised for a town planner.[19] Mawson, who was chosen to prepare a report, was a mixture of the visionary and flamboyant huckster. When lecturing at the University of Toronto, he once declared that "city planners... save souls" and later confessed in his autobiography that he "indulged in oratorical flourishes which sane propaganda does not call for."[20] Mawson established his reputation in Canada mainly through promotional lecture tours; projects were handled by his Vancouver office. To promote his Calgary concept, he published *Calgary, Past, Present and Future,* 1912, an illustrated book which outlined in detail his plans and philosophy for the redesigning of the city. Mawson's ideas were grounded in a European history of utopian cities and literature, for example, the work of the Renaissance architect Filarete or Francis Bacon's *The New Atlantis,* which Mawson quoted in his Calgary presentation.[21] Mawson was also influenced by Baron Haussmann's redesigning of Paris and by the World's Columbian Exposition in Chicago in 1893. The latter embodied most of the principles of the City Beautiful Movement, which "emphasized formal, axial urban planning, with careful management of vistas and landmarks,"[22] such as train stations, exhibition halls or civic complexes that were situated as the dramatic and picturesque termini of wide, tree-lined boulevards or of bridges. These features may be found in Mawson's plans for Calgary, as seen in the design for the baroque Civic Centre used as a frontispiece for *Calgary, Past, Present and Future* (cat. 244, illus., see also cat. 16).

At heart, Mawson's values were those of a fading empire, as his plan for an "Industrial Village for Partially Disabled Soldiers," published in *An Imperial Obligation,* or his work on the Royal Fine Arts Commission in England, the agency responsible for placement of war memorials, testifies.[23] War memorials were a tangible link to empire and occupied an important place in the concept of the City Beautiful as the focal point of the planned vista on a prominent

street, as in Saskatoon or Winnipeg, or the hub of Victoria Park in Regina.[24] By 1920, however, eroded by the war and an emerging consumer society which looked more to America than to Britain, the values of the empire seemed less secure. Despite his promotional schemes, most of Mawson's efforts on the Prairies were never realized. Nevertheless, something of the visionary quality of his partially implemented plan for Regina persists in the mirage-like oasis of parks, water and green space on the flat prairie seen today in Wascana Park (cat. 23, illus.).[25]

ARCHITECTURE

AND ART

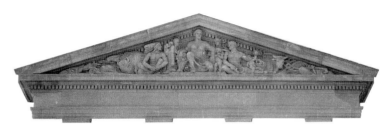

In his proposals for Calgary, Mawson favored a lavish style of architecture with specific reference to classical and English forms rendered in the 19th-century style of the École des Beaux-Arts. The Beaux-Arts style was eclectic and was used extensively in the design of the legislative and some commercial buildings on the Prairies. It grew out of a teaching program based on the atelier or studio system, which emphasized engineering, construction, architectural history, drawing, critique and design. The products of this studio work were meticulously finished, large-scale, hand-colored presentation drawings. This method was imported to North America and grounded architects here in a European vocabulary of forms and design.[26]

The architects most often chosen to design public buildings in the West were from eastern Canada, for example, Frank Darling and John Andrew Pearson of Toronto (cat. 35, illus.) or Percy Erskine Nobbs (cat. 30, illus.) and Edward Maxwell from Montréal (cat. 10, illus.). The similarity of architectural styles in the West is a result of both this eastern influence and the similarity of

Above: 225. Anonymous, Detail of Pediment Sculpture, *Legislative Building, Regina*, n.d.

35. Unknown draughtsman (L.R.) for Frank Darling and John Andrew Pearson, architects, *Rendered Perspective for the Canadian Bank of Commerce at 389 Main Street, Winnipeg, Manitoba*, c. 1920, Collection Centre Canadien d'Architecture/Canadian Centre for Architecture, Montréal

training that many local and eastern architects shared. A national architectural agenda, implemented by the Department of Public Works before World War I, is evident in the standardized designs for post offices in prairie cities by Dominion Architect David Ewart, which alternate from Beaux-Arts to Romanesque styles, depending on the importance of the city in question (cats. 284 & 288, illus.).

The style of architecture of the prairie legislative buildings often reinforced a connection with both English and American civic forms, for example, the Alberta legislature, designed by Provincial Architect Allen Merrick Jeffers, which was modeled on the Minnesota State Capitol.[27] An idea of the immense presence this bizarre conjunction of pristine and gleaming temple architecture and treeless prairie must have had when first completed may be seen in Inglis Sheldon-Williams's painting *Construction of Parliament Buildings, Regina,* 1913 (cat. 20, illus.). The legislative buildings not only symbolized the importance of the capital cities but were also tangible links to the pageantry and ceremony of the British Empire. The iconography of the sculpture and paintings in the legislative buildings (not to mention the political process) also reinforced the colonial heritage through imagery commemorating World War I or the early explorers of the region. Indians were often represented within these allegorical schemes as classical figures equal to the settlers, as in the pedimental sculpture above the main entrance to the Saskatchewan legislature (cat. 225, illus.). This reference to the unifying role of government between the two groups is an example of how an essentially subjugated and marginalized people in the body politic were ironically heroicized in official iconography.

While emphasizing classical design and decoration, many buildings, erected from 1910 on, adopted modern building techniques which used iron frame-works or reinforced concrete. The more important public buildings were faced with local limestone or terracotta, which created an opulent and shimmering effect in the prairie sunlight, while factory buildings tended to be built of brick with minimal decoration. Many of the latter were influenced by American industrial architecture as, for example, the American architect Oscar A. Eckerman's John Deere warehouses in Regina and Winnipeg, which repeated a basic plan used across North America by this company.[28]

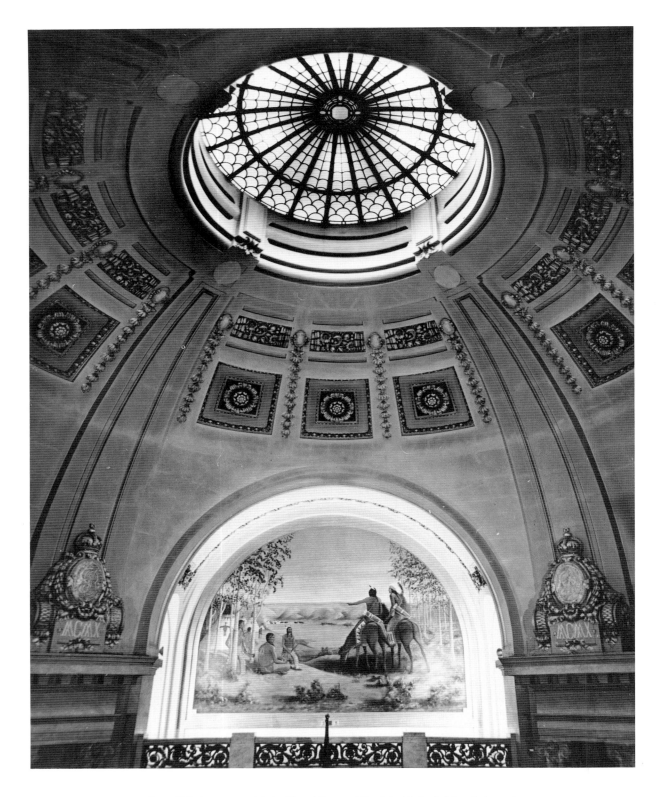

Above: 226. Anonymous, *Interior View of Dome and Mural, Legislative Building, Regina*, n.d.

Opposite: 198. Lewis B. Foote, *Interior of the Rotunda and Dome of the Legislative Building, Winnipeg, June 1920*

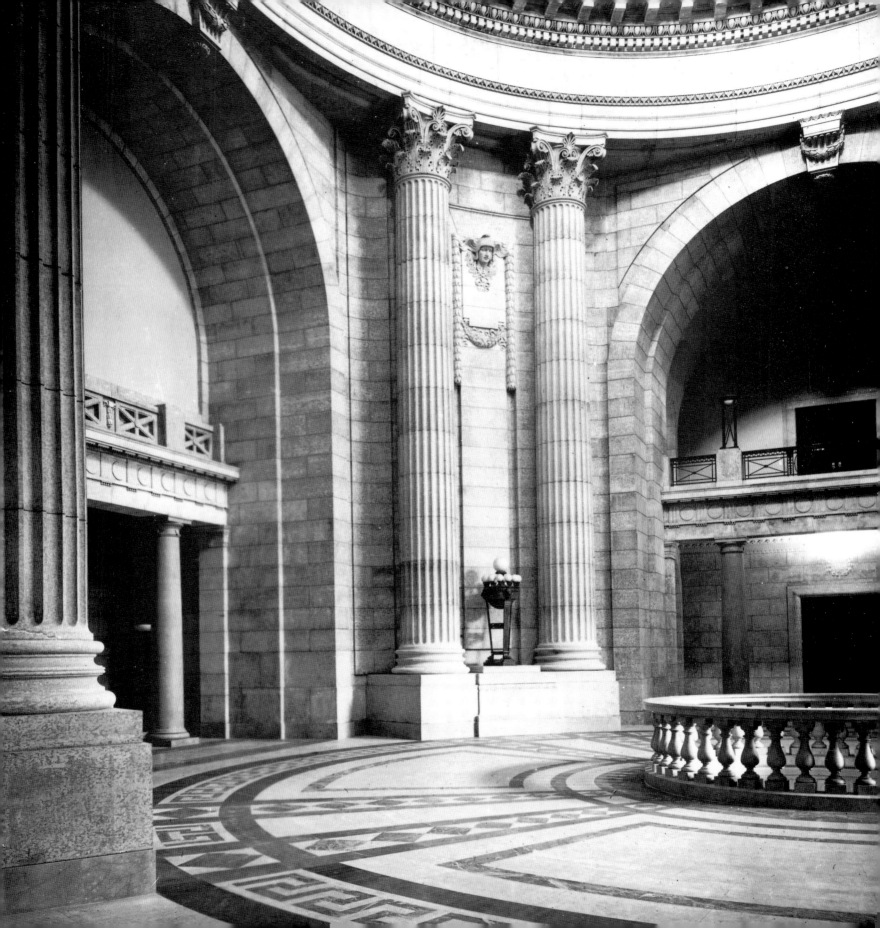

52. A.C. Leighton, *Interior, Parliament Buildings, Winnipeg*, 1929. Glenbow Collection

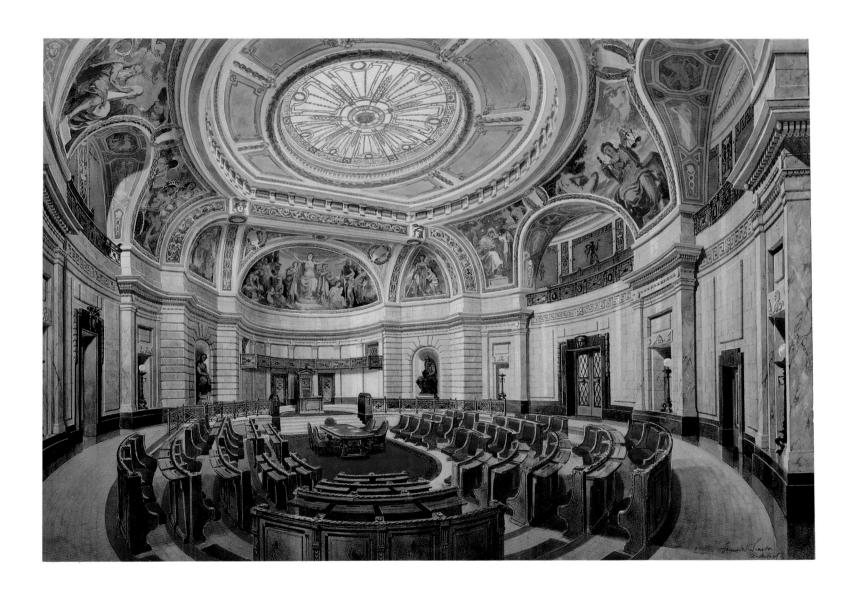

19. Frank Worthington Simon, *Interior of the Legislative Building* (Winnipeg), c. 1912–15

During the first two decades of this century, professional artists, mostly from the British Isles, began to take up permanent residence on the Prairies. Among them were Inglis Sheldon-Williams, A.C. Leighton, Cyril H. Barraud, Alexander J. Musgrove, Walter J. Phillips, and Augustus Kenderdine, who brought an English sensibility to their interpretation of prairie life. Portraiture and landscape were their mainstay but the urban view was not ignored and was often treated as an element of a picturesque landscape composition. Some artists used the public or commercial architecture in the urban West as the subject of their work, as did Barraud in his etchings of Winnipeg buildings, such as *C.N.R. Station*, 1914 (cat. 27, illus.), or Sheldon-Williams in his views of government buildings in

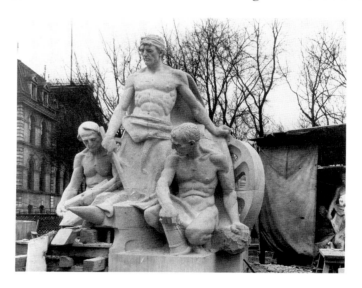

194. Anonymous, *Statuary Group "Industry" Before Elevation to the Dome of the Manitoba Legislative Building*, c. 1918

Regina (cat. 20, illus.). Many of these artists shared in the material wealth and social esteem of the business élite within an emerging urban cultural circle and were involved in the formation of art schools and art departments at the new universities. Their style would have an influence in the West for some time to come. The establishment of universities and art schools in the major prairie cities encouraged prairie artists to express their relationship to place and to explore contemporary practice. At this time too, cities in the Canadian West came increasingly under the influence of the United States through Hollywood films and mass circulation magazines. In these cities, department stores, movie palaces,

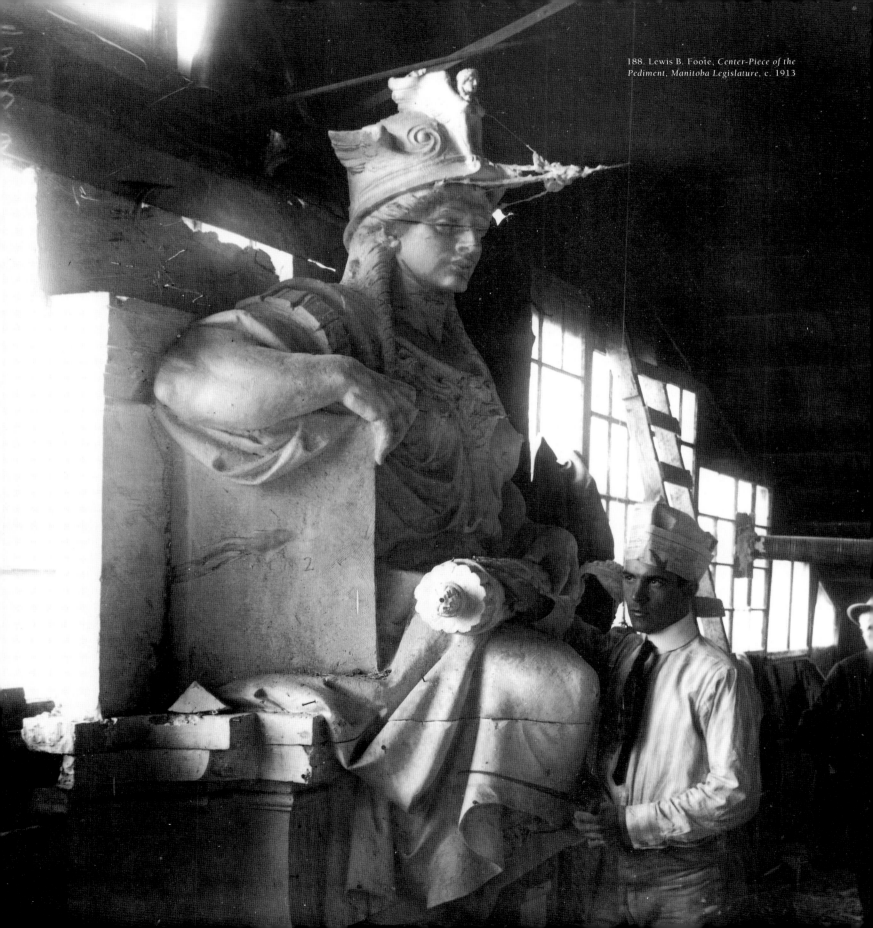

188. Lewis B. Foote, *Center-Piece of the Pediment, Manitoba Legislature*, c. 1913

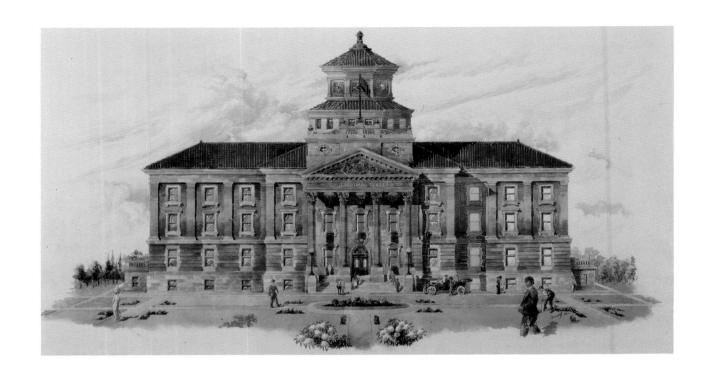

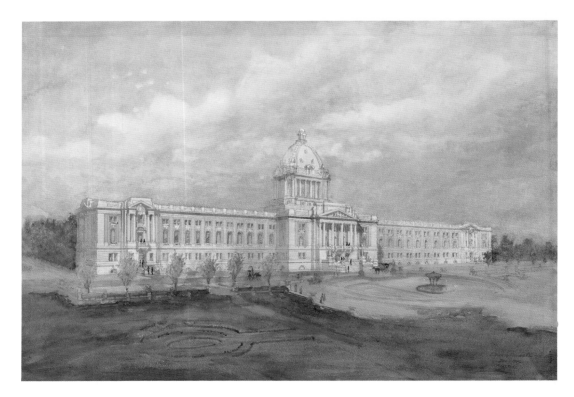

Top: 13. Victor William Horwood, *Administration Building, Agricultural College, University of Manitoba, Winnipeg*, 1912

Bottom: 10. Edward Maxwell, *Legislative and Executive Building, Regina, Saskatchewan*, 1907. Collection of the National Gallery of Canada, Ottawa. Royal Canadian Academy of Arts diploma work, deposited by the artist, Montréal 1911

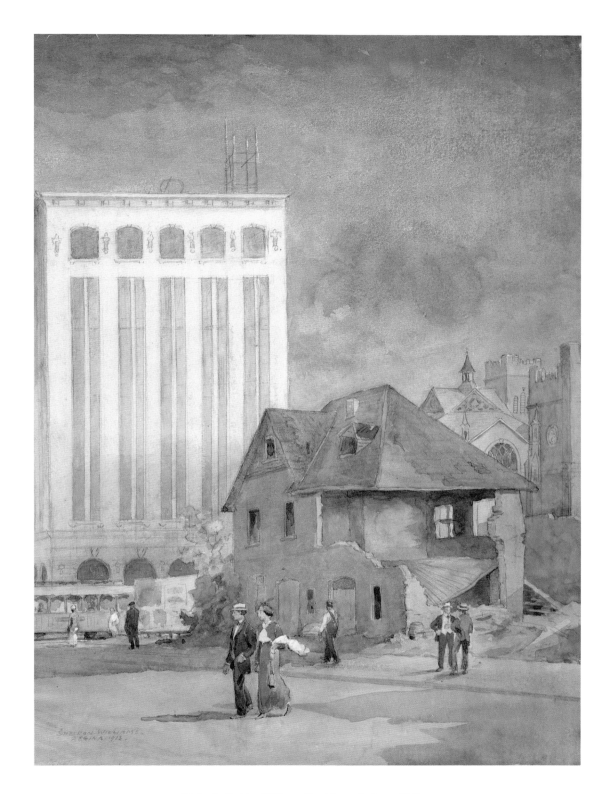

18. Inglis Sheldon-Williams, *Street Scene, Regina*, c. 1912

automotive dealerships and gas stations were evidence of an increasing modernity, a faster, less inhibited lifestyle that introduced the forms of a shared North American popular culture and led away from the attachment to England. This broadening of influence was reflected in the arts community, as seen in the varied backgrounds of the staff at the Winnipeg School of Art during the 1920s. Frank H. Johnston, a Torontonian and member of the Group of Seven, became the principal in 1921, to be succeeded in 1924 by C. Keith Gebhardt, a graduate of the Chicago Art Institute School, who then hired Winnipeg-born Lionel LeMoine FitzGerald as an instructor. FitzGerald became director of the school in 1929.[29]

L.L. FitzGerald had studied in New York at the Art Students League during the winter of 1921–22 and there had become aware of the emerging Regionalist and American Scene movements, which looked to the local as the source of artistic expression. FitzGerald's work from the late 1920s, such as *Pritchard's Fence* (cat. 48), reflects this influence in the clearly defined rhythmic forms and smooth sculptural modeling used to interpret his residential environment in Winnipeg. These views of quiet backyards and streets are distant from the mundane, promotional character of earlier urban representation. They are poetic considerations of form and rhythmic interval, where the structures of the city echo and reinforce those of nature. These paintings acknowledge the urban scene as a self-sufficient subject for art, equal to the landscape in importance. The prairie city had emerged as a place with a distinct image and voice.

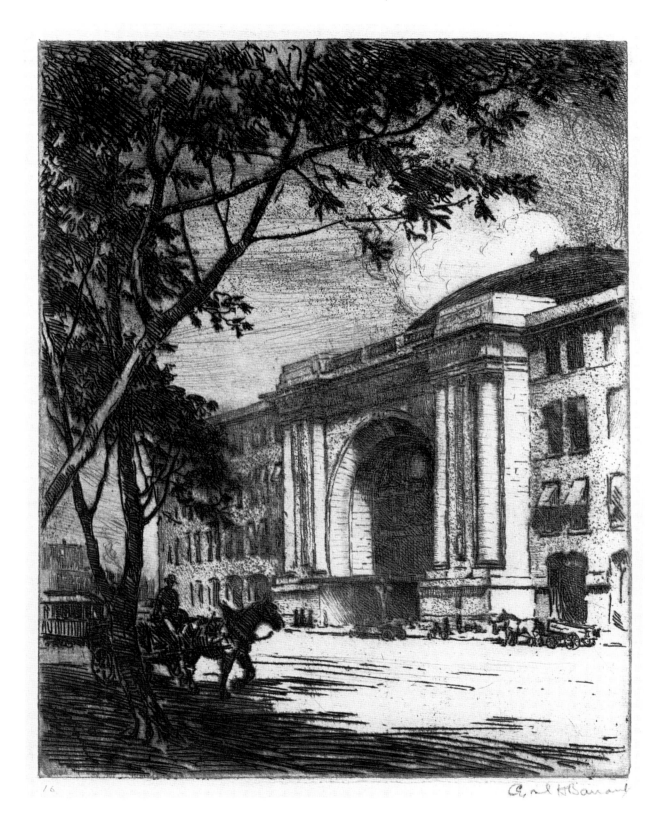

16

27. Cyril H. Barraud, *C.N.R. Station*, 1914

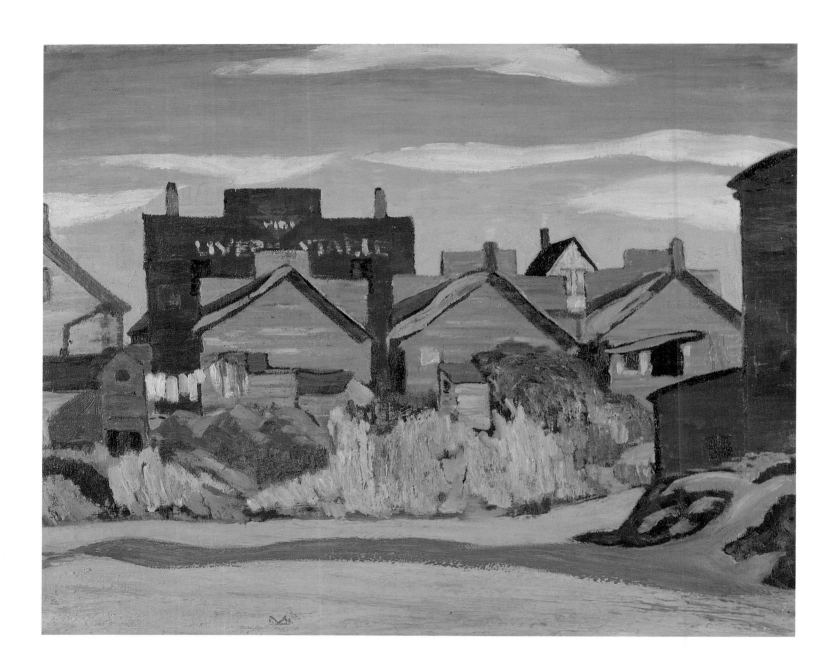

49. Illingworth Kerr, *Behind the False Fronts—Back of Main Street*, 1928–29

Crescent Park, Moose Jaw, Canada.

Post Office, Lethbridge, Alberta.—9.

WALK YOUR HORSES
AUTOMOBILES NOT TO EXCEED

Hotel Qu'Appelle, Regina, Sask. (Grand Trunk Pacific Railway)

"The Fort Garry" Grand Trunk Pacific's New Hotel,
Winnipeg, Man, Canada

Rotunda

Union Station

ATION, WINNIPEG, MAN.

Waiting Room.

N. R. STATION AND BOARD OF TRADE BUILDING, SASKATO

BIRKS

41. C. Keith Gebhardt, Detail of *St. Charles Hotel, Winnipeg*, 1927

39. Lionel LeMoine FitzGerald, *Backyards, Water Street,* 1927. Collection of the National Gallery of Canada, Ottawa

Above: 62. Caven Atkins, *Political Discussion, Depths of Depression, Winnipeg*, 1932 Opposite: 76. Augustus Kenderdine, *Broadway Bridge, Saskatoon*, c. 1935

A
SENSE
OF REGION

The 1930s brought to an abrupt end the utopian dream of unlimited prosperity
in the West. With the Depression came a reevaluation of a failing economic
system and an attempt to encourage social renewal through cooperative
economics and radical social action. This fostered an idea of the Canadian West
as a region with a distinct identity, culture and economy. The 1930s on the
Prairies saw a drastic hiatus in urban development and manufacturing, and
saw the city, as it became the focal point of both agrarian and urban protest,
transformed from the site of a utopian dream of wealth into a battleground of
political ideology. Political revolt and riot in prairie cities during the 1930s were
in stark contrast to the buoyant optimism and boosterism of the early years of
the century. The protests were extensively photographed and documented in
the local press as the strikes and marches became violent and lives were lost
(cats. 195, 196, 207 & 215, illus.). Out of this protest came the creation of
regional political parties: the Co-operative Commonwealth Federation (CCF)
(cat. 210) and the Social Credit Party.

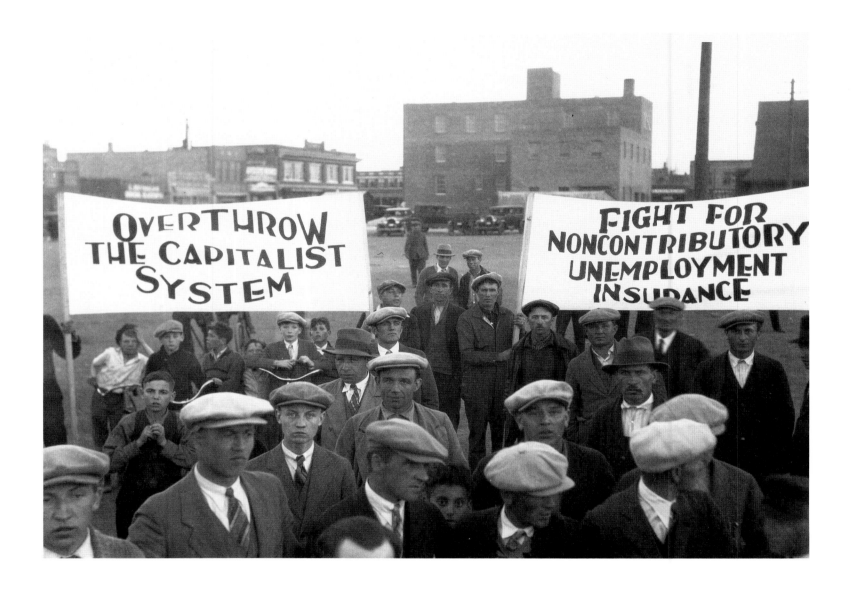

215. Dick Bird, *Demonstration of Strikers at Market Square prior to Regina Riot, 1935*

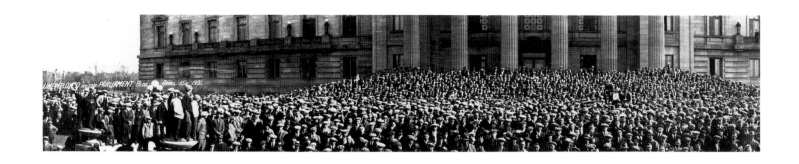

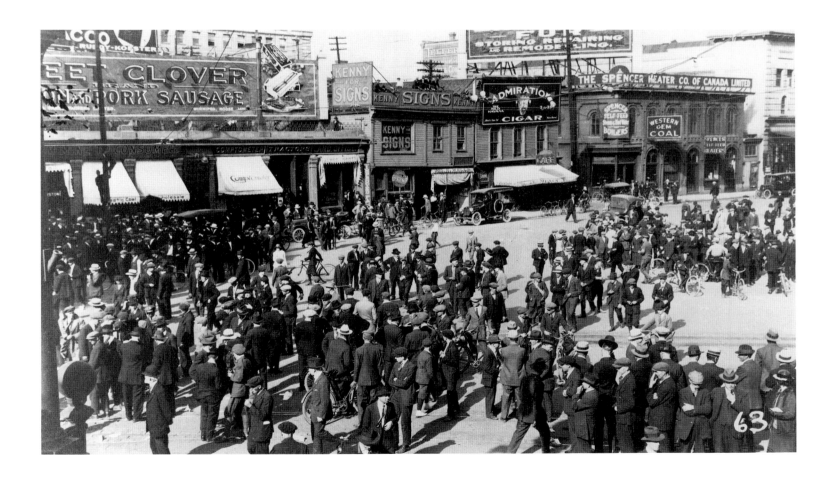

Top: 207. Lewis B. Foote, *Unemployed at the Parliament Buildings, Winnipeg,* 1931

Bottom: 196. Lewis B. Foote, *Winnipeg General Strike. Crowd at Portage and Main Street, June 21,* 1919

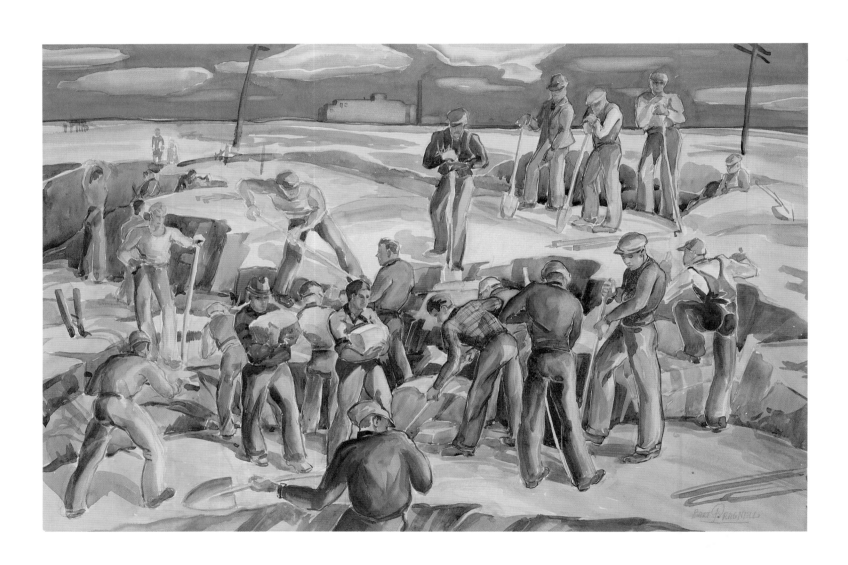

70. Bartley Robilliard Pragnell, *Relief*, c. 1933

In the 1930s, prairie artists were adversely affected by loss of business opportunities and patronage for their work, as were artists across Canada and the United States. This might explain their reluctance to depict images of poverty or desolation in their painting, which seems curious, given the highly charged urban atmosphere reported in the newspapers. Fritz Brandtner, Caven Atkins, Charles Comfort and Philip Surrey all worked in Winnipeg in the early 1930s and might have forged a distinctly prairie form of urban and political art had they stayed. Working at Brigden's, a commercial graphics firm in Winnipeg, these artists had the benefit of close contact, which fostered their discussion of common artistic interests (cat. 47). Brandtner, in particular, because of his grounding in German Expressionism, was positioned to bring social issues to prominence in his art. He and Atkins depicted Winnipeg industrial sites and

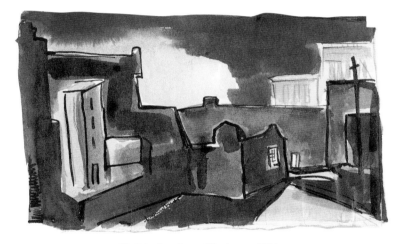

60. Fritz Brandtner, *Winnipeg*, c. 1931

street scenes starkly and expressively as alien and hostile environments, emptied of human presence (cats. 67 & 72, illus.). Although there is little overt political reference, the mood and intent are clearly a reflection of the somber environment of economic collapse. This is explicit in Atkins's *Political Discussion, Depths of Depression, Winnipeg,* 1932 (cat. 62, illus.), where he makes specific reference to the city as an arena for political activity.

The work of these two Winnipeg painters reflects a growing interest among Canadian artists of this time in a distinctly Canadian art which expressed regional difference. The Group of Seven had established a Canadian school that

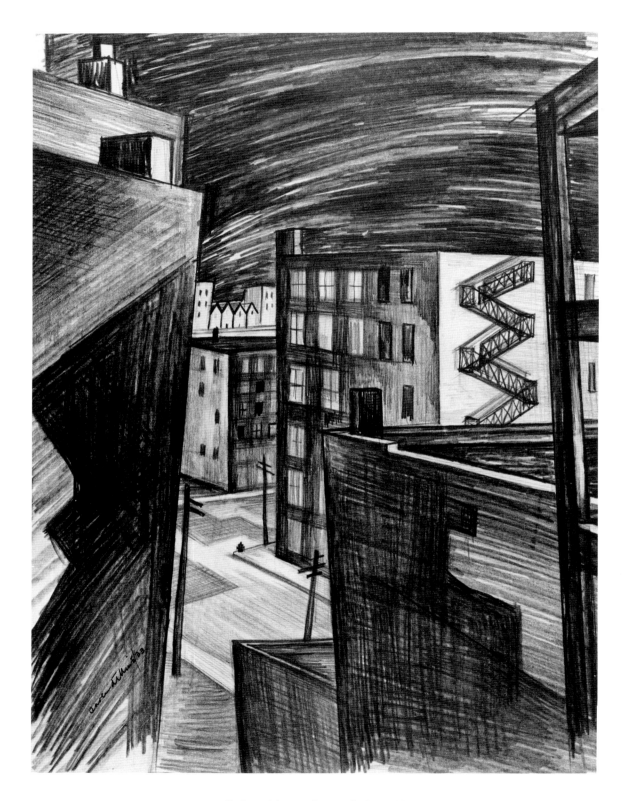

67. Caven Atkins, *Night View of a City*, 1933

"put forth a vision of the Canadian landscape in a sort of pre-cultural state, devoid of the influence of different cultures which transformed it into inhabited territory."[30] However, the empty landscape was perceived to be a less effective subject for an urban and socially engaged art by some of the artists in the Canadian Group of Painters, formed in Toronto in 1930, who included André Biéler, Paraskeva Clark, Jack Humphrey and Miller Brittain. They actively pursued an art rooted in place, and their example would have an influence on some prairie artists. There was also the influence of contemporary American artists, who, supported by the Works Progress Administration (WPA) and related programs, responded to the interwoven themes of modernism and

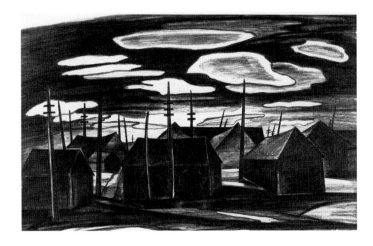

54. Fritz Brandtner, *Regina*, 1930

social reform. This is seen in the work of painters Louis Lozowick and Charles Sheeler or the photographer Walker Evans, which utilized industrial forms or documented social conditions. Other artists, including Thomas Hart Benton, John Steuart Curry and Grant Wood, closely connected to the American Scene Movement, reacted negatively towards modernism and foreign influence, and based their art, which was demonstrably anti-urban and anti-intellectual, on the values of rural and small town life. Canadian artists were well aware of these American positions, especially after the Kingston Conference in 1941.

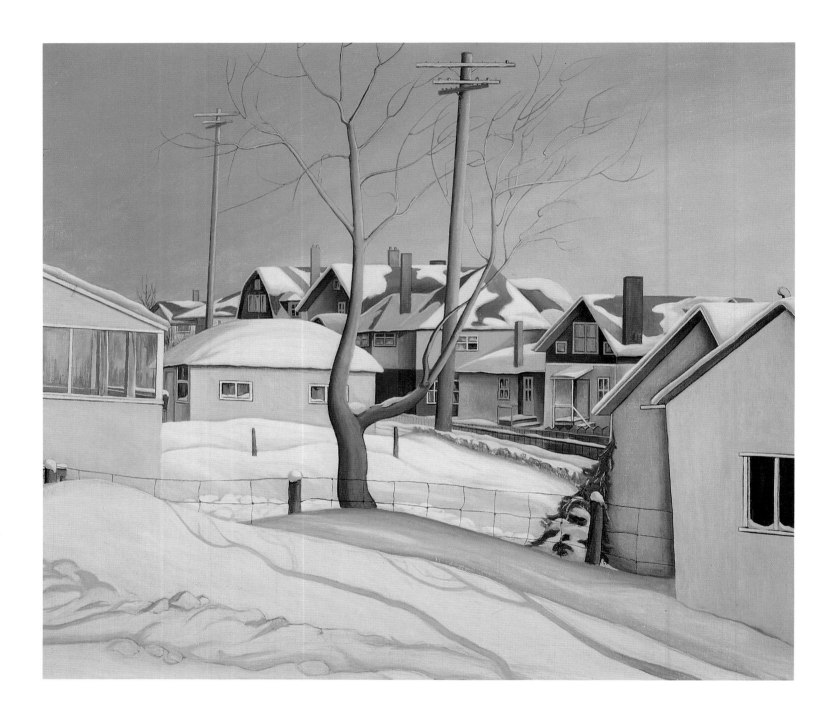

64. H. Eric Bergman, *Winter in Winnipeg*, 1932

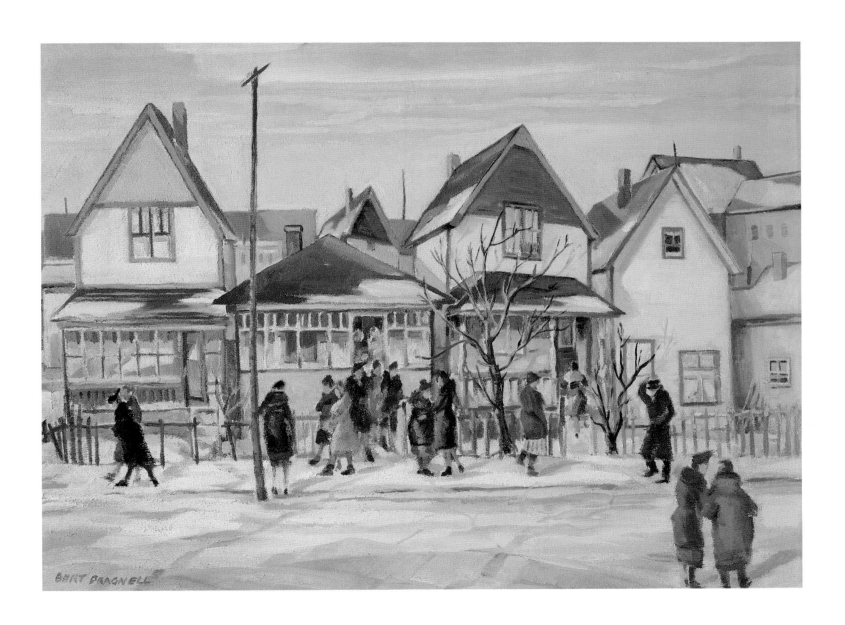

63. Bartley Robilliard Pragnell, *Tea Party*, 1932

During the 1930s and 1940s, prairie artists increasingly began to look at what was distinct and unique about their region. In a general way, their painting focused on the city and moved into it as if through a kind of close-up lens. By eschewing the tendency of earlier artists to use the city as an element in a picturesque landscape, artists in the 1930s began to see the city as a self-contained subject which could accommodate both social commentary and visual documentation. FitzGerald, in his meticulous icons of the prairie city, such as *Doc Snyder's House,* 1931 (cat. 56, illus.), captured the stark clarity of form and intensity of light so typical of the prairie city. While he avoided any specific social commentary in his work, FitzGerald was concerned with a union of inner emotions and objective form. The paintings become almost moral

86. Margaret Shelton, *Calgary,* 1939. Glenbow Collection

statements of an artist's relationship to place; however, they are less concerned with an exaltation of the city and the machine than they are with a metaphysical concept of form.

Nature was also the dominant theme in the work of Illingworth Kerr. Kerr was strongly influenced by the Group of Seven, and his swirling, brightly hued paintings of the vast Prairie were among the first to give this landscape a modern expression. However, throughout his life, Kerr also had a strong interest in the urban environment as a subject, especially that of his home town of Lumsden, Saskatchewan (cat. 49, illus.), and later of Calgary (cat. 152). These paintings share the dramatic quality and style of his landscapes, becoming evocative theatre sets which delight in the mysterious quality of urban life.

Henry G. Glyde and Bartley Robilliard Pragnell were also concerned with a narrative and thematic approach, and their work may be compared to that of the American Scene artists. Both artists privileged the human figure, as well as emphasizing the picturesque qualities of the local and urban environment. They also produced a substantial body of work which used the prairie town and city as the site for an art of social commentary. Glyde in the 1930s often used the small town as a backdrop to bucolic country scenes of skaters, musicians or farmers, which explored the formal qualities of light and architecture, as in *Outskirts of Lethbridge, Alberta,* 1938 (cat. 83). While Pragnell painted both urban and interior scenes during the 1930s (cats. 63 & 74), he was also one of

57. Lewellyn Petley-Jones, *Untitled* (crane and building, Edmonton), 1931

the few artists working on the Prairies at this time to depict the human side of the Depression, for example, *Relief,* c. 1933 (cat. 70, illus.).

The Saskatoon artist Stanley Brunst represented the city extensively in his work through the thirties and forties with an emphasis on arbitrary color and distortions of form unusual for this time in artistic representation. Brunst's quixotic modernist practice, seen in his many views of Saskatoon (cat. 87, illus.), derived from his interest in overall design and the impact of reproductions of modern European and American paintings he had seen in art magazines. His work reflects both the isolation of artists on the Prairies and their desire to be connected to a larger world.

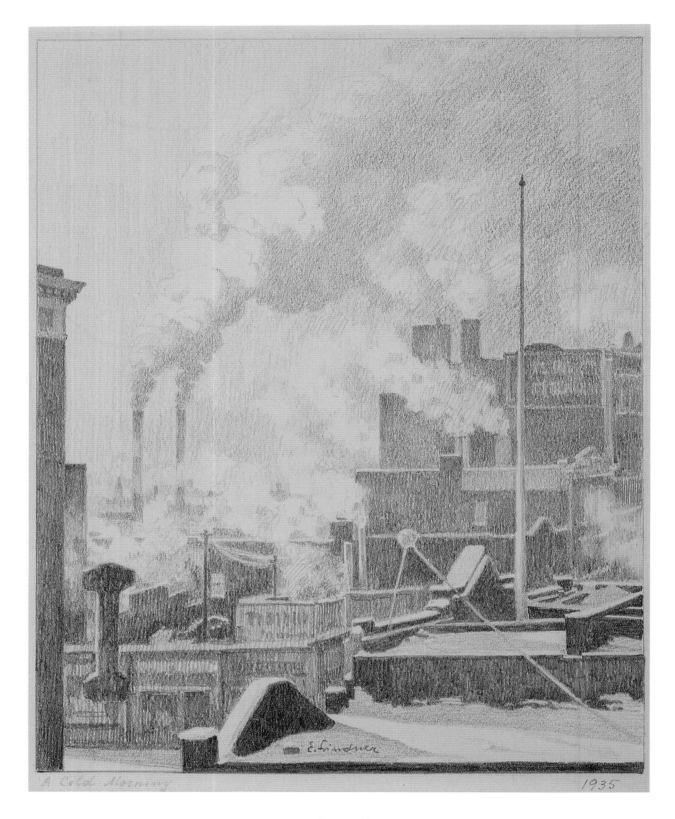

A Cold Morning

1935

75. Ernest F. Lindner, *A Cold Morning*, 1935

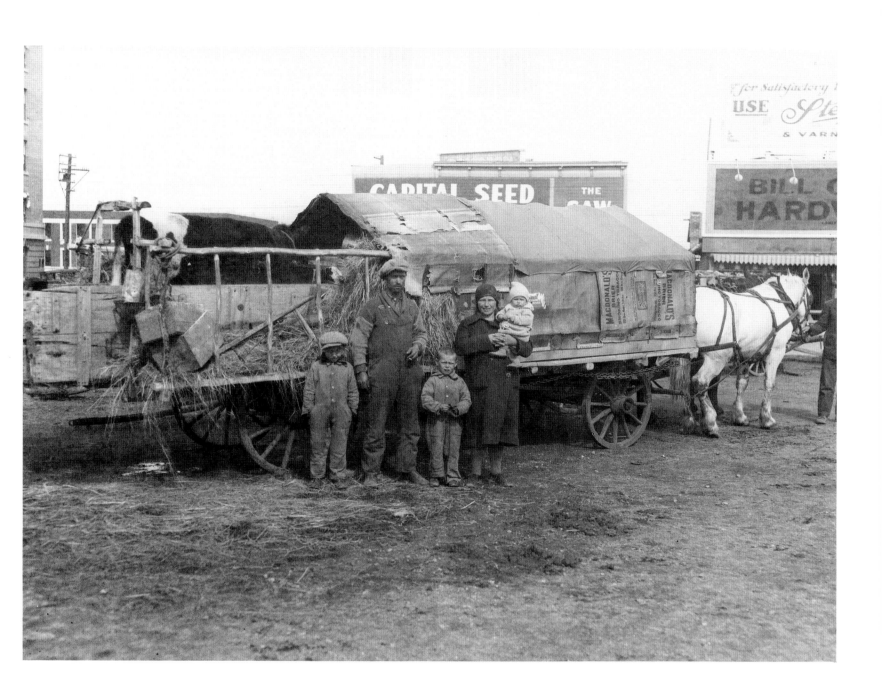

209. Anonymous, *Daynaka family, Edmonton*, 1933

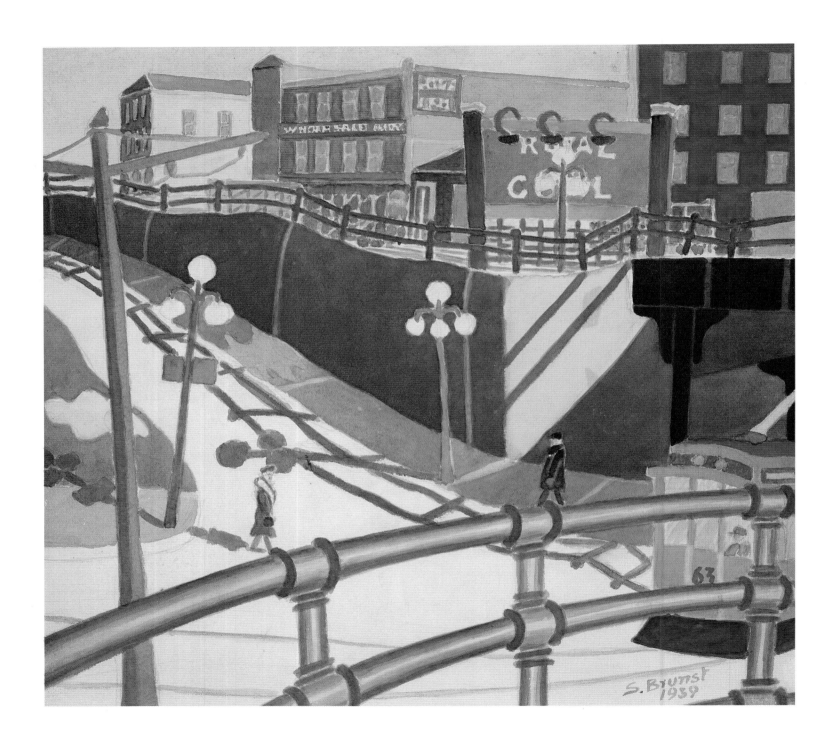

87. Stanley Brunst, *Untitled* (rail tunnel, Saskatoon), 1939

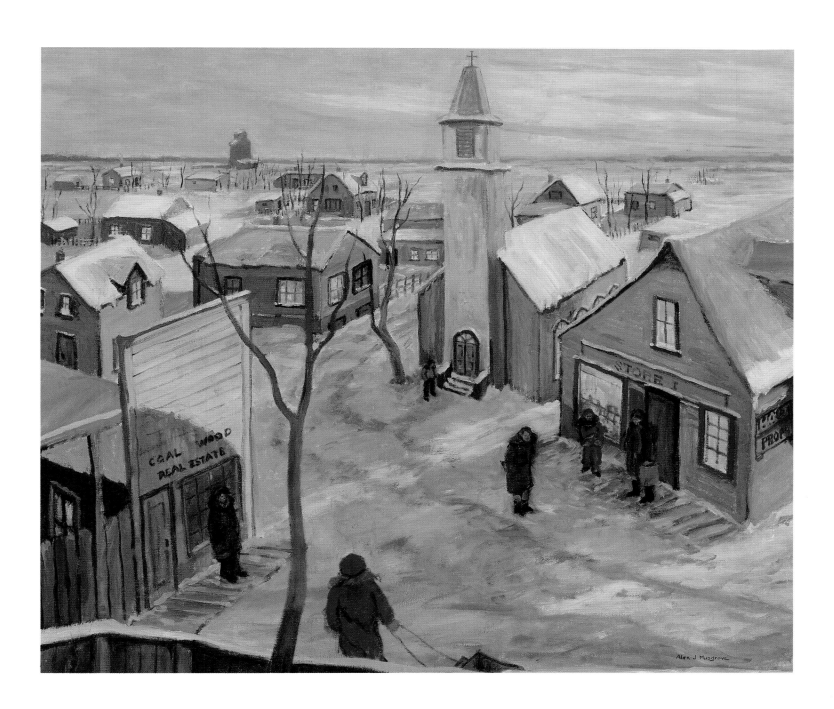

95. Alexander J. Musgrove, *Coming Dusk, Prairie Village*, c. 1940

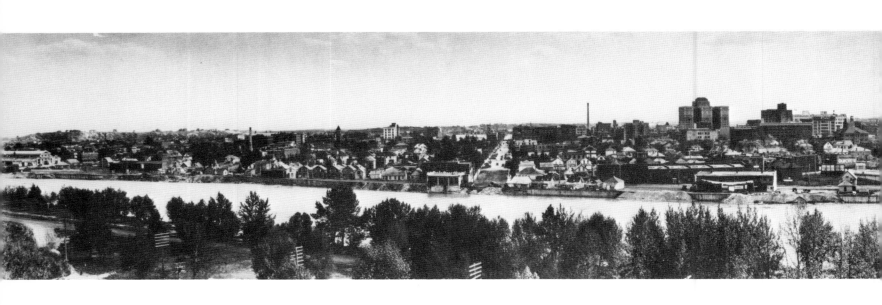

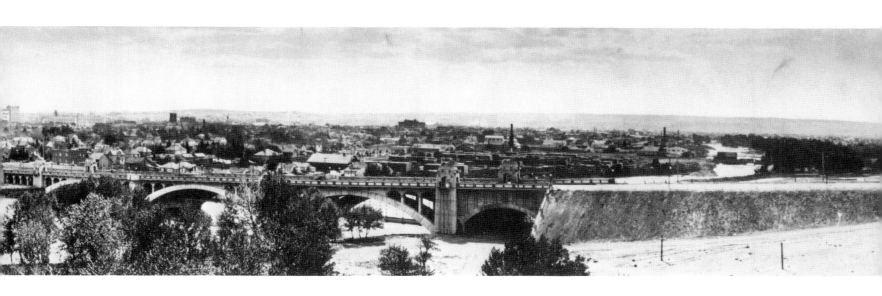

Fig. 1. William John Oliver (1887–1954), *Untitled* (view of Calgary), c. 1930. Courtesy of the Glenbow Archives, Calgary. PE–14–1

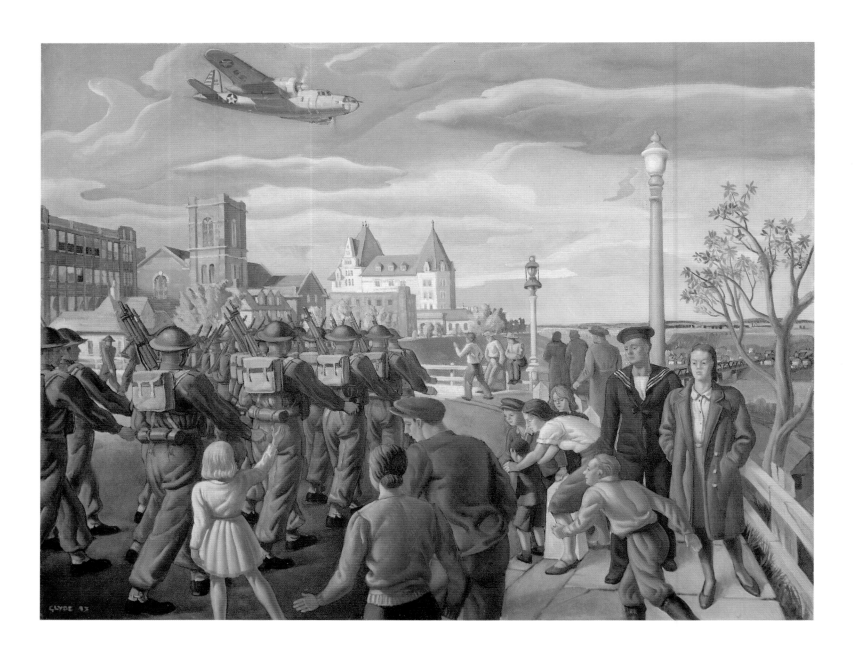

Above: 104. Henry G. Glyde, *Edmonton*, 1943 Opposite: 262. *Untitled* (artillery shells, Calgary), 1940. Glenbow Collection

THE
WAR YEARS

World War II ended the Depression and brought the Prairies a renewed vitality as factories and production plants to serve the war effort were opened. The war effort in the prairie cities also became an important subject for artists; H.G. Glyde's *Edmonton,* 1943 (cat. 104, illus.), and W.J. Phillips's *Dawn, Edmonton Airport,* 1942 (cat. 101, illus.), are almost social realist statements of sacrifice and determination by military and civilian workers, the men and women behind the war effort.

Glyde had perhaps a more complex view of the war than any other artist working on the Prairies. During the 1940s, he addressed the conflict from a metaphorical and allegorical vantage and used the urban or small town environment as the setting for narratives of biblical and heroic scope. Like Thomas Hart Benton, the American painter whom he had met at the Kingston Conference,[31] Glyde often used the monumental figure in a local setting in his paintings during the 1940s. This allowed him to explore his interest in the themes and compositional devices of classical painting while documenting his local environment.[32] In *The Exodus,* 1941 (cat. 99, illus.), Glyde used the city of Calgary as a contemporary setting for an apocalyptic biblical event in order to comment on the universality of suffering and displacement caused by war. Glyde updated this epic approach in *Aftermath,* 1952 (cat. 132, illus.), where

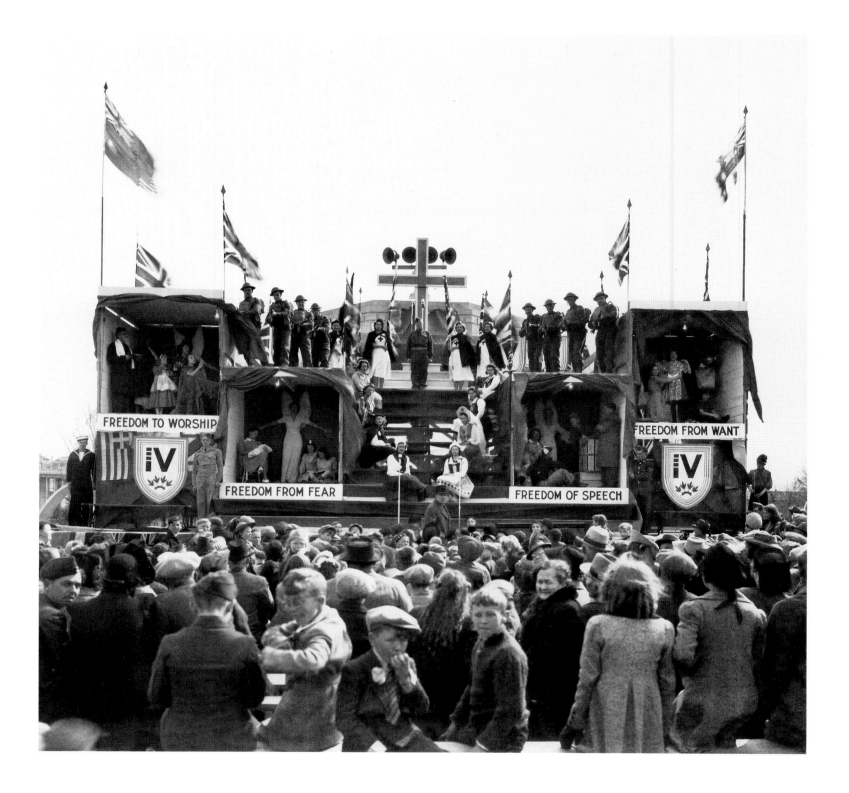

218. Leonard Hillyard, *Victory Bond Float on 2nd Avenue, Saskatoon*, c. 1940

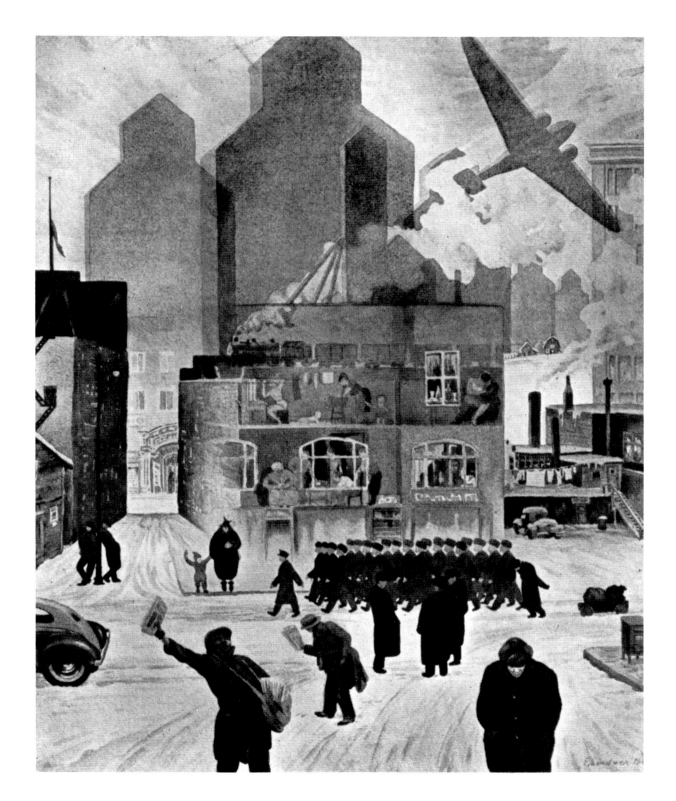

265. Ernest F. Lindner, *Prairie City in 1940*

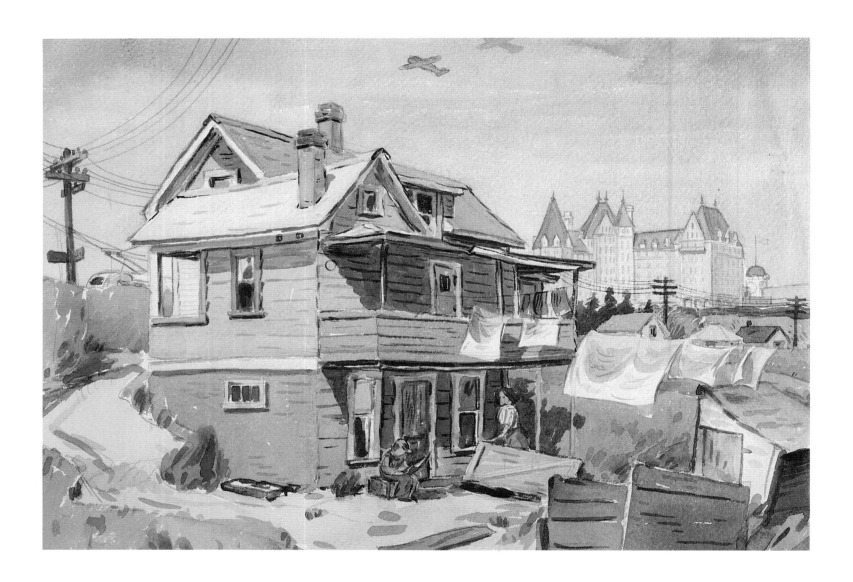

108. Wesley Fraser Irwin, *Old House in Edmonton #2*, c. 1944. Glenbow Collection

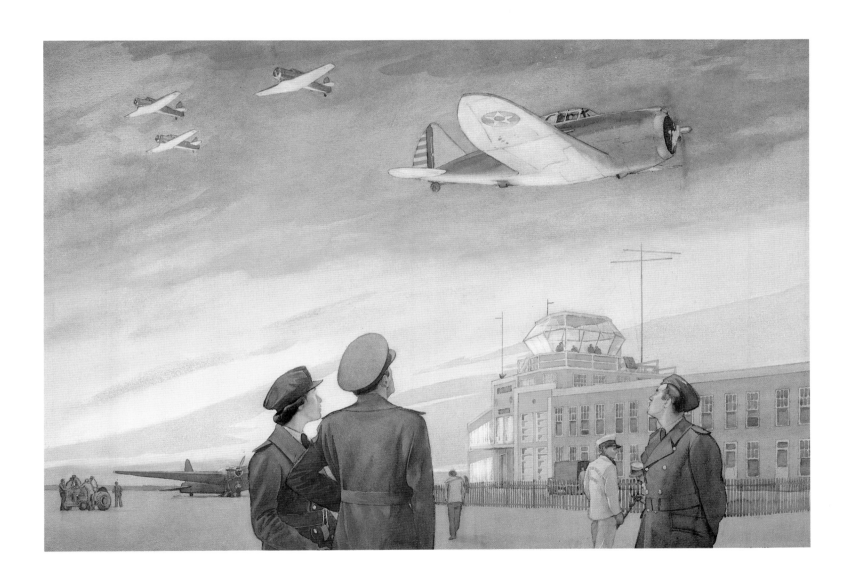

101. Walter J. Phillips, *Dawn, Edmonton Airport*, 1942

the jumbled smoking ruins of Edmonton and its fleeing and dying inhabitants become the theatre of a modern and even more destructive kind of warfare.

The city and the war are also prominent subjects in Pragnell's work during the war years.[33] His sketch books and graphic work depict images of drunken soldiers lurching out of bars or recruits sweeping floors in the barracks. Throughout the 1940s too, Pragnell continued his interest in the figure in the urban setting, often rendering it loosely and freely in watercolor or thinned oil medium (cat. 113).

The war often seemed to give a heightened sense of emotion to the work of many artists. This may be seen in H. Eric Bergman's *Off to War,* 1943 (cat. 105, illus.), in which the artist's son, glimpsed through a window, leaves home on a blustery winter day. The drawing conveys a subtle sense of sadness and loss of youth.

In addition to painting, the block print was used extensively during the 1940s to represent intimate views of the artists' immediate environment. This medium allowed experimentation with the formal innovations of modernism while using the local scene as a source of pictorial and anecdotal interest. Margaret Shelton's *East Calgary,* 1940 (cat. 89, illus.), and Ernest F. Lindner's *Dead End,* c. 1945 (cat. 110), are typical examples.

Noticeably absent on the Prairies during this time is work by photographers which used the city as a subject for aesthetic study, although commercial and documentary photography did concentrate on the war effort, especially on cooperative activities such as rallies, factory work and rationing (cats. 218 & 262, illus.). In Vancouver, John Vanderpant worked in a pictorialist style which increasingly utilized industrial forms, and amateur photographers, such as Leslie G. Saunders in Saskatoon, occasionally used the city in photographs (cat. 223). However the relative paucity of the urban subject in photography in the West is a reflection of the still primarily rural character of the prairie region at the time, compared to the heavily industrialized eastern United States where most urban photography was centred.

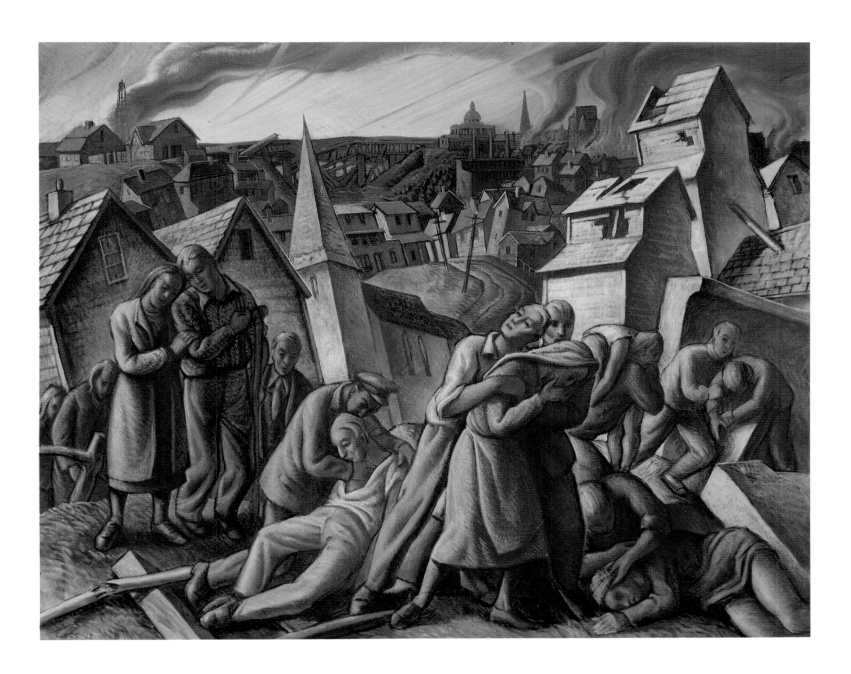

132. Henry G. Glyde, *Aftermath*, 1952

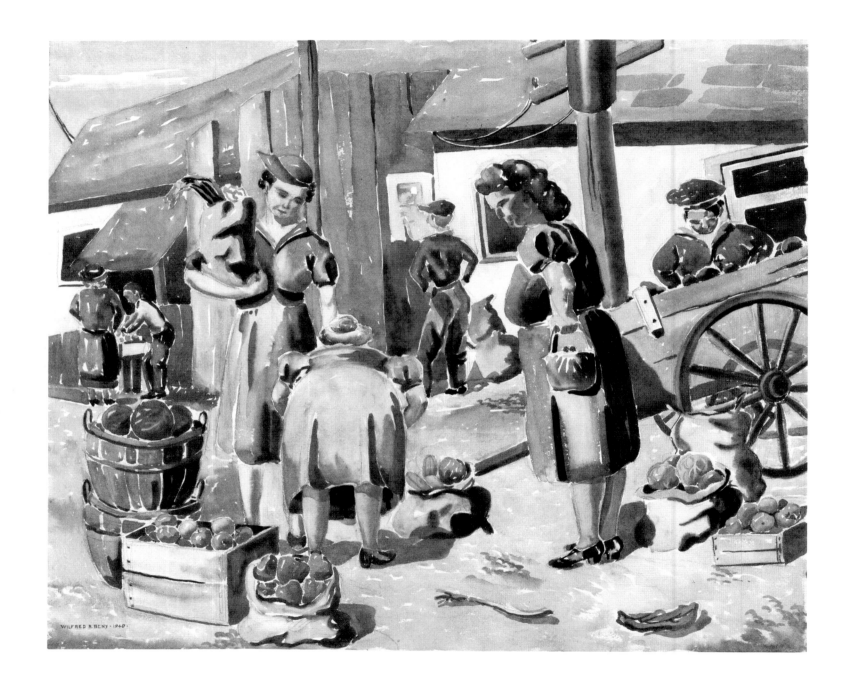

92. Roloff Beny, *Untitled* (market scene, Medicine Hat), 1940

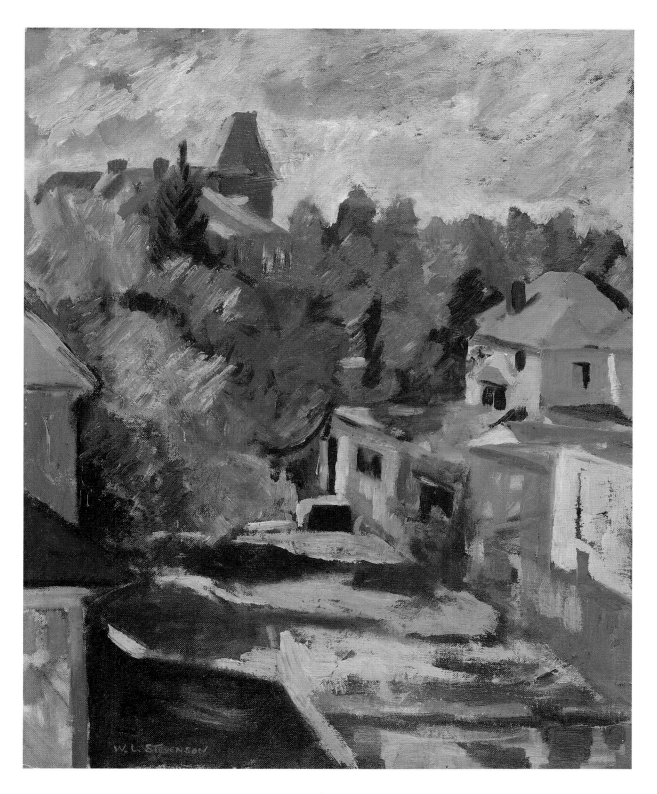

94. William Stevenson, *Across the Road* (St. Mary's, Calgary), c. 1940

Gibson Photo
1948.

221. John W. Gibson, *Untitled* (view of Saskatoon), 1948. Glenbow Collection

Above: 140. Lionel LeMoine FitzGerald, *Untitled* (abstract), c. 1954 Opposite: 131. Marcel G. Vance, *Spirit of Saskatchewan*, c. 1951

MODERNISM
AND POPULAR
CULTURE

The 1950s inaugurated a period of increased prosperity that brought the
western region closer to continental and international artistic movements. This
was, in part, due to the economic dominance of North America after the war.
The pervasive force of American popular culture, promoted through television,
advertising, film, music, radio and magazines, would decisively orient the
prairie city towards the United States. Architecture, design, interior decoration,
music and art were remarkably homogeneous in the 1950s and tended to elimi-
nate notions of difference rather than accentuate regional, geographic, or cultural
characteristics; these were more likely to be relegated to the world of kitsch.

The city itself was to become the vehicle of modernity. Architects and designers
began a wholesale adoption of the International Style which incorporated the
curtain wall building and modern interior design into a new generation of office
buildings. In Calgary, the first office tower built to accommodate the oil business
was The Barron Building, designed by local engineer Jack Cawston and opened in
1951. The oil boom would change the face of many western cities. Architectural
firms, such as Rule, Wynn, Rule in Edmonton, designed buildings conforming to

the demands of an international and corporate style of architecture that would transform the urban landscape of every major prairie city (cat. 124).

Artists, as well, began to explore new styles in their work. Abstraction, with its multiple reflective viewpoints, fractured planes and geometric forms, was especially suited to the modern cityscape. The representation of the local in this work, however, is still very apparent, as may be seen in James McLaren Nicoll's *Shacks and Refinery,* c. 1950 (cat. 126, illus.). While FitzGerald continued to paint realist urban views, such as *From an Upstairs Window, Winter,* 1950–51 (cat. 130, illus.), he began a sustained series of abstract paintings and drawings. Some of this work, for example, *Untitled* (abstract), c. 1954 (cat. 140, illus.), has obvious reference to architectural forms, but this artist seemed to be moving away from the narrative and descriptive in his paintings to explore the expressive possibilities of color and form alone.

Of major significance at midcentury was the emergence of a generation of artists who were very receptive to modernism. Their work from the 1950s straddles a border between abstraction and figurative painting, and many would not paint in a fully abstract style until the early 1960s. Roy Kiyooka's *City, My City,* c. 1955 (cat. 142), and Otto Rogers's *City of Light,* 1959 (cat. 146, illus.), show a preoccupation with both the larger format and gestural freedom that reflects the influence of European and New York abstraction. Prairie artists wishing to establish a link with international developments gradually replaced subject matter with abstracted form or gesture in their work. This led away from the city as a passive or descriptive subject to the city as the site of inner experience, internalized in the studio. Marion Nicoll's painting of 1960 *The City—Sunday* (cat. 148, illus.) affirms a new subjectivity; the topography of the city is only alluded to in the rectangular forms of the composition and the title.

On the Prairies, as artistic practice became more abstract in the 1950s and architecture less concerned with representation in friezes and relief sculpture, free-standing sculpture and mural projects increasingly replaced architectural details as the symbols of progress. Many artists became interested in public art as an expression of modernity and its relationship to an urban experience. For example, Saskatoon artist William Perehudoff's grid-like murals, painted in

148. Marion Nicoll, *The City—Sunday*, 1960

126. James McLaren Nicoll, *Shacks and Refinery*, c. 1950

1955 for the waiting room of the Saskatoon bus depot of the Saskatchewan Transportation Company (cat. 272), while not referring to the city directly, are about speed, mobility and their importance to modern life.[34] Robert Murray's abstracted drawings for a fountain outside Saskatoon's city hall refer directly to the role of water in prairie life (cat. 149). These drawings, and the final sculpture, also relate to the scale of the human body within a modern urban environment.

In popular design, the representation of the city proliferated, especially in advertising. The Seagram Company commissioned well-known Canadian artists, including Goodridge Roberts, William Winter (cat. 137, illus.), and A.C. Leighton (cat. 133), to paint views of the major Canadian cities. The paintings were then toured worldwide as a promotional exhibition and used as images in Seagram's ads in mass circulation magazines (cat. 271, see cat. 134, illus.).

The city also found an unexpected ally during this time in the work of amateur and folk artists who were often outside institutional and professional circles. This disparate and idiosyncratic group tended to use the city as a recurring subject in their work, where, through obsessive and repetitive imagery, it took on a personal and psychological aura (cats. 131, 143, illus. & 147).

By 1960, for those artists who sought a practice closer to the internationalism of contemporary art, the city began to lose its importance as a subject, preempted by both the frequency of its commercial representation in the mass media and by the adoption of a vocabulary of abstraction. On the Prairies, the city continued to be the most important site of artistic production, but its image was increasingly rejected by artists who desired to move beyond what they perceived to be the regionalism of an earlier generation. As a subject with renewed meaning, the city would have to wait until artists began to rework the vocabulary of international abstraction, merging this language with other concerns, both artistic and social, to reaffirm the importance of place.

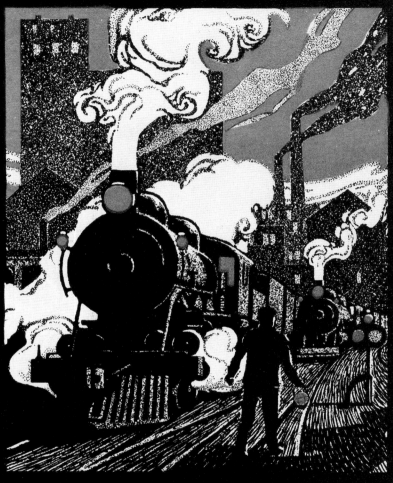

276. *C.P.R. Transcona*, n.d.
Glenbow Collection

NOTES

1. Alan F.J. Artibise, *Winnipeg: An Illustrated History* (Toronto: James Lorimer & Co., and Ottawa: National Museum of Man, 1977), 200.

2. Stanley G. Triggs, *William Notman: The Stamp of a Studio* (Toronto: Art Gallery of Ontario and The Coach House Press, 1985), 70. In exchange for free transportation on the railway, the Notmans made the prints available for use in CPR promotion; the Notmans retained the negatives as well as copyright and the privilege of selling the photographs in the trains, stations, and hotels along the line.

3. See Allan Pringle, "William Cornelius Van Horne, Art Director, Canadian Pacific Railway," *The Journal of Canadian Art History,* volume VIII/1 (1984): 50.

4. Pringle, "William Cornelius Van Horne, Art Director, Canadian Pacific Railway," 53.

5. Pringle, "William Cornelius Van Horne, Art Director, Canadian Pacific Railway," 59–60.

6. Triggs, *William Notman: The Stamp of a Studio,* 71.

7. Virginia Berry, *Vistas of Promise* (Winnipeg: Winnipeg Art Gallery, 1987), 13.

8. Artibise, *Winnipeg: An Illustrated History,* 20.

9. Artibise, *Winnipeg: An Illustrated History,* 25.

10. Some towns, established in anticipation of the railway, were not so lucky, namely, Emerson, Manitoba, the Gateway City. Founded in 1876, Emerson once rivalled Winnipeg in population. Strategically located on the rail line to St. Paul, this town experienced a speculative real estate boom like Winnipeg but failure to obtain the CPR line and the establishment of trade tariffs with the USA resulted in Emerson's eventual decline.

11. For a discussion of the role of the postcard in the colonization process, see Gareth Stanton, "The Oriental City: A North African Itinerary," *Third Text,* nos. 3 and 4 (Spring/Summer 1988).

12. Quoted in Brian P. Melnyk, *Calgary Builds: The Emergence of an Urban Landscape 1905–1914* (Edmonton: Alberta Culture, and Regina: Canadian Plains Research Centre, 1985), 22.

13. John Crosby Freeman, "Thomas Mawson: Imperial Missionary of British Town Planning," *racar* vol. 2, no.2 (1975): 37.

14. In 1898 the Garden City Association was formed in England to promote the ideas of Ebenezer Howard, espoused in his book *Garden Cities of Tomorrow,* "… towns should be designed with the health and social happiness of all their inhabitants in mind, instead of catering only for an élite few and allowing the uncontrolled expansion of cities that created slums for the lower classes." Quoted in E. Joyce Morrow, *Calgary Many Years Hence: The Mawson Report in Perspective* (Calgary: City of Calgary/University of Calgary, 1979), after illus. 11.

15. Edwinna von Baeyer, "The Battle Against Disfiguring Things": An Overview of the Response by Non-Professionals to the City Beautiful Movement in Ontario from 1880 to 1920, *Bulletin* vol. 11, no. 4, (Ottawa: Society for the Study of Architecture in Canada, Dec. 1986), 4.

16. Winnipeg, for example, had severe problems with sanitation (culminating in the typhoid epidemic of 1904–1905), overcrowding, and lack of education for immigrant children; these problems were endemic in the North End of Winnipeg where many immigrants lived. See Artibise, *Winnipeg: An Illustrated History,* 102–104.

17. See Ronald Rees, *New and Naked Land: Making the Prairies Home* (Saskatoon: Western Producer Prairie Books, 1988), 97–106.

18. Figures from 1901 and 1911 Dominion Census; quoted in Melnyk, *Calgary Builds: The Emergence of an Urban Landscape 1905–1914,* 21.

19. Morrow, *Calgary Many Years Hence: The Mawson Report in Perspective,* after illus. 26.

20. Freeman, "Thomas Mawson: Imperial Missionary of British Town Planning," 41.

21. Morrow, *Calgary Many Years Hence: The Mawson Report in Perspective,* after illus. 16.

22. Trevor Boddy, *Modern Architecture in Alberta* (Edmonton: Alberta Culture and Multiculturalism, and Regina: Canadian Plains Research Centre, 1987), 29.

23. Freeman, "Thomas Mawson: Imperial Missionary of British Town Planning," 39.

24. The history of the Winnipeg cenotaph, which is located on the centre of Memorial Boulevard leading to the main entrance of the legislative buildings, is revealing. The first contest for the design was won by the Toronto sculptor Emmanuel Hahn. However on February 25, 1926, the committee rejected his design, paid him the $500.00 prize money and re-opened the contest. His involvement with the project was terminated presumably because of the inappropriateness to such a project of his German background. Hahn had, in fact, come to Canada in 1892 and had been a naturalized Canadian since the age of 11. The second contest was won by Elizabeth Wyn Wood. Wood was married to Mr. Hahn, a fact the committee had overlooked; in November of 1927 they rejected her design as well but gave her the $500.00 prize money. Gilbert Parfitt, later provincial architect in Manitoba, at last carried the project through; unveiling of the monument was on November 7, 1928. Mr. Parfitt had been in Canada since 1912 when he emigrated from England. Quoted in Betty Jane Wylie,"Winnipeg's Cenotaph," *Manitoba Pageant* (Manitoba Historical Society, vol. 8, no. 2 Jan. 1963).

25. In 1912 Mawson was asked by the Saskatchewan government to design a landscaping plan for Wascana Lake which included a 300-acre housing estate. Mawson's plans were never fully implemented but "the layout of the crescent residential area to the west of Wascana Park, the formal gardens in front of the Legislature, the width of Broad and Albert streets, and the separation of the southern residential from northern industrial areas of Regina" reflect some of the concepts of his plan. Quoted in Saskatchewan Association of Architects, *Historic Architecture of Saskatchewan* (Regina: Focus Publishing Inc., 1986), 82. See also Rees, *New and Naked Land: Making the Prairies Home,* 130–135.

26. In Canada, an atelier was established by the Beaux-Arts Society in Toronto under the patronage of architect John Lyle in the autumn of 1908. For a more detailed account of the Beaux-Arts style in Canada, see Kelly Crossman, *Architecture in Transition: From Art to Practice, 1885–1906* (Montreal and Kingston: McGill-Queen's University Press, 1987), chapter 6.

27. See Crossman, *Architecture in Transition,* chapter 9, on the competition for the Saskatchewan legislative buildings and the influence of American and British models on Canadian government buildings.

28. For more on the process of dissemination of industrial architecture in North America, see Leonard K. Eaton, "Oscar A. Eckerman: Architect to John Deere & Company, 1897–1942," *racar,* vol. 3, no. 2 (1976).

29. See Marilyn Baker, *The Winnipeg School of Art: The Early Years,* exhibition catalogue (Winnipeg: University of Manitoba Press, 1984).

30. François-M. Gagnon, "Painting in Quebec in the Thirties," *The Journal of Canadian Art History,* vol. III, nos. 1 and 2 (Fall 1976): 3.

31. Glyde had met the American regionalist artist Thomas Hart Benton at the Kingston Conference in 1941 and was interested in the modelling and rhythmic compositions of Benton's work. There seems to be a demonstrable connection between Benton's work with its penchant for allegory and Glyde's from this time. Patricia Ainslie, *A Lifelong Journey, The Art and Teaching of H.G. Glyde,* exhibition catalogue (Calgary: Glenbow Alberta Institute, 1987), 42.

32. Ainslie, *A Lifelong Journey,* 44.

33. Pragnell enlisted with the RCAF in 1941, receiving his commission as an administrative pilot officer in 1943. He was transferred to Ottawa where he organized the art programs at RCAF bases across Canada. See George Moppett, *Bart Pragnell: A Retrospective,* exhibition catalogue (Saskatoon: Mendel Art Gallery, 1990), 10.

34. Z.D., "First Mural in Public Building Here Adorns Bus Depot Wall," *Saskatoon Star-Phoenix,* 22 September 1955.

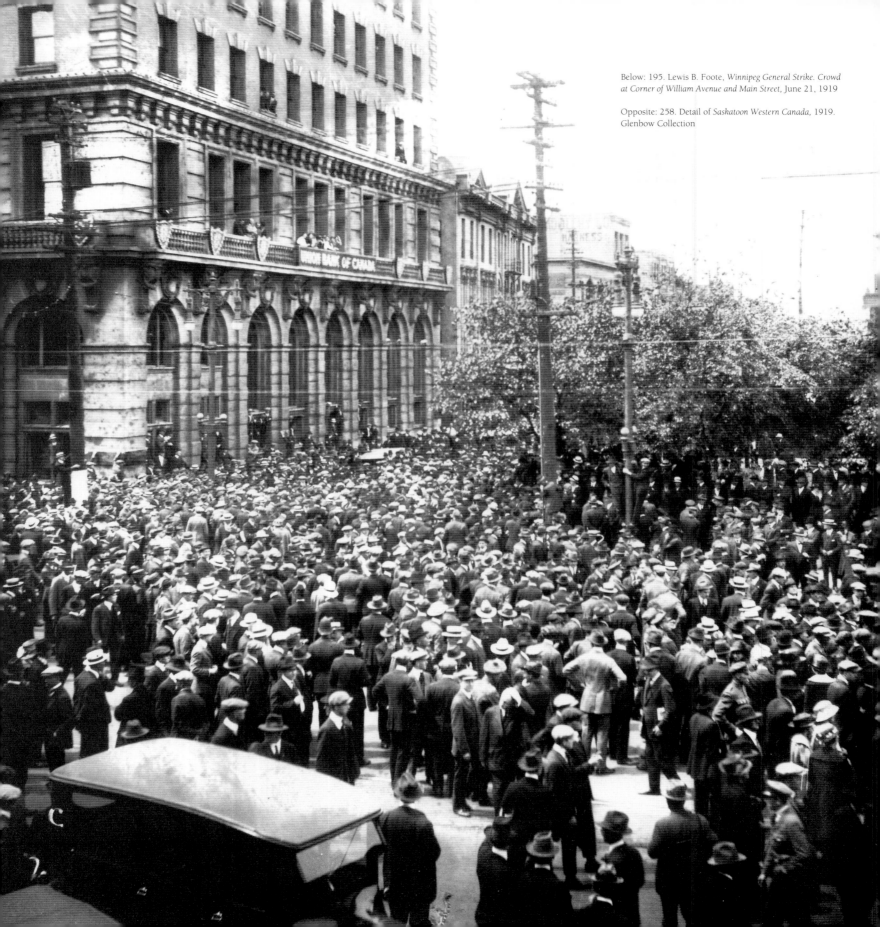

Below: 195. Lewis B. Foote, *Winnipeg General Strike. Crowd at Corner of William Avenue and Main Street*, June 21, 1919

Opposite: 258. Detail of *Saskatoon Western Canada*, 1919. Glenbow Collection

"BRAND NAME" VS. "NO-NAME"

A HALF-CENTURY OF THE REPRESENTATION OF WESTERN CANADIAN CITIES IN FICTION

GUY VANDERHAEGHE

Not far from the centre of the American Continent, midway between the oceans east and west, midway between the Gulf and the Arctic Sea, on the rim of a plain, snow swept in winter, flower decked in summer, but, whether in winter or in summer, beautiful in its sunlit glory, stands Winnipeg, the cosmopolitan capital of the last of the Anglo-Saxon Empires,—Winnipeg, City of the Plain, which from the eyes of the world cannot be hid. Miles away, secure in her sea-girt isle, is old London, port of all seas; miles away, breasting the beat of the Atlantic, sits New York, capital of the New World, and mart of the world, Old and New; far away to the west lie the mighty cities of the Orient, Peking and Hong Kong, Tokio and Yokohama; and fair across the highway of the world's commerce sits Winnipeg, Empress of the Prairies. Her TransContinental railways thrust themselves in every direction,—south into the American Republic, east to the ports of the Atlantic, west to the Pacific, and north to the Great Inland Sea.[1]

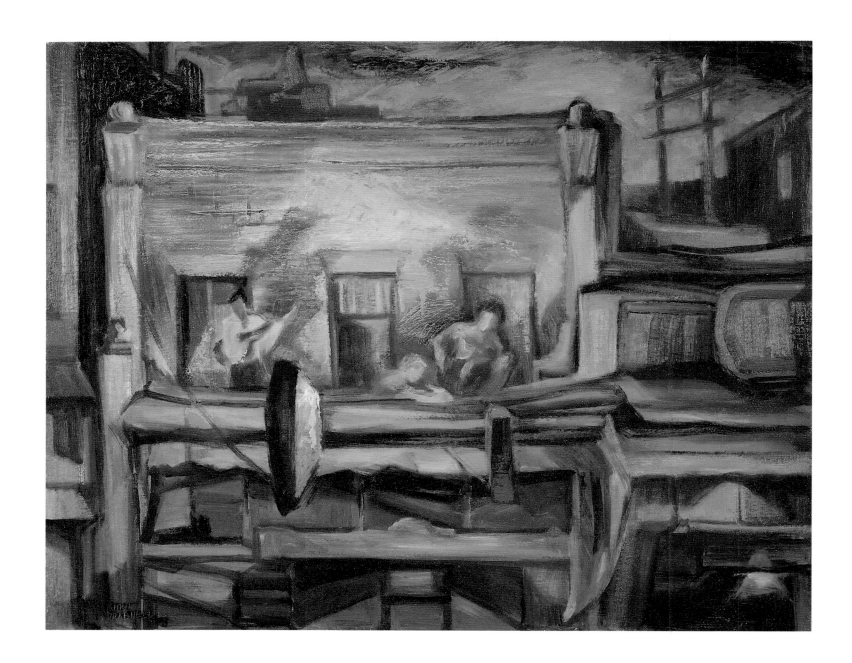

118. Bartley Robilliard Pragnell, *Main Street Balcony*, 1948

With this flourish of unCanadian immodesty, Ralph Connor began his novel, *The Foreigner.* Published in 1909, the book ushered the prairie city into western Canadian fiction. A world away, while Connor composed *The Foreigner,* James Joyce happened to be inquiring of his brother Stanislaus, "Is it not possible for a few persons of character and culture to make Dublin a capital such as Christiana has become?"[2] Lying behind Joyce's question was the uncertainty that every artist situated outside the great centres of cultural production is likely, at one time or another, to anxiously confront. Can the local eccentricities and raw life of a remote, provincial city such as Dublin or Saskatoon be transmuted into artistic gold? Is there hope for great art outside New York, London, Paris? Joyce was encouraged by the success of the dramatist Henrik Ibsen, who, while writing in a little-known language, Norwegian, had nevertheless become the most discussed and admired playwright of his day, a man who had brought Christiana (present-day Oslo) front and centre to the stages of the world, bathing it in the limelight. With Ibsen's reassuring example before him, Joyce wrote *Dubliners, A Portrait of the Artist as a Young Man,* and *Ulysses,* works in which "dear old dirty Dublin" was exalted to mythic status, a city fit to host the reincarnation of an ancient Greek hero. It might require genius to do it, but Joyce was convinced that the backwater could be made an all-embracing ocean.

The Joycean solution to creation on the artistic margins was one which western Canadian writers in the half-century following *The Foreigner* were blind to, or responded to with an almost palpable ambivalence. For writers up until 1960, the representation of prairie cities was not only a problem of how to characterize the infant metropolises, but also of acknowledging their very existence. Connor's initial burst of tub-thumping was to be succeeded mostly by silence and hesitant diffidence on the part of writers who aspired to "artistry" and "seriousness" in the years following. It was a long time before any other novelists would dare to emulate Connor's unbridled civic enthusiasm. Neither Calgary, Edmonton, Regina, nor Saskatoon ever found themselves thrust into a paragraph where they were made to brashly rub shoulders with London, New York, Peking, Tokyo, or Yokohama.

Ironically, Ralph Connor, probably the least artistically gifted of the handful of prairie novelists writing about western Canadian cities in the first half-century,

was the writer who succeeded in achieving one of the most striking depictions of early urban life. Several factors were responsible for this. Chief among them was that the writing of *The Foreigner* coincided with a wave of national self-confidence fired by rapid industrial progress and relentless development of the West, a confidence which found its most famous expression in Prime Minister Wilfrid Laurier's claim that, "The nineteenth century was the century of the United States. I think we can claim that it is Canada that shall fill the twentieth century."[3] In a time of burgeoning nationalism, a panegyric to a city held to embody so many national hopes and aspirations seemed perfectly natural.

Second, Connor, a Presbyterian clergyman with a social conscience, had discovered that a dose of "facts" mixed with Victorian melodrama exactly served his aims as a writer. The darling of the earnest, book-buying, church-going public, he saw novels primarily as a means of attracting attention to pressing social, religious, and political issues. *The Foreigner* was a titillating concoction of slums, wicked villains, selfless missionaries, social activists, even a Russian Horatio Alger who also happened to be the son of a dangerous nihilist, but underneath the cloak of "cloak and dagger," at the heart of the book, was a debate central to the emerging nation. This debate concerned eastern European immigration and what it meant for Canada. Many Canadians may have resigned themselves to immigration as an unfortunate necessity, the only way of filling up the vast spaces of the West. But others saw it as an insidious danger, suspecting that the very foundations of Canadian government, Canadian political liberty, and the Canadian legal system were being undermined by ignorant, uncouth foreigners to whom centuries of despotism had taught nothing but a fear of the knout.

Connor, however, welcomed the despised eastern Europeans, arguing that a policy of education and benevolent assimilation would turn them into good citizens. To illustrate his conviction he wrote *The Foreigner,* a book which chronicles the transformation of a young Russian boy, Kalman Kalmar, into a worthy Canadian. In telling this comforting and uplifting story, Connor offered readers glimpses of Winnipeg street life, Galician weddings, and unsavory immigrant housing, a world which many of his contemporaries were scarcely aware existed, and of which there is not the slightest hint in Sara Jeannette Duncan's coy report on Winnipeg to the *Montreal Star* in 1888.

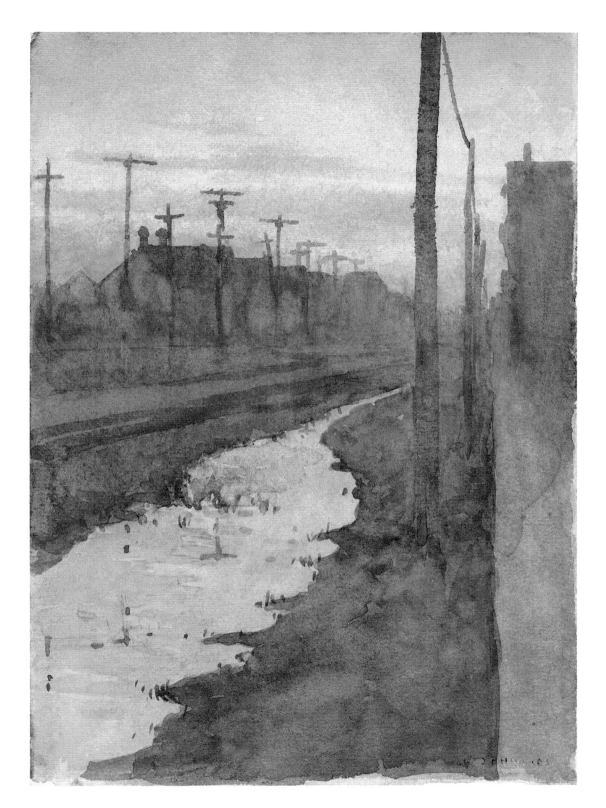

32. Walter J. Phillips, *After the Rain* (North Winnipeg), 1918

Another thing that one does not expect in Winnipeg, for some inexplicable reason, is the artistic modern wooden house. Why Eastlake and the reign of Queen Anne should be shut out of one's western conceptions does not readily appear, perhaps because the shanty of the pioneer is so intimately associated with prairie architecture, but they are shut out; and chairs of "antique oak," tiled fire places and Kaga vases, strike one oddly for a while....Tennis lawns there are and boat houses on the rear grounds that slope down to the water's edge. Past them six canoes abreast, full of young men and maidens, singing as they float down the river in the clear moonlight of the prairies, often make an idyllic picture on a summer evening.[4]

Against Sara Jeannette Duncan's genteelly respectable cameo of Winnipeg society, Connor pitted a darker, grimier portrait of immigrant life.

There they pack together in their little shacks of boards and tar-paper, crowding each other in close irregular groups as if the whole wide prairie were not there inviting them....All they ask is bed space on the floor or, for a higher price, on the home-made bunks that line the walls, and a woman to cook the food they bring her; or, failing such a happy arrangement, a stove on which they may boil their varied stews of beans or barley, beets or rice or cabbage, with such scraps of pork or beef from the neck or flank as they can beg or buy at low price from the slaughter houses, but ever with the inevitable seasoning of garlic, lacking which no Galician dish is palatable. Fortunate indeed is the owner of a shack, who, devoid of hygienic scruples and disdainful of city sanitary laws, reaps a rich harvest from his fellow-countrymen, who herd together under his pent roof.[5]

The Foreigner, despite being a bad novel, nevertheless broke virgin ground in the representation of the western Canadian city. The desire to have fiction serve practical ends led Connor to deal with new realities, the accelerating urbanization of Canadian life and the changing ethnic composition of the country, which other writers who aspired to serve "higher," "purer" aesthetic ends were blind to. Although his characterization of eastern Europeans may be judged racist or, at best, patronizing by today's standards, nevertheless he was one of the first writers to recognize the immigrants' existence and recognize that they would change the country in ways that could scarcely be anticipated. In the preface to The Foreigner he wrote,

In Western Canada there is to be seen to-day that most fascinating of all human phenomena, the making of a nation. Out of breeds diverse in traditions, in ideals, in speech, and in manner of life, Saxon and Slav, Teuton, Celt and Gaul, one people is being made. The blood strains of great races will mingle in the blood of a race greater than the greatest of them all.[6]

Winnipeg was the scene of a great national experiment, the laboratory of this auspicious mingling.

Connor's concern with communicating the seriousness of the social crisis caused him to muster a wealth of "sociological" detail to "prove" his points. From this distance, it is impossible to vouch for the accuracy of these details, but there is little doubt that the focus on the textures of city life, the hectic bustle of the streets, the turmoil of the train station, the grit and squalor of the slums, help mark *The Foreigner* as one of the earliest Canadian novels to possess that intangible—a truly urban feel.

Despite this beginning, in the four decades following *The Foreigner,* the city largely disappears from sight, and the life of the farm and the small town dominates the imagination of writers, a not surprising development when it is remembered that the region remained overwhelmingly rural. Nevertheless, the extreme one-sidedness of the picture is worth remarking. Why such a nearly total neglect of cities? Particularly when they were the sites of stirring events, events which might have provided plenty of raw material for fiction. Why no novel of the Regina cyclone which devastated the city, killed twenty-eight persons, injured two hundred, and left five hundred buildings destroyed?[7] Why no novel of the Winnipeg General Strike of 1919, or the Regina Riot of 1935?

The answer may simply be that writers were at a loss how to represent the prairie cities. They lacked appropriate models. Art, more than most artists would like to admit, relies on imitation. Writers in western Canada could depict small towns confidently because a satisfactory method of representation had been worked out earlier in the fiction of the American West. With minor adjustments in regard to weather and landscape, Willa Cather's Hanover, Nebraska; Sherwood Anderson's Winesburg, Ohio, offered useful blueprints.

"The town is, in our tale, called 'Gopher Prairie, Minnesota,' " wrote Sinclair Lewis in *Main Street.* "But its Main Street is the continuation of Main Streets everywhere. The story would be the same in Ohio or Montana, in Kansas or Kentucky or Illinois and not very differently would it be told Up York State or in the Carolina hills."[8] Or, one might be tempted to add, in Manitoba, Saskatchewan, and Alberta. The fictional North American small town had

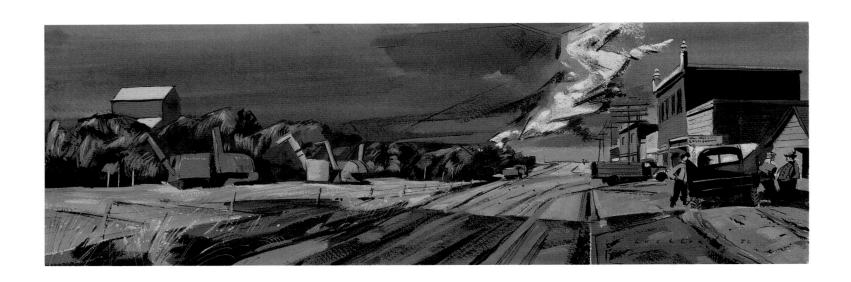

138. Kenneth Campbell Lochhead, *Untitled* (Main Street, Pense, Saskatchewan), 1953

evolved into a place where interchangeable false-fronted buildings lined interchangeable Main Streets, and if christened with some innocuous and characterless name, such as Riverview, Horizon, or Crocus, wore an air of comforting anonymity.

This strategy was useful when representing a small town because the reader possessed no counter-image to contradict the one the writer offered him. For instance, no one has a picture of the *real* Horizon to conflict with the one which Sinclair Ross paints. But when drawing upon the city for a setting the writer had two choices. He could use an existing city—as Connor did with Winnipeg —or he could invent a city as Sinclair Lewis attempted to do in *Babbitt*.

> The towers of Zenith aspired above the morning mist; austere towers of steel and cement and limestone, sturdy as cliffs and delicate as silver rods. They were neither citadels nor churches, but frankly and beautifully office-buildings....
>
> Over a concrete bridge fled a limousine of long sleek hood and noiseless engine. ...Below the bridge curved a railroad, a maze of green and crimson lights. The New York Flyer boomed past, and twenty lines of polished steel leaped into the glare.
>
> ...Cues of men with lunch-boxes clumped toward the immensity of new factories, sheets of glass and hollow tile, glittering shops where five thousand men worked beneath one roof, pouring out the honest wares that would be sold up the Euphrates and across the veldt. The whistles rolled out in greeting a chorus cheerful as the April dawn; the song of labor in a city built—it seemed—for giants.[9]

Despite the fact that Lewis's description is arresting, he has a problem. The realistic novel operates on principles of verisimilitude. Zenith poses nagging questions which detract from the fictive dream. "If it's a city built for giants, why haven't I heard of it?" the reader is likely to ask. Zenith cannot be accepted on faith the way Horizon or Gopher Prairie can, places so tiny and insignificant that they could easily have escaped the reader's attention. Zenith, on the other hand, cries out to be identified, invites the reader to play a version of the *roman à clef* game, to demand, "Which city is Zenith *really?*" And if Zenith is really Detroit, or Minneapolis, or Cleveland, why not name it in the first place?

The reluctance to name the city (if it was Detroit or Minneapolis) might have been because as the century wore on, the Hollywood movie became the chief shaper of North American perceptions of urban life. Increasingly in American

film, a few cities (New York, Chicago, Los Angeles, sometimes Philadelphia and San Francisco) became the paradigm of "real" cities, places where important things happened, or could be expected to happen. No Hollywood producer operating in the 1930s and 1940s would be likely to consider seriously setting a story within the boundaries of Duluth, Pittsburgh, Cleveland, Des Moines, or, for that matter, Edmonton. These cities were, by unspoken agreement, disqualified as worthy settings for modern urban dramas.

Dick Harrison has suggested that the effect the potent image of the Hollywood Mountie had on the popular imagination prevented the development of an indigenous fictional version of the Mountie in western Canadian writing.[10] If Hollywood could refashion such a quintessentially Canadian symbol as the Mountie, and smother competing interpretations in the cradle, one can only guess what a debilitating effect the movies had on the confidence of western Canadian writers when it came to portraying the cities of their region. The movies were fixing the image of the contemporary city firmly in the public's mind, and the image they were fixing was the image of New York, Los Angeles, and Chicago.

Still, some western writers, because of situations and themes they wished to explore, found themselves compelled to use urban settings. When they did, most showed an extraordinary unwillingness to identify which cities they were writing about, as if they feared that putting a name to them was an invitation to derision. The result was the city *qua* city, a bare bones sketch of the urban with most distinguishing features eradicated, a place faceless and, above all, nameless.

Even in those novels with small-town settings, writers avoided identifying the larger centres which acted as magnets for characters eager to escape into a wider, freer world. In Sinclair Ross's *As For Me and My House,* Mr. and Mrs. Bentley leave Horizon to become proprietors of a secondhand bookstore in a "little city" where they used to live. The little city has a university and is two hundred miles southeast of Horizon, but what city is it?[11] Geographical evidence suggests it can only be Winnipeg, but Winnipeg is never named. In a similar fashion, while there is passing mention made of Calgary and Edmonton in Edward McCourt's *Music at the Close,* where Neil Fraser attends university is never stated, nor is the site of the riot of striking coal miners in southern Saskatchewan given as Estevan.

When a city is named, it is likely for comic purposes, as in *Sarah Binks*. There the Sweet Songstress of Saskatchewan's visit to Regina with her paramour, Henry Welkin, is described at length.

> …Sarah and Henry Welkin visited all the places of interest. Twice they went to the opera. Again and again they rode on Regina's street car. The cafés, Chinatown, the Botanical Gardens, the Union station—Henry Welkin was eager that his young *protégée* should drink life to the full. He took her to the aquarium and to the public library, and together they studied what fish and what manuscripts were available at these places. They made the rounds of the art galleries; they visited the parliament building and studied its geology. Nor was the world of commerce neglected; together they visited the department stores, the groceterias, the banks, the freight yards, and the big implement warehouse of the firm which Henry represented and which he was particularly anxious for her to see. Sarah drank it all in. She was eager and she had youth.…From Willows to Regina was a far bigger step than she had anticipated.[12]

It is interesting to note that it is permissible to name Regina in this context. In this case, the writer's representation coincides with what is already a firmly established assumption, that cities like Regina are wastelands, which makes any suggestion that a visit to them might be intellectually stimulating, by definition, hilarious. This despite the fact that by 1947, the date of the publication of *Sarah Binks,* Regina had already earned a reputation as a centre for advanced social thinking and innovative public policy.

By the 1950s, some prairie writers had begun to react to the works of writers such as Ross, Frederick Philip Grove, and W.O. Mitchell. Edward McCourt, for one, had come to feel that the main characteristic and limitation of prairie fiction was a preoccupation with the overwhelming physical environment of the Prairie, which distracted from the real business of writing, which was to bring people to life.[13] Accordingly, when he came to write his novel *The Wooden Sword,* published in 1956, he made his protagonist a university professor who, though he lives in a western city, hates the Prairie. The fact that McCourt was himself a professor of English at the University of Saskatchewan might lead one to assume that it is Saskatoon he is writing about. Yet if it is Saskatoon, it is drawn in a way to evade positive identification, with a minimum of brief descriptions. To anyone familiar with the University of Saskatchewan, this depiction may be vaguely familiar, but no more than vaguely familiar.

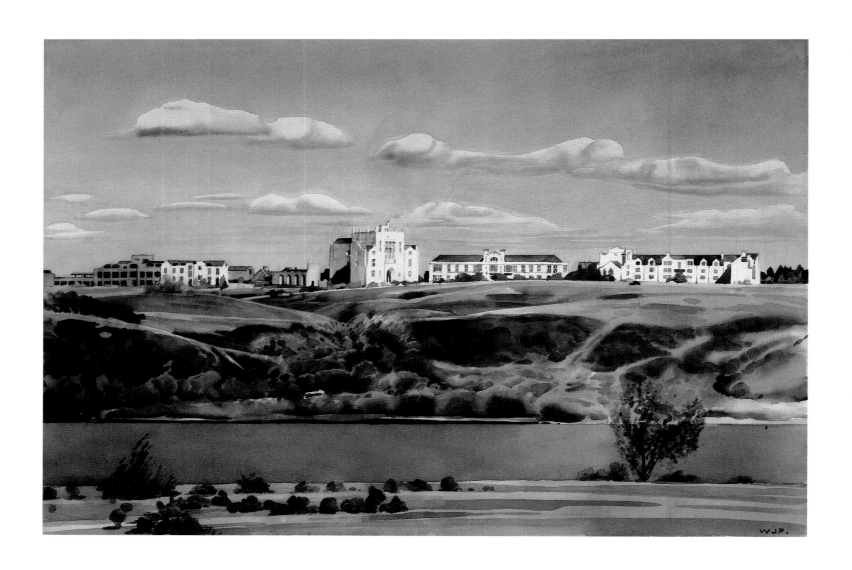

96. Walter J. Phillips, *University of Saskatchewan*, c. 1940

> The University in sight now. Grey stone battlements clear against the sky. Dreaming spires like lonely uplifted fingers, signposts of culture, symbolic of the vision of the founders. Skeleton girders everywhere. Somebody always building something. For years now, Steven reflected, he had been competing unsuccessfully against the noise of riveting machines, bulldozers, cement mixers. Here no holy hush of cloistered halls.[14]

All McCourt's descriptions in this novel are equally attenuated, abstract, and unspecific. Readers are launched into the unnamed streets of an unnamed city with an unnamed river flowing through it. McCourt's fictional aim of bringing people to life is defeated by this approach because fictional people, like real people, draw life from their surroundings, are colored and influenced by their milieu. Lacking these supports, his characters float like bloodless ghosts in a grey limbo.

Adele Wiseman's *The Sacrifice,* published in 1956, the same year as *The Wooden Sword,* is unquestionably the most artistically complex and mature of the novels of this period, a reworking and updating of the biblical story of Abraham and Isaac which has something in common with Joyce's reworking and updating of the story of Ulysses. However, unlike Joyce who brought his native city Dublin to the forefront in his retelling of the myth, Wiseman leaves the city of her birth virtually invisible. While a rich rendering of Jewish immigrant life might lead one to presume the city of *The Sacrifice* is the city in which Wiseman was raised, the evidence to support such a contention hardly exists.

As the novel begins, a train slows on the outskirts of a city. Abraham, the patriarch of a family of Jewish immigrants, impulsively decides that he has had enough of travelling, this is where he will settle. In a variety of languages, Ukrainian, Yiddish, Polish, German, he asks the conductor the name of the city. The uncomprehending official can give him no answer because he cannot understand the question. And when the conductor does announce the next stop to the rest of the passengers, Wiseman handles it with a single sentence that divulges nothing. "The conductor called out the name of the city."[15]

If anything, Wiseman's setting is even shadowier than McCourt's in *The Wooden Sword.* One short passage places it in an undulating landscape, with a clear division between heights and flats, and a double-humped mountain bearing a

brooding lunatic asylum on its back. None of which suggests Winnipeg. Where are we? It is impossible to say.

With John Marlyn's *Under the Ribs of Death,* published in 1957, we come full circle and return to the novel set within the precincts of an actual western city. His novel, like Connor's, is about immigrants and about Winnipeg, a book which resounds with names familiar to every Winnipegger: Henry Avenue, Salter Street, Selkirk Avenue, College Avenue, Portage and Main, the corner of Logan and Main, Alexander Avenue. In fact, the city of Winnipeg itself rises to the status of a character, its topography reflecting the inner world of the novel's protagonist, Sandor Hunyadi, son of a Hungarian immigrant. For Sandor the North End represents everything that is to be rejected and to be fled from; the

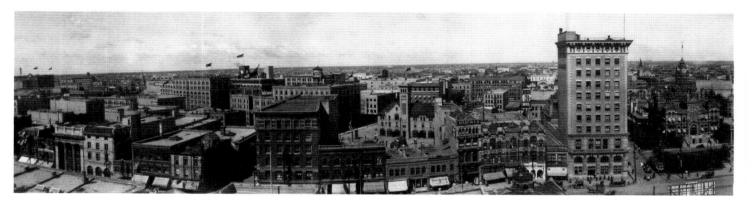

184. Peter Schawang, Detail of *Panoramic View of Winnipeg, July 21, 1911*

South End, where the rich English live, everything that is to be sought and pursued. The contrast of South End luxury and privilege with North End poverty and disadvantage is symbolized by the streets themselves. When Sandor Hunyadi is interviewed by a WASP businessman, he realizes that he has made a mistake by mentioning that his father lives on Selkirk Avenue.

> The silence in the room was edged with old fears that set him trembling, with suddenly remembered North End talk of discrimination beyond the invisible barrier of Portage and Main, talk which he had always disregarded as having no possible reference to himself, but only to half-qualified, dime-a-dozen clerks. For nine years Nagy had been beating it into his head that this kind of prejudice was a luxury no business man could afford, and he had come to believe it, even though he still found it distasteful to deal with North End people.[16]

72. Fritz Brandtner, *Winnipeg Night,* c. 1933

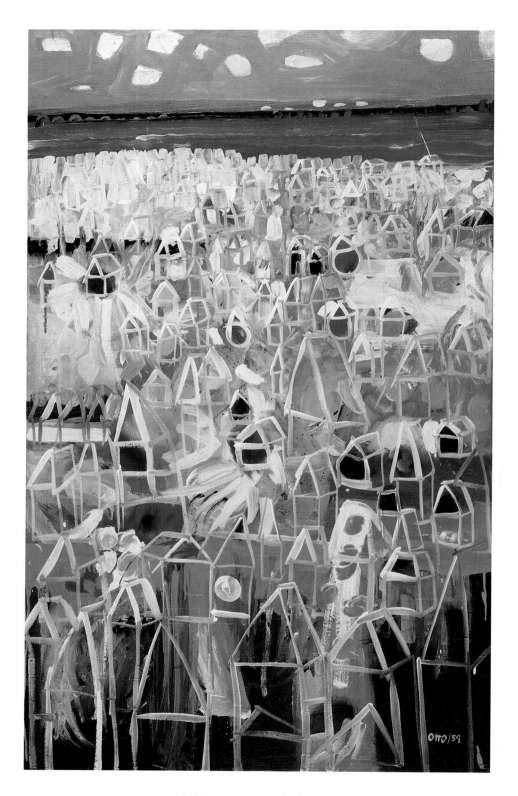

146. Otto Rogers, *City of Light*, 1959

Under the Ribs of Death shares more with Ralph Connor's *The Foreigner* than just a simple willingness to root a story in an actual place. Its theme is also assimilation, this time from the perspective of the immigrant. Sandor Hunyadi, like Kalman Kalmar, becomes a business success and, like Kalman Kalmar, he becomes "English," even to the extent of changing his name to Alex Hunter. But *Under the Ribs of Death,* unlike *The Foreigner,* is shot through with regret for what has been lost in the journey to respectability and acceptance. The difference in the authors' attitudes is best illustrated by the party scenes involving immigrants which their novels contain. Connor, the outsider, typifies the celebrations of the foreigners as drunken, brutish, and violent. Marlyn, the insider, depicts them as warm, exuberant, loving, rather than dangerous.

> The food arrived, the hot steaming fragrance of it filling the room, savoury and varied and as spicy as an adventure, rich with the treasured cooking-lore of the whole of Europe. Crumb by crumb the women had garnered the skill and details, the piquant flavours and the subtle aromas from a thousand sources—small ingenuities that came from poverty, recipes taken from the vanquished and imposed by conquerors, graciously given by neighbours or stolen from friends, handed down from mother to daughter so that at last in Frau Hunyadi's kitchen there came to fruition an age-long process, proudly, lovingly, and painstakingly fulfilled.[17]

Under the Ribs of Death is concerned with the loss of identity, and identity is intimately wrapped up with whatever sets the individual apart, with differences of every kind, including minute differences of place and atmosphere. The no-name generic city, the blank backdrop could not have served Marlyn's purposes. The writing of the history of one immigrant boy, Sandor Hunyadi, became the writing of a history of immigration in one city. This demanded a great deal of sociological detail, but the detail was married to a comprehensive artistic vision in which Winnipeg itself became the symbolic map upon which a young man's spiritual and psychological pilgrimage may be traced. Marlyn's *Under the Ribs of Death* may be no *Ulysses*, but it nevertheless answered Joyce's question with an emphatic yes, suggesting that acknowledging and celebrating origins may make better aesthetic sense than disavowing and disguising them.

For fifty years, the western Canadian city scarcely made an appearance in fiction and when it did, the representation was usually an uneasy compromise between

what had to be said because characterization and plot demanded it, and the desire not to divulge where you were really talking about. Simply put, the root cause of this was a lack of confidence, confidence of every kind. To begin with, western Canadian writers, like the Irishman Joyce, had doubts about the material they found to hand. Could it really be the stuff of art? Added to that, as the century matured, whatever initial economic optimism and pride the new western cities had excited tended to wear away as two world wars, depression, and a decade of drought stunted their growth and frustrated their promise. It was one thing to sing the praises of a prospective "capital of the last of the Anglo-Saxon Empires," but when the city failed to live up to expectations, that gave pause. It was hard to be enthusiastic about failure without looking ridiculous.

The lack of a model to guide the representation of small, provincial cities also proved to be a problem. Movie makers concentrated on a few great cities as embodiments of urban sophistication and dynamism, exacerbating those feelings of self-doubt and inferiority that had always been present in the citizens of less cosmopolitan centres. Either consciously, or unconsciously, writers accepted the hidden message. Big things happen in big cities.

This left writers who wanted to tackle certain urban issues in a quandary. If the place where they lived failed to meet "world-class" standards and might possibly provoke snickers as the subject of literature, what was to be done? The most frequent way of dealing with the problem was the creation of the no-name city, a city that tried to pass muster by refusing to give away what it really was. As a strategy, this was in most cases self-defeating, giving a strange air of unreality to novels which were, by and large, realistic in style.

In the years following the publication of Marlyn's book, the old problems have persisted, even though circumstances have encouraged writers to turn to the prairie city as a subject and setting more often. For example, the cultural nationalism of the late sixties demanded writers emphasize Canadian distinctiveness and, by implication, adopt Marlyn's example. This subtle change in attitude is best illustrated in the work of writers whose careers encompass both periods. For instance, Adele Wiseman's *Crackpot* is much more clearly and unambiguously situated in North End Winnipeg than her earlier *The Sacrifice*.

Still, one fact remains unaltered. The image of the city presented in the pervasive popular media is still being drawn outside the borders of the region and its power is still a threat to indigenous literary representations. The no-name city has not been irretrievably consigned to the dustbin of western Canadian literary history, as I well know. When I came to write my urban novel *My Present Age* in 1984, something prevented me from putting a name to the city whose geography played as large a role in the psychology of my protagonist as Winnipeg's had in Sandor Hunyadi's. What seemed an insignificant matter then, does not, with hindsight, seem so insignificant now, but rather a retreat into evasion, a failure of artistic nerve, and a refusal to assert the validity of a place and a voice. It seems that for artists on the margins, autonomy can only be bought at the price of vigilant self-awareness.

NOTES

1. Ralph Connor, *The Foreigner* (Toronto: The Westminster Company Limited, 1909), 11.

2. James Joyce as quoted in Richard Ellmann, *James Joyce* (New York: Oxford University Press, 1965), 216.

3. Wilfrid Laurier as quoted in John Robert Colombo, ed., *Colombo's Canadian Quotations* (Edmonton: Hurtig Publishers, 1974), 332.

4. Sara Jeannette Duncan, "Winnipeg: `The Veritable West'," in T.E. Tausky, ed., *Selected Journalism* (Ottawa: The Tecumseh Press, 1978), 79–80.

5. Connor, *The Foreigner,* 14–15.

6. Ralph Connor, Preface to *The Foreigner* (Toronto: The Westminster Company Limited, 1909).

7. John H. Archer, *Saskatchewan: A History* (Saskatoon: Western Producer Prairie Books, 1980), 162.

8. Sinclair Lewis, *Main Street* (New York: Buccaneer Books, 1976), 6.

9. Sinclair Lewis, *Babbitt* (New York: Harcourt, Brace & World, Inc., 1950), 1–2.

10. Dick Harrison, *Unnamed Country: The Struggle for a Canadian Prairie Fiction* (Edmonton: University of Alberta Press, 1977), 163.

11. Sinclair Ross, *As For Me and My House* (Toronto: McClelland & Stewart Ltd., New Canadian Library, 1967), 160.

12. Paul Hiebert, *Sarah Binks* (Toronto: McClelland & Stewart Ltd., 1971), 90–91.

13. Winnifrid Bogaards, Introduction to Edward McCourt, *The Wooden Sword* (Toronto: McClelland & Stewart Ltd., New Canadian Library, 1975).

14. Edward McCourt, *The Wooden Sword* (Toronto: McClelland & Stewart Ltd., New Canadian Library, 1975), 21.

15. Adele Wiseman, *The Sacrifice* (Toronto: The Macmillan Company of Canada Limited, 1956), 5.

16. John Marlyn, *Under the Ribs of Death* (Toronto: McClelland & Stewart Ltd., New Canadian Library, 1984), 136.

17. Marlyn, *Under the Ribs of Death,* 136.

177. Lewis B. Foote, *L.B. Foote Photographer Wpg. Taking a Birds-Eye View of the City*, 1906

WELCOME.

Culture was a key part of city-state life. The great names in classic literature—philosophers such as Plato and Aristotle, playwrights like Euripedes and Aristophanes, and the historians Thucydides and Herodotus—were part of an immense cultural outpouring that also included architecture and the visual arts, in particular, sculpture, in which the natural human form was celebrated. Added to this was a vast system of mythic gods and creatures handed down from the time of the legendary Homer. Their names have entered our European cultural consciousness and stayed there for millennia.

Similarly, the cultural achievements of the Roman Empire, especially in literature, were impressive. However, it was not until the time of the Italian city-states, a thousand years after the Romans, that there arose a spirit of innovation, enquiry and artistic revolution known as The Renaissance, which matched that of the Greeks. Once again it was the city-state that provided the context in which the arts flourished. The names of cities such as Venice, Florence, Milan and Rome are associated with the great names in European art: Botticelli, Michelangelo, Leonardo da Vinci and Titian; writers such as Petrarch and Machiavelli; and the great patrons of the arts, the Medici and the Borghese.

The Italian city-states were a creation of Mediterranean commerce and banking, shrewd politics and visionary cultural values. Wealth was the driving power that summoned a new era in European civilization. It is worth remembering that the words "city" and "civilization" have their roots in the Latin words *civilis* and *civitas,* which referred to urban citizenry and the importance of the city in creating culture.

The factors of wealth, political power, and the social need for artistic expression are also present in the histories of Canada's prairie cities. Although they are not city-states in the classic sense, their geographic proximity, their historic ties, similar social roots and traditions express a unified reality also present in the Greek and Italian city-states. They share a geography and a language that allow them to identify with each other as well as express differences.

Thinking of Winnipeg, Regina, Saskatoon, Calgary and Edmonton as counterparts of the historic city-states may seem far-fetched and it is, if we try to

equate them in terms of cultural achievement; but the exercise is helpful if we think of these five prairie cities as playing a role in the West similar to their ancient forebears in fostering artistic expression. It is in the prairie cities that prairie culture is most often exhibited, staged, televised and taught. These five urban centres were and remain the key players in regional culture. Their competitiveness and their rising and falling status vis-à-vis each other are simply a confirmation of a similar history among the Greek and Italian city-states.

The idea of viewing the five cities of the West as "city-states" comes out of my own experience of the region and its cities over the past forty years. I have been a Westerner and an urban dweller all my life, having lived for extensive periods of time in Winnipeg (eighteen years), Edmonton (thirteen years) and Calgary (eight years), while being a frequent visitor to Regina and Saskatoon. During this time I have been disappointed with the limited role that the cities of the West play in the dominant mythology of the region. Compared to the Métis buffalo hunter or the sun-burnt farmer on his tractor, the images of the prairie city are almost an afterthought.

The contradiction between the region's urban heritage and its stereotypic images is worth exploring. A contemporary book of photographs about the region, *Prairie Dreams* by Courtney Milne, is a perfect example of the forgotten status of the city. There is not one urban image in the book. The message is clear: the prairie identity is rural and the prairie and the city are poles apart. I would like to suggest that rethinking the region in terms of a group of city-states would redress the balance, undermine these traditional stereotypes and help to recognize the future of the region as an urban-centred phenomenon, which demographics tell us it already is.

An anti-urban bias runs through our heritage and has its roots as far back as Roman times, when the city was portrayed as a source of decadence and indulgence, while the countryside was heralded as the home of virtue. In the early 20th century, religious fundamentalism enhanced this attitude by denouncing cities as the source of sin, where temptation and vice lurked for the unwary.

This bias imprinted itself on the prairie mind. Not only were prairie cities considered full of moral dangers, but they were also viewed as re-creations of 19th-century eastern Canadian cities with little character of their own. Western Canada's leading urban historian, Alan Artibise, claims the opposite— that prairie cities developed a character all their own.[1] They are cities with broad streets, a predominance of single family homes and low-density housing, a sense of spaciousness that reflects both the flat prairie landscape and the newness of cities begun from scratch no more than a century ago. They are cities for whom transportation is a raison d'être and where immigrant and speculator, entrepreneur and worker, banker and farmer fought for survival and success. They may be new cities based on late 19th- and early 20th-century economic needs, but clones of Toronto they are not.

The Canadian historian J.M.S. Careless has focused on the historic origins of western cities as "creations of the railway."[2] This is not completely accurate because Winnipeg and Edmonton pre-dated the railway, but it is true that the railway turned them into cities. Careless calls them "urban outposts" of central Canada, even if their urban profile is different.[3] He views them as a string of cities along the 49th parallel expressing the East-West character of Canada created since Confederation.

Since prairie cities developed with the mass migration promoted by Canadian authorities in the late 19th century, there is a tension between their indigenous character with its regional politics and the central Canadian vision of them as a corridor of Anglo-Canadian culture and society. The creation of provincial governments in the region restrained urban power by making municipal government a subordinate level of politics.

A PERSONAL
URBAN ODYSSEY

In the bitter cold of December 1949, my father's arms carried me down from the coal-fired, smoke-belching transcontinental train that had brought my family to Winnipeg from the port of Halifax, thousands of miles to the east. Our transatlantic passage had been on a converted troop ship filled with post-war survivors, refugees seeking a new and safe life.

We were part of a brief upsurge in postwar immigration to the West that was only a trickle compared to the great human flood of a half-century earlier which had inundated the region with eager, homesteading pioneers. The historian Careless makes the demythologizing observation that prairie urbanization had proceeded then at a *faster* rate than rural settlement.[4] The figures are worth noting—thirty-eight percent of Alberta's residents were urban dwellers in 1911 (the height of the agrarian period) and the figure for Manitoba was even greater—forty-three percent.[5]

When I began my life as an urban Westerner, I was part of a significant population in the region that was not rural. All my childhood and youthful memories are urban, as are those of my adult life. I see the West through urban eyes—eyes that see brick and concrete towers, imposing mansions and clapboard row housing, diesel buses and freeways, and ubiquitous suburban lawns with planted spruce trees.

This is the way millions of Westerners see the region. Out of a current population of 4.6 million in the three prairie provinces, 2.6 million live in the five major cities. If we add the populations of smaller cities like Lethbridge, Red Deer, Brandon, and larger towns like Fort McMurray and Thompson, there are about three million prairie people living in urban settings. That is almost seventy percent of the region's population and the percentage keeps growing annually. How could a social and economic reality that includes two out of three people not be central to the region's imagination? A good question.

Western city-dwellers must not think of themselves as strangers to the western identity. In the period of agrarian settlement we were an integral part, and now are

137. William Winter, *Winnipeg, Gate to the West*, c. 1952

a dominant part, of that identity. Careless has pointed out that "…the urban West was decidedly a fact of life before 1914…."[6] So our pedigree goes back to the beginnings of white agrarian settlement. But what about the pre-urban, pre-railway, pre-agrarian period of the aboriginal peoples, the Métis hunters and the fur trade?

In 1858 H.L. Hime, a Toronto photographer with the Assiniboine and Saskatchewan Exploring Expedition, produced a series of photographs of the West that captures that pre-agrarian moment on the verge of disappearing. What is striking about the images is the sense of isolation that the stand-alone buildings have, whether St. Boniface Cathedral or walled Fort Garry. Prairie space dominates each image. The buildings speak more of intention and aspiration than reality, more of absence than presence.[7] For the white imagination, the West in the pre-agrarian period was simply emptiness seeking fulfillment. Mid-19th-century travellers felt themselves to be on the edge of civilization and their eye sought out any sign of its presence.

The "urban" reality of the fur trade era, if we can even speak of such a thing, was the trading post or fort. It was the central meeting and trading place, where transportation, business and cultures intersected. The trading post prefigured the urban reality because it had connections to an international economy and it created a small, permanent concentration of population in a sea of aboriginal mobility.

Of course trading posts were not cities, nor towns, and often they were barely fit to be considered a village, yet their general character set them in opposition to the surrounding culture and lifestyle. When western cities developed as part of agrarian settlement, they made the fur-trading posts part of their identity. This was true of Winnipeg, which, when I arrived in 1949, was the pre-eminent urban reality in the West—the *primus inter pares* of the five major cities of the region. Winnipeg's fur trade history was part of my education, as was its sense of urban importance. By the time I was ready to leave in the late 1960s, that pre-eminence was fading as Alberta's cities began to take on a leading role in the region. The railway economy that had made Winnipeg a centre of small manufacturing, commodity and goods trans-shipment was in decline. In 1920 sixty percent of the region's manufacturing occurred in Winnipeg, but by 1967 Alberta's manufacturing sector surpassed Manitoba's.[8]

I had come from Europe to Winnipeg by ship and train but when I returned to Europe in 1968 I flew. This was symbolic of the new technological and economic forces that would change the power relationships among prairie cities. Being accustomed to living in a leading edge urban environment, it is not surprising that I found myself in Edmonton at the beginning of the 1970s. The seventies belonged to an Alberta made wealthy and powerful by oil and gas. It was the province with the largest population in the region and a magnet for investment and the generation of wealth. Alberta was booming.

What I brought with me from Winnipeg to Edmonton and later to Calgary was a certain sense of what urban life is—straight, tree-lined streets boxed in rectangular grids, life on the block, neighborhood corner stores, the amenities of public transportation and urban entertainment. Everything from schools to pools was in close proximity. The sense of the crowd and the largeness of multi-story buildings and time spent walking on concrete are all integral to the urban experience in both Winnipeg and Edmonton. So are parks and green spaces and playgrounds. It is all a rich mosaic of experiences.

The city has a sense of being self-contained and self-sufficient, a world unto itself. To this can be added the history of a city, its ethnic neighborhoods and multicultural life, its class divisions, its socio-economic hierarchy, its élites and its underclass. The urban dweller is quick to learn its special places and its danger spots, and to see its evolution, its transformation with each new influx and migration. The city changes.

It was in Edmonton that I first imagined the West as a political system of city-states because my involvement in literary publishing took me from prairie city to prairie city, visiting bookstores and writers. The *NeWest* project, a magazine and book publishing venture that I launched in 1975, allowed me to make spring and fall trips across the Prairies and keep up contacts with each city's artistic community. Through these contacts I saw how different the culture of each city was, and yet I also felt a deep identification in each city with its prairie sisters. There was rivalry but also respect. *NeWest* was an urban prairie project and it is not surprising that its various parts are now resident in three prairie cities, symbolizing urban differences and regional unity.

135. Ronald York Wilson, *Regina, City in the Wheat Fields*, c. 1952

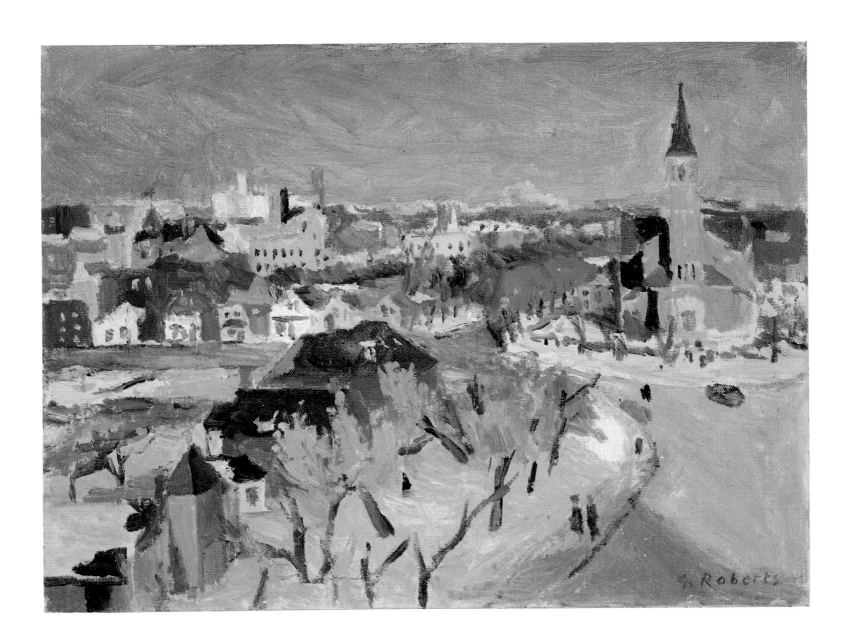

136. Goodridge Roberts, *Saskatoon*, c. 1952

A HISTORICAL SURVEY

My personal urban odyssey resonates in the life of every urban dweller—whether longtime residents, immigrants from other countries and regions, rural refugees from an increasingly devastated farm economy, or migrants from other cities. Our stories are both private and universal. The struggle to survive in the prairie city and to improve conditions for the next generation is balanced with the memories of childhood friends, school adventures, and adulthood. For all those who have been long-term residents of the city of their birth and whose families have been urban dwellers for generations, there are an equal number who are first-timers and for whom an urban heritage is a pioneering experience, an innovation in the family tree.

Whatever our personal story, our lives are part of a general historical flow that created an environment of ghettos, gardens and suburban hopes. In the early days of the prairie city, at the turn of the century, the main themes of city life in the West were boosterism and urban rivalry as various centres vied with each other for prominence.[9] It was an age of city building. In the case of Calgary, Saskatoon and Regina, it was building from scratch, creating a city on top of the prairie soil where only grass existed. In the case of Winnipeg and Edmonton, it was building a modern city of hospitals, schools, industries and commercial enterprises.

This founding and building process began about 1880 and was complete by 1920. "In the booster era, the era of the commercial and early industrial city," Alan Artibise writes, "there was an identification by the booster élites of their fortune with the fortunes of a specific community."[10] Each élite tried to attract capital and workers to its locale. Paul Voisey, writing about early urbanization, described Winnipeg as "a glittering example of successful town promotion."[11] At the turn of the century, it far outdistanced other places, generating wealth, jobs and poverty.

Artibise tells us that this "booster" phase was replaced after World War I with a spirit of "corporatism" which lasted until after World War II. In the corporate phase, the founding élites had secured their status, their enterprises were growing and the institutions of government and commerce were headquartered in the urban core. Although the Depression struck at many of these private fortunes, the cities continued to be a source of capital, enterprise, and connections. The business of the region flowed in and out of the cities.

134. Charles F. Comfort, *Edmonton, Skyline of the North*, c. 1952

The most recent phase in urban life is termed "regional" by Artibise. He sees the cities as developing their own economic and social identity through the provision of key services in health, education and finance to the surrounding territory. We can imagine these cities as radiating concentric circles of power with some overlap. Lethbridge is in the sway of Calgary, while Red Deer is divided between Calgary and Edmonton. The dual city phenomenon in Alberta and Saskatchewan creates an interplay between cities, encouraging transportation and communication between the two centres as business and government go about their affairs.

Prairie cities may be considered magnets that both attract and repel each other, pushing and pulling constantly. Their strength is in their ability to influence smaller places and repel the influence of other cities, and so create a distinct identity. No one confuses Saskatoon with Regina or Calgary with Edmonton. They are entities in their own right with a culture and economy all their own, yet their expansionist roots are firmly in the agrarian period.

Voisey describes the symbiotic relationship that existed between rural settlement and the spectacular growth of prairie cities. Between the turn of the century and World War I, the population of the West quadrupled and the needs of this population were met by cities and towns. "The growth of the cities…was an economic response to massive rural settlement," he writes.[12] It was not surprising, in Voisey's view, that Winnipeg should grow so fast, since southern Manitoba had been the most densely settled part of the region.

In 1881 the Canadian census registered Winnipeg as the only city in the North-West. Its population was 8,000. Thirty years later, its population was 144,000, with Calgary at 44,000, and Saskatoon at 12,000.[13] Sixty years later, Winnipeg had 540,000 residents, Calgary 400,000 and there were 126,000 in Saskatoon. By the 1980s, Winnipeg's population was being surpassed by both Calgary and Edmonton because Alberta's economic expansion in the 1970s had attracted people to these two booming centres.

The social composition of prairie cities in the early period encompassed a broad and diverse spectrum. Twenty-five percent of working people were in the professional or service occupations; twenty percent in trade and merchandising; twenty percent in construction; fifteen percent in railways; an equal percentage

in manufacturing; and five percent in finance.[14] As prairie society developed, each city evolved specialized features. Winnipeg's role as a railway hub diminished after 1960, as did its economic importance. Calgary's role in oil and gas increased in the 1960s and 1970s but then faced downsizing in the 1980s and 1990s, while Regina and Edmonton developed bureaucracies linked to their being the seats of provincial governments.

In the past thirty years no one prairie city has been able to dominate the others the way Winnipeg did prior to World War II. Obviously the young of Saskatoon and Regina (and in my case Winnipeg) did move to Edmonton and Calgary in the boom times, but the basic balance and symmetry of the five city-state system have remained. No great new city has arisen and no one city has collapsed. Winnipeg may have fallen behind Calgary and Edmonton, but Winnipeg remains a gateway to western consciousness with some of the richest cultural life in the region. A realignment of power has occurred but that is a natural historic progression.

Two factors are important in maintaining this "steady-state" reality. First, the distances between the cities are sufficient to allow independent development of a hinterland linked to that city. The distances are also large enough to encourage the development of locally centred institutions such as art galleries, museums, sports teams, etc. Secondly, the cities themselves are small by world standards. There is no great metropolis on the Prairies that overshadows other cities. Small cities tend to develop a full range of cultural, social and economic services, which may not always be of the highest calibre but which allow a broad spectrum of local activity of all sorts. These are cities with populations big enough to justify each having its own university, for example, but small enough not to dominate neighboring cities.

Not having a New York or Los Angeles in the West means that there is a decentralized feeling to the region that suits a confederational model which favors city-states. For a century the five cities have provided the basic framework of urban distribution in the three prairie provinces and that model has not changed dramatically during that time. There is nothing afoot at the moment or on the horizon that would suggest that this historic framework is about to undergo some major upheaval. Growth in Edmonton and Calgary has slowed down. Saskatoon

and Regina are holding their own. Winnipeg continues to preserve its status. What would be required to upset this system would be some fundamental economic or political upheaval that would reorient the basic nature of the region.

Even though the West does not have a metropolis, it does have cities with significant ghettos and areas of older housing that attract an ever-changing mosaic of immigrants and refugees. Visible minorities are a growing force in western cities as Canada reflects new patterns of immigration and as aboriginal populations increase in urban centres. Immigrants traditionally settle in cities where they can find government services, educational facilities, employment and fellow immigrants. Aboriginal people, especially in Regina and Winnipeg, are an expanding population seeking new opportunities. Prairie cities have maintained the multicultural flavors that they have had from their beginnings.

145. Henry G. Glyde, *End of the Prairie*, 1957

THE FUTURE OF THE
FIVE CITY-STATES

The city-state is not a common reality in our world (Singapore is the most famous). Yet its future may be more promising than its recent history. Currently the nation-state remains the benchmark of political status. A country with a capital city and a large land base is the norm. But that does not mean that other forms of sovereignty will not arise in the future. The current tensions in established states may require novel solutions. Canada is no exception.

Unification in Europe and continentalism in North America have undermined national boundaries and national authority. The tension over Quebec independence has produced various formulas for restructuring the country should Quebec leave. These pressures influence political thought in western Canada and raise questions about the possibility of a postprovincial system of government in the region. Would not a confederation of city-states be a viable option?

The provincial system of government was a creation of geography and history. A country as large as Canada, it was argued, could not be centrally governed solely through the instruments of a national government. The federal concept recognized the division of powers between the provinces and Ottawa, and so the provinces became a basic unit of Canadian identity. In turn, provincial governments balanced rural and urban interests, trying to represent the needs of both constituencies. In the provincial system, small rural populations were able to exert power vis-à-vis the more populous urban areas. In a city-state system, the primacy of cities would be recognized and rural interests would be subordinated. One could not have twenty-five percent of the population dictating to the other seventy-five percent.

Would there be advantages to the rural areas in such a system? I believe there would be. The map of western Canada would be redrawn. Alberta, Saskatchewan and Manitoba would cease to exist. In their place would be a region divided into five city-states, having all the powers that the three provinces now have—five provincial capitals if you like. The rural inhabitants

in each city-state would relate to the capital city and the smaller centres under its control, linking their economic future to that of the city-state. It makes more sense for a beet farmer in southern Alberta to have Calgary as his seat of government than Edmonton. This move would allow a mixing of private and public roles for each city rather than one place being the "government town."

Unfortunately this vision will not work because it does not mesh well with the geography of the region, whose northern, nonagrarian areas are far from the urban centres created on the plains by agrarian settlement patterns from a century ago. What would one do—allow Regina's territory to extend almost up to Saskatoon's boundary because Saskatoon would be responsible for everything to the north? And what about Winnipeg, which so dominates Manitoba? Such a political model would leave Manitoba belonging to Winnipeg.

This little fantasy will not work, but the purpose of the exercise is valid—how to imagine the city in the West in a new way. Alan Artibise tells us, "Canadians are an urban people. More than seventy-five percent of the country's population lives in cities."[15] Westerners are an urban people like other Canadians. This fact must be recognized. At some point the city has to become a dominant power in both the cultural and political mythologies of the region.

The urban landscape—the cityscape—is the daily reality for almost seventy percent of prairie people. That reality has to spill over into our self-understanding and self-actualization. The current political structures are a product of an agrarian age and rural dominance. That approach is no longer valid, but the western city has yet to take its place of prominence in our mindscapes.

In the search for what is truly western, the prairie city has been systematically ignored and set aside. This has been an exercise in self-denial because the West has been an urban reality from the time of European agrarian settlement. It is time for self-denial to end. The land cannot be the sole arbiter of our identity, nor the farmer our sole representative. We have been obsessed with the land and its meaning for more than a century. Perhaps it is time now to reflect on the cities we have built and seek to understand how our identity is expressed through them. Such an exercise could herald a cultural renaissance.

NOTES

1. Alan F.J. Artibise, "Exploring the North American West: A Comparative Perspective," *The American Review of Canadian Studies,* vol. 14, no. 1 (Spring 1984).

2. J.M.S. Careless, "Aspects of Urban Life in the West, 1870–1914" in G.A. Stelter and A.F.J. Artibise, eds., *The Canadian City: Essays in Urban History* (Toronto: McClelland & Stewart Ltd., 1977): 127.

3. J.M.S. Careless, "Metropolitan and Region: The Interplay Between City and Region in Canadian History before 1914," *Urban History Review,* no. 3-78: 117–118.

4. Careless, "Aspects of Urban Life in the West," 126.

5. Careless, "Aspects of Urban Life in the West," 125.

6. Careless, "Aspects of Urban Life in the West," 125.

7. See Richard J. Huyda, *Camera in the Interior: H.L. Hime Photographer* (Toronto: Coachhouse Press, 1975).

8. Neil Seigfried, "The Westward Shift of Manufacturing on the Prairies," *Prairie Forum,* vol. 11, no. 1 (Spring 1986): 87.

9. Artibise, "Exploring the North American West," 23.

10. Artibise, "Exploring the North American West," 25.

11. Paul Voisey, "The Urbanization of the Canadian Prairies 1871–1916" in R.D. Francis and H. Palmer, eds., *The Prairie West: Historical Readings* (Edmonton: University of Alberta Press, 1985): 385.

12. Voisey, "The Urbanization of the Canadian Prairies," 389.

13. Voisey, "The Urbanization of the Canadian Prairies," 390.

14. Voisey, "The Urbanization of the Canadian Prairies," 392.

15. Alan F.J. Artibise, "Canada as an Urban Nation," *Daedalus,* vol. 117, no. 4 (Fall 1988): 237.

43. Murray Brown, *Elevation to Second Ave., Theatre, Saskatoon*, 1928

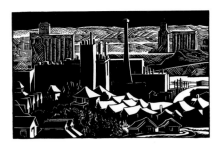

All dimensions are in centimeters; height precedes width, precedes depth. Listings indicate either an original from a collection or a reproduction courtesy of the holder.

A. Paintings, Prints, Drawings, and Sculpture

1. Sydney Prior Hall (1842–1922)
The Hudson's Bay Company Mill at Prince Albert, 1881
Graphite on paper
11.3 x 18.5
Collection of the National Archives of Canada, Ottawa

2. Frederick B. Schell (1839–1902)
Winnipeg from Saint Boniface, 1881
Pencil, watercolor and opaque watercolor on paper
25.2 x 35.2
Collection of the National Archives of Canada, Ottawa

3. D. Macdonald (active c. 1867–1897)
Winnipeg's Main Street, 1882
Oil on canvas
61.8 x 106.0
Collection of the City of Winnipeg. On permanent loan to the Winnipeg Art Gallery.

4. Samuel Hooper (1851–1911)
Volunteer Memorial Erected by the Citizens of Winnipeg 1886 in memoriam of the Fallen and Killed at Fish Creek and Batoche, 1886
Pen and ink on paper
75.4 x 58.5
Collection of the National Archives of Canada, Ottawa

5. Melton Prior (1845–1910)
View of Calgary, Alberta, c. 1887
Pencil on paper
25.4 x 42.6
Collection of the Glenbow Museum, Calgary

6. Thomas Mower Martin (1838–1934)
Main Street, Winnipeg, c. 1890
Watercolor on paper on board
32.2 x 45.2
Collection of the Glenbow Museum, Calgary

7. Percy F.S. Spence (n.d.)
The Manitoba Volunteers being addressed by the Mayor of Winnipeg before leaving for the South African War, 1899
Watercolor and ink on paper
21.0 x 31.8
Collection of the Glenbow Museum, Calgary

8. Charles William Jefferys (1869–1951)
Main Street, Winnipeg, Looking South, 1902
Pen and ink on card
41.9 x 50.8
Collection of Robert Stacey, Toronto

9. Charles William Jefferys (1869–1951)
Stephen Avenue, Calgary, 1902
Pen and ink on card
29.7 x 37.2
Collection of Robert Stacey, Toronto

10. Edward Maxwell (1868–1923)
Legislative and Executive Building, Regina, Saskatchewan, 1907
Watercolor and pen and ink on paper
53.5 x 78.8
Collection of the National Gallery of Canada, Ottawa. Royal Canadian Academy of Arts diploma work, deposited by the artist, Montréal, 1911

11. Harold Stoner (n.d.)
Untitled (view of the Saskatchewan Legislative Building), c. 1910
Watercolor on paper
75.0 x 121.0
Collection of the Regina Plains Museum, Regina

12. Emily Carr (1871–1945)
Edmonton, c. 1911
Watercolor on paper
14.2 x 17.7
Collection of the British Columbia Archives and Records Service, Victoria. Newcombe Collection

13. Victor William Horwood (1878–1938)
Administration Building, Agricultural College, University of Manitoba, Winnipeg, 1912
Watercolor on paper
64.0 x 88.0
Collection of the Manitoba Provincial Archives, Winnipeg

14. Charles William Jefferys (1869–1951)
The Pathmakers, 1912
Watercolor on paper
25.7 x 26.0
Collection of The University of Lethbridge, Lethbridge. Purchased 1987 with funds provided by The Alberta Advanced Education Endowment and Incentive Fund

15. Thomas H. Mawson (1861–1933)
City of Calgary, Preliminary Town Planning Scheme, Elevations and Sections of Departmental Buildings and City Hall, c. 1912
Pencil, ink and watercolor on paper, mounted in mylar
35.0 x 119.0 (upper sheet);
41.0 x 139.0 (lower sheet)
Collection of the Canadian Architectural Archives, University of Calgary Libraries, Calgary. Mawson Collection

16. Thomas H. Mawson (1861–1933)
The Civic Centre As It May Appear Many Years Hence, c. 1912
Pencil, ink and color wash on paper
69.0 x 107.0
Collection of the Canadian Architectural Archives, University of Calgary Libraries, Calgary. Mawson Collection

17. Thomas H. Mawson (1861–1933)
The Exhibition Ground, City of Calgary, Preliminary Town Planning Scheme, c. 1912
Pencil, ink and watercolor on paper
28.0 x 140.5
Collection of the Canadian Architectural Archives, University of Calgary Libraries, Calgary. Mawson Collection

18. Inglis Sheldon-Williams (1870–1940)
Street Scene, Regina, c. 1912
Watercolor on paper
56.0 x 42.0
Collection of the City of Regina

19. Frank Worthington Simon (1862–1933)
Interior of the Legislative Building (Winnipeg), c. 1912–15
Watercolor on paper
71.0 x 99.1
Collection of the Manitoba Provincial Archives, Winnipeg

20. Inglis Sheldon-Williams (1870–1940)
Construction of Parliament Buildings, Regina, 1913
Watercolor over pencil on paper
19.0 x 25.4
Collection of the Province of Saskatchewan. Held in trust by the Moose Jaw Art Museum, Moose Jaw

21. Cyril H. Barraud (1877–1965)
J. J. McDiarmid's Workshop, 1913
Etching on paper
12.7 x 20.0
Collection of John P. Crabb, Winnipeg

22. Reinhold Gundlach (n.d.)
The Path of Progress, 1913
Watercolor on paper
66.0 x 101.6
Collection of George T. Williams, Winnipeg

23. Thomas H. Mawson (1861–1933)
Proposed Subdivision of Property and Lay-Out of Grounds for Lieutenant-Governor's Residence, Regina, Saskatchewan, 1913
Watercolor and ink on paper
66.5 x 101.5
Collection of the Saskatchewan Archives Board, Regina

24. Inglis Sheldon-Williams (1870–1940)
View of Legislature (Regina), 1913
Watercolor and charcoal on board
30.5 x 24.0
Collection of the Regina Public Library, Regina

25. Inglis Sheldon-Williams (1870–1940)
CPR Freight Yards, c. 1913
Watercolor and charcoal on illustration board
35.2 x 53.2
Collection of the City of Regina

26. Inglis Sheldon-Williams (1870–1940)
Land Titles Office, Regina, c. 1913–17
Watercolor, tempera and pencil on paper laminated to cardboard
21.4 x 16.3
Collection of the Glenbow Museum, Calgary

27. Cyril H. Barraud (1877–1965)
C.N.R. Station, 1914
Etching on paper
32.1 x 24.0
Collection of the Winnipeg Art Gallery, Winnipeg

28. William G. Griffiths (1885–1955)
Saskatoon in 1914, 1914
Oil on canvas
47.8 x 91.0
Collection of the University of Saskatchewan, Saskatoon

29. Cyril H. Barraud (1877–1965)
Untitled (Winnipeg scene, Red River), 1914
Etching on paper
14.9 x 35.1
Collection of the Winnipeg Art Gallery, Winnipeg

30. Percy Erskine Nobbs (1875–1964) and Frank Darling (1850–1923)
University of Alberta, Edmonton, General View, Looking North Showing Scheme of Buildings Proposed in 1912, Revised 1915, 1915
Colored ink on paper
60.0 x 121.0
Collection of the University of Alberta Archives, Edmonton

31. Anonymous
City of Lethbridge, c. 1915
Oil on board
101.6 x 274.3
Collection of The University of Lethbridge, Lethbridge. Gift of the Ukrainian Canadian Association, 1971

32. Walter J. Phillips (1884–1963)
After the Rain (North Winnipeg), 1918
Watercolor on paper
24.7 x 17.1
Collection of John P. Crabb, Winnipeg

33. Francis Henry Portnall (1886–1976)
Proposed War Memorial, Winnipeg, c. 1918
Ink on paper
50.8 X 67.3
Collection of the Saskatchewan Archives Board, Regina

34. F. Chapman Clemesha (1876–1958)
Cenotaph Maquette, c. 1920
Painted plaster
121.9 x 30.4 x 30.4
Collection of Ir. E. Hendrik Grolle, Regina

35. Unknown draughtsman (L.R.) for Frank Darling (1850–1923), and John Andrew Pearson (1867–1940), architects
Rendered Perspective for the Canadian Bank of Commerce at 389 Main Street, Winnipeg, Manitoba, c. 1920
Graphite and colored wash on woven paper laid down on board
93.0 x 64.8
Collection Centre Canadien d'Architecture/ Canadian Centre for Architecture, Montréal

36. Noax (n.d.)
Untitled, c. 1920
Ink on paper
22.0 x 47.0
Collection of the Saskatchewan Archives Board, Regina

37. Lionel LeMoine FitzGerald (1890–1956)
Lombard Street, 1923
Drypoint on paper
7.8 x 6.9
Collection of Robert and Margaret Hucal, Winnipeg

38. Alexander J. Musgrove (1890–1952)
The Bridge, c. 1925
Oil on canvas
50.5 x 40.8
Collection of the Winnipeg Art Gallery, Winnipeg. Gift of Mr. and Mrs. John P. Crabb

39. Lionel LeMoine FitzGerald (1890–1956)
Backyards, Water Street, 1927
Drypoint on paper
24.2 x 22.9
Collection of the National Gallery of Canada,
Ottawa

40. Illingworth Kerr (1905–1989)
Prairie Town, Early Morning, 1927
Oil on canvas
50.5 x 61.0
Collection of the Glenbow Museum, Calgary

41. C. Keith Gebhardt (1899–1982)
St. Charles Hotel, Winnipeg, 1927
Graphite on paper
27.5 x 31.0
Collection of the Winnipeg Art Gallery, Winnipeg.
Gift of the artist

42. Walter J. Phillips (1884–1963)
A Winnipeg Street Snow-Bound, 1927
Woodcut on paper
13.8 x 18.4
Collection of the Mendel Art Gallery, Saskatoon.
Bequest of Dr. Jean E. Murray, 1981

43. Murray Brown (1884–1958)
Elevation to Second Ave., Theatre, Saskatoon, 1928
Watercolor and graphite on paper
45.8 x 40.2
Collection of the Mendel Art Gallery, Saskatoon.
Gift of Maggie Yeo and Larry Paskaruk, 1986

44. C. Keith Gebhardt (1899–1982)
Foot of Alexander St., Winnipeg, 1928
Graphite on paper
28.6 x 23.0
Collection of the Winnipeg Art Gallery, Winnipeg.
Gift of the artist

45. C. Keith Gebhardt (1899–1982)
Jarvis St., Winnipeg, 1928
Graphite on paper
24.0 x 31.4
Collection of the Winnipeg Art Gallery, Winnipeg.
Gift of the artist

46. Illingworth Kerr (1905–1989)
A Western Theatre, 1928
Oil on canvas
61.3 x 76.8
Collection of the Glenbow Museum, Calgary

47. Fritz Brandtner (1896–1969)
At Brigden's, Winnipeg, c. 1928
Ink on paper
30.4 x 19.1
Collection of the Winnipeg Art Gallery, Winnipeg.
Acquired with funds from the estate of Mr. and
Mrs. Bernard Naylor

48. Lionel LeMoine FitzGerald (1890–1956)
Pritchard's Fence, c. 1928*
Oil on canvas
71.6 x 76.5
Collection of the Art Gallery of Ontario, Toronto.
Bequest of Isabel E.G. Lyle, 1951
*Shown only at the Mendel Art Gallery, Saskatoon

49. Illingworth Kerr (1905–1989)
Behind the False Fronts—Back of Main Street,
1928–29
Oil on canvas
61.5 x 75.7
Collection of the Mendel Art Gallery, Saskatoon

50. William Gysbert Van Egmond (1883–1949)
and Stanley E. Storey (1888–1959)
Balfour Apartments, Regina, 1929
Pencil and watercolor on buff paper
49.2 x 70.4
Collection of the Saskatchewan Archives Board,
Regina. Alan Vanstone Collection

51. A.C. Leighton (1901–1965)
East End of Edmonton, 1929
Watercolor on paper
30.4 x 39.4
Collection of the Glenbow Museum, Calgary

52. A.C. Leighton (1901–1965)
Interior, Parliament Buildings, Winnipeg, 1929
Watercolor on paper
34.9 x 45.1
Collection of the Glenbow Museum, Calgary

53. Lewellyn Petley-Jones (1908–1986)
Untitled (rebuilding the Edmonton Power Plant),
1929
Watercolor on paper
38.0 x 55.6
Collection of Matthew Petley-Jones, Vancouver

54. Fritz Brandtner (1896–1969)
Regina, 1930
Pencil on paper
23.5 x 34.9
Collection of the Leonard & Bina Ellen Art Gallery,
Concordia University, Montréal

55. William Stanley Bates (1872–1949)
Elevation and Section, St. Mary's Church, Calgary,
c. 1930
Pen and watercolor on paper
38.0 x 48.0
Collection of the Glenbow Archives, Calgary

56. Lionel LeMoine FitzGerald (1890–1956)
Doc Snyder's House, 1931
Oil on canvas
74.9 x 85.1
Collection of the National Gallery of Canada,
Ottawa. Gift of P.O. Ross, Ottawa, 1932

57. Lewellyn Petley-Jones (1908–1986)
Untitled (crane and building, Edmonton), 1931
Watercolor on paper
24.6 x 31.0 (sight)
Collection of Matthew Petley-Jones, Vancouver

58. Zoe Dunning (1877–1962)
South Calgary, c. 1931
Watercolor on paper
34.6 x 40.3
Collection of the Alberta Foundation for the Arts,
Edmonton

59. A.C. Leighton (1901–1965)
Untitled (houses on a hill, Edmonton), c. 1931
Watercolor on paper
28.0 x 35.5
Collection of the Alberta Foundation for the Arts,
Edmonton

60. Fritz Brandtner (1896–1969)
Winnipeg, c. 1931
Ink and watercolor on paper
11.3 x 18.3 (sight)
Collection of The Edmonton Art Gallery, Edmonton.
Purchased with funds donated by the Women's
Society of The Edmonton Art Gallery

61. Lionel LeMoine FitzGerald (1890–1956)
Railway Station, c. 1931–32
Graphite on paper
30.5 x 34.9
Collection of the Art Gallery of Ontario, Toronto

62. Caven Atkins (1907–)
Political Discussion, Depths of Depression, Winnipeg,
1932
Watercolor and ink on paper
27.3 x 36.6 (sight)
Collection of the artist, Southfield, Michigan

63. Bartley Robilliard Pragnell (1907–1966)
Tea Party, 1932
Oil on paper board
45.6 x 60.9
Collection of the Mendel Art Gallery, Saskatoon

64. H. Eric Bergman (1893–1958)
Winter in Winnipeg, 1932
Oil on canvas board
60.3 x 70.1
Collection of Mr. and Mrs. H.E.J. Bergman,
Winnipeg

65. Myrtle Jackson (n.d.)
Calgary, c. 1932
Watercolor, brush and pen on paper
29.1 x 37.1
Collection of the Glenbow Museum, Calgary

66. Caven Atkins (1907–)
Brick Processing Plant, St. James, Manitoba, 1933
Watercolor, ink and conté on paper
41.9 x 43.7
Collection of the artist, Southfield, Michigan

67. Caven Atkins (1907–)
Night View of a City, 1933
Graphite on paper
28.6 x 22.2
Collection of the artist, Southfield, Michigan

68. Walter J. Phillips (1884–1963)
Our Street, 1933
Woodcut on paper
10.6 x 17.3
Collection of the Mendel Art Gallery, Saskatoon.
Bequest of Dr. Jean E. Murray, 1981

69. Bartley Robilliard Pragnell (1907–1966)
Moose Jaw, c. 1933
Watercolor on paper
24.0 x 34.0
Collection of Lynn and Ken Martens, Calgary

70. Bartley Robilliard Pragnell (1907–1966)
Relief, c. 1933
Watercolor on paper
49.6 x 74.5
Collection of SaskTel, Regina

71. Robert Newton Hurley (1894–1980)
Untitled (roofs), c. 1933
Watercolor on paper
21.0 x 25.1
Collection of the Mendel Art Gallery, Saskatoon.
Gift of Ernest F. Lindner, 1967

72. Fritz Brandtner (1896–1969)
Winnipeg Night, c. 1933
Ink on paper
32.7 x 21.6
Collection of the Winnipeg Art Gallery, Winnipeg.
Acquired with funds from the estate of Mr. and
Mrs. Bernard Naylor

73. Walter J. Phillips (1884–1963)
Untitled (view of Headingly, Manitoba), 1934
Watercolor on paper
36.0 x 51.0
Collection of the University of Winnipeg,
Winnipeg

74. Bartley Robilliard Pragnell (1907–1966)
A Moose Jaw City Office, c. 1934
Watercolor and colored pencil on paper
25.2 x 35.4
Collection of the Mendel Art Gallery, Saskatoon.
Gift of the Pragnell family in memory of the artist,
1988

75. Ernest F. Lindner (1897–1988)
A Cold Morning, 1935
Graphite on paper
36.3 x 29.0
Collection of the Mendel Art Gallery, Saskatoon

76. Augustus Kenderdine (1870–1947)
Broadway Bridge, Saskatoon, c. 1935*
Oil on canvas
81.0 x 177.5 cm
Collection of the Mendel Art Gallery, Saskatoon.
Gift of Canadian National Hotels, Bessborough
Hotel, 1973
*Shown only at the Mendel Art Gallery, Saskatoon

77. Robert Campbell (1883–1967)
Cloverdale Road, Edmonton, c. 1935
Watercolor on paper
26.6 x 18.4
Collection of the Glenbow Museum, Calgary

78. Robert Newton Hurley (1894–1980)
North Park, Backyard Winter, c. 1935
Watercolor on paper
43.0 x 36.0
Collection of Regina Public Library, Regina

79. Robert Newton Hurley (1894–1980)
Factoria, 1937
Watercolor on paper
27.0 x 22.0
Collection of Lynn and Ken Martens, Calgary

80. Stanley Brunst (1894–1962)
The Sign of Spring, 1937
Watercolor on card
26.5 x 23.5
Collection of the Mendel Art Gallery, Saskatoon.
Gift of Dr. and Mrs. C.G. Morrison, 1982

81. Henry G. Glyde (1906–)
Vegreville (landscape with cart), 1937
Watercolor on paper
26.6 x 36.1
Collection of The University of Lethbridge,
Lethbridge. Purchased 1987 with funds provided
by the Province of Alberta Endowment Fund

82. Robert Newton Hurley (1894–1980)
Untitled (prairie town), c. 1937
Watercolor and graphite on paper
38.9 x 42.5
Collection of the Mendel Art Gallery, Saskatoon

83. Henry G. Glyde (1906–)
Outskirts of Lethbridge, Alberta, 1938
Watercolor and pencil on paper
36.0 x 26.0
Collection of the Glenbow Museum, Calgary

84. Stanley Brunst (1894–1962)
Untitled (machinery composition), 1938
Watercolor on card
49.0 x 27.8
Collection of the Mendel Art Gallery, Saskatoon.
Gift of Dr. and Mrs. C.G. Morrison, 1982

85. Bartley Robilliard Pragnell (1907–1966)
Untitled (man on bench), c. 1938
Colored pencil and graphite on paper
19.5 x 12.5
Collection of the Mendel Art Gallery, Saskatoon

86. Margaret Shelton (1915–1984)
Calgary, 1939
Watercolor on paper
34.9 x 44.9
Collection of the Glenbow Museum, Calgary

87. Stanley Brunst (1894–1962)
Untitled (rail tunnel, Saskatoon), 1939
Watercolor on paper
39.5 x 43.5
Collection of the Mendel Art Gallery, Saskatoon.
Gift of Dr. and Mrs. G. G. Morrison 1982

88. Henry G. Glyde (1906–)
Lethbridge, c. 1939
Watercolor on paper
26.6 x 36.8
Collection of Medicine Hat Museum and Art
Gallery, Medicine Hat

89. Margaret Shelton (1915–1984)
East Calgary, 1940
Linocut
16.1 x 24.0
Collection of the Glenbow Museum, Calgary

90. Jessie Ursenbach (n.d.)
Ellison Mills, 1940
Watercolor on paper
37.2 x 55.5
Collection of the Alberta Foundation for the Arts,
Edmonton

91. Eva Mendel Miller (1919–)
Saskatoon, 1940
Oil on paper board panel
41.0 x 55.8
Collection of the Mendel Art Gallery, Saskatoon

92. Roloff Beny (1924–1984)
Untitled (market scene, Medicine Hat), 1940
Watercolor and pencil on paper
50.8 x 60.9
Collection of The University of Lethbridge,
Lethbridge

93. Ernest F. Lindner (1897–1988)
A.L. Cole Power Station, Saskatoon, c. 1940
Tempera on composition board
74.0 x 160.0
Collection of the Saskatoon Board of Education,
Saskatoon

94. William Stevenson (1905–1966)
Across the Road (St. Mary's, Calgary), c. 1940
Oil on board
49.5 x 39.0
Collection of Lynn and Ken Martens, Calgary

95. Alexander J. Musgrove (1890–1952)
Coming Dusk, Prairie Village, c. 1940
Oil on canvas
79.2 x 92.0
Collection of the Winnipeg Art Gallery, Winnipeg.
Gift of Mr. and Mrs. John P. Crabb

96. Walter J. Phillips (1884–1963)
University of Saskatchewan, c. 1940
Watercolor on paper
34.0 x 50.0
Collection of the University of Saskatchewan,
Saskatoon

97. Ernest F. Lindner (1897–1988)
Bessborough Hotel, Saskatoon, 1941
Watercolor on paper
32.5 x 27.9
Collection of The Edmonton Art Gallery, Edmonton.
Donated by Dr. Illingworth Kerr, 1981

98. Margaret Shelton (1915–1984)
Chinese Laundry, 1941
Linocut
12.0 x 15.4
Collection of the Glenbow Museum, Calgary

99. Henry G. Glyde (1906–)
The Exodus, 1941
Oil and tempera on masonite
60.7 x 77.5
Collection of the Alberta Foundation for the Arts,
Edmonton

100. James McLaren Nicoll (1909–1985)
The Bridge, 1942
Watercolor on paper
34.5 x 45.0
Collection of the Glenbow Museum, Calgary

101. Walter J. Phillips (1884–1963)
Dawn, Edmonton Airport, 1942
Watercolor on paper
56.8 x 79.1
Collection of The Edmonton Art Gallery,
Edmonton. Gift of J.A. Imrie, Dr. Orr, and
Mrs. H.R. Milner, 1943

102. H. Eric Bergman (1893–1958)
South Window, 1942
Oil on canvas
69.3 x 81.8
Collection of the Winnipeg Art Gallery, Winnipeg.
Gift of Mrs. R. Fraser and Mrs. H. Barbour in
memory of their father, Mr. George Wilson

103. Robert Newton Hurley (1894–1980)
North Battleford—At Sunset, c. 1942
Watercolor and graphite on paper
13.3 x 27.3
Collection of the Mendel Art Gallery, Saskatoon.
Gift of Mrs. Mary E. Moffat in memory of her
parents, Mr. and Mrs. H.L. Montgomery, 1993

104. Henry G. Glyde (1906–)
Edmonton, 1943
Oil on canvas
82.2 x 106.0
Collection of The Edmonton Art Gallery,
Edmonton. Gift of the artist, 1943

105. H. Eric Bergman (1893–1958)
Off to War, 1943
Pencil on paper
36.8 x 49.5
Collection of Mr. and Mrs. H.E.J. Bergman,
Winnipeg

106. Alison Newton (1890–1967)
House on Hargrave Street, c. 1943
Watercolor on paper
44.5 x 37.4
Collection of Robert and Margaret Hucal, Winnipeg

107. F. Douglas Motter (1913–)
Calgary Zoo, 1944
Watercolor on paper
36.8 x 48.3
Collection of the City of Calgary

108. Wesley Fraser Irwin (1897–1976)
Old House in Edmonton #2, c. 1944
Watercolor on paper
27.4 x 38.4
Collection of the Glenbow Museum, Calgary

109. William Perehudoff (1919–)
Prairie Town—Langham, 1945
Watercolor on paper
39.4 x 56.9
Collection of the Mendel Art Gallery, Saskatoon.
Gift of Ernest F. Lindner, 1967

110. Ernest F. Lindner (1897–1988)
Dead End, c. 1945
Linocut on paper
24.1 x 30.4
Collection of John P. Crabb, Winnipeg

111. Wesley Fraser Irwin (1897–1976)
Gallery Visitors, 1946
Gouache on paper
34.4 x 27.9
Collection of the City of Calgary

112. Ed McCheane (n.d.)
Untitled (excavation, Saskatoon), 1946
Watercolor on paper
40.6 x 55.8
Collection of John P. Crabb, Winnipeg

113. Bartley Robilliard Pragnell (1907–1966)
Untitled (workers), 1946
Watercolor and charcoal on paper
35.9 x 64.5
Collection of the Alberta Foundation for the Arts,
Edmonton

114. Bartley Robilliard Pragnell (1907–1966)
Untitled (geometric buildings), c. 1946
Conté on paper
21.0 x 30.4
Collection of the Mendel Art Gallery, Saskatoon

115. Lionel LeMoine FitzGerald (1890–1956)
Untitled (back garden with gate), 1947
Watercolor on paper
61.0 x 45.4
Collection of the Winnipeg Art Gallery, Winnipeg.
Gift of the Women's Committee

116. Luke Lindoe (1913–)
Untitled (a view of Calgary from Sunnyside), 1947
Watercolor on paper
29.2 x 39.3
Collection of the Medicine Hat Museum and Art
Gallery, Medicine Hat

117. Lionel LeMoine FitzGerald (1890–1956)
Untitled (winter landscape), c. 1947
Watercolor on paper
60.7 x 45.8
Collection of the Winnipeg Art Gallery, Winnipeg.
Gift of the Women's Committee

118. Bartley Robilliard Pragnell (1907–1966)
Main Street Balcony, 1948
Oil on board
40.4 x 50.8
Collection of The Edmonton Art Gallery,
Edmonton. Purchased in 1990 with funds from the
Art Associates of The Edmonton Art Gallery

119. McGregor Hone (1920–)
Red House, 1948
Oil on masonite panel
35.4 x 31.8
Collection of the Mendel Art Gallery, Saskatoon.
Purchased with funds from the Canada Council
Special Purchase Assistance Program, 1990

120. Horace Watson Wickenden (1901–)
Untitled (industrial area), c. 1948
Watercolor and ink on paper
7.0 x 10.0
Collection of the Mendel Art Gallery, Saskatoon.
Gift of George Swinton, 1987

121. Maxwell Bates (1906–1980)
Central Park, Calgary, 1949
Lithograph on paper
21.0 x 18.4
Collection of the Alberta Foundation for the Arts,
Edmonton

122. John Snow (1911–)
Market, 1949
Watercolor on paper
19.5 x 25.5
Collection of the artist. Courtesy of Canadian Art
Galleries, Calgary

123. Tom Guest (n.d.)
Progress, c. 1949*
Oil on masonite
121.9 x 243.8
Collection of the Saskatoon Public Library,
Saskatoon
*Shown only at the Mendel Art Gallery, Saskatoon

124. Rule, Wynn, Rule
Coca-Cola Plot Plan Proposed Planting, c. 1949
Color pencil and pencil on paper
64.0 x 91.0
Collection of the Canadian Architectural Archives,
University of Calgary Libraries, Calgary. Rule,
Wynn, Rule Collection

125. James McLaren Nicoll (1909–1985)
Bowness Street Car - 5 P.M., c. 1950
Oil on canvas
69.0 x 54.0
Collection of the Bowness Senior Citizens' Club,
Calgary

126. James McLaren Nicoll (1909–1985)
Shacks and Refinery, c. 1950
Oil on board
50.0 x 60.0
Collection of Lynn and Ken Martens, Calgary

127. A.C. Leighton (1901–1965)
View of Edmonton from North Saskatchewan River,
c. 1950
Watercolor on paper
39.3 x 41.5
Collection of the Glenbow Museum, Calgary

128. Clara Samuels (1914–1988)
View of the Legislature (Regina), c. 1950
Oil on canvas
61.0 x 71.3
Collection of the MacKenzie Art Gallery, Regina.
Gift of Joseph and Martin Samuels in memory of
their parents, Victor and Clara

129. Robert Vincent (1908–1984)
Saskatoon Broadway Bridge, c. 1950–67
Watercolor and ink on paper
28.3 x 38.5
Collection of the Mendel Art Gallery, Saskatoon

130. Lionel LeMoine FitzGerald (1890–1956)
From an Upstairs Window, Winter, 1950–51
Oil on canvas
61.0 x 45.7
Collection of the National Gallery of Canada,
Ottawa

131. Marcel G. Vance (1909–c.1982)
Spirit of Saskatchewan, c. 1951
Oil on canvas board
54.5 x 68.0
Collection of Cecilia Côté, Saskatoon

132. Henry G. Glyde (1906–)
Aftermath, 1952
Mixed media on canvas
81.3 x 101.8
Private collection, Edmonton

133. A.C. Leighton (1901–1965)
Calgary, in the Foothills, c. 1952
Oil on canvas
61.2 x 86.5
Collection of Seagrams of Canada, Montréal

134. Charles F. Comfort (1900–)
Edmonton, Skyline of the North, c. 1952
Oil on canvas
76.1 x 101.8
Collection of Seagrams of Canada, Montréal

135. Ronald York Wilson (1907–1984)
Regina, City in the Wheat Fields, c. 1952
Oil on canvas
76.5 x 101.7
Collection of Seagrams of Canada, Montréal

136. Goodridge Roberts (1904–1974)
Saskatoon, c. 1952
Oil on canvas
30.5 x 40.4
Collection of Seagrams of Canada, Montréal

137. William Winter (1909–)
Winnipeg, Gate to the West, c. 1952
Oil on canvas
55.9 x 81.3
Collection of Seagrams of Canada, Montréal

138. Kenneth Campbell Lochhead (1926–)
Untitled (Main Street, Pense, Saskatchewan), 1953
Gouache and ink on paper
16.6 x 46.8
Collection of the Winnipeg Art Gallery, Winnipeg.
Gift of Vernon S. Mackelvie in memory of his
parents, Charles W. L. Mackelvie and Josephine
(Hibbard) Mackelvie, and his brother, James A.
Mackelvie, killed in action in World War II

139. Eli Bornstein (1922–)
Saskatoon, 1954
Etching on paper
35.3 x 56.3
Collection of the Mendel Art Gallery, Saskatoon

140. Lionel LeMoine FitzGerald (1890–1956)
Untitled (abstract), c. 1954
Oil on masonite
31.4 x 36.0
Collection of the Winnipeg Art Gallery, Winnipeg.
Donation from the Douglas Duncan Estate

141. Dorothy Knowles (1927–)
Early Spring, 1955
Watercolor on paper
60.3 x 41.9
Collection of the artist. Courtesy of Art Placement,
Saskatoon

142. Roy Kiyooka (1926–)
City, My City, c. 1955
Oil on masonite
76.3 x 152.7
Collection of the National Gallery of Canada,
Ottawa

143. Roland Keevil (1887–1963)
Untitled (Saskatoon), c. 1955
Oil on canvas board
34.2 x 44.4
Collection of Neil Richards, Saskatoon

144. Edward John Hughes (1913–)
Calgary, Alberta, c. 1956
Watercolor on paper
52.0 x 61.6
Collection of the Glenbow Museum, Calgary

145. Henry G. Glyde (1906–)
End of the Prairie, 1957
Mixed technique on masonite
61.0 x 101.5
Collection of the University of Alberta, Edmonton.
Central Collection

146. Otto Rogers (1935–)
City of Light, 1959
Oil on canvas
147.5 x 91.0
Collection of the Mendel Art Gallery, Saskatoon.
Gift of the artist in memory of his parents, Otto
Victor Rogers and Mary Jane Rogers, 1988

147. Robert Vincent (1908–1984)
Paris Cafe, 1959
Oil on board
51.0 x 61.0
Collection of Jack Severson, Regina

148. Marion Nicoll (1909–1985)
The City—Sunday, 1960
Oil on canvas
88.9 x 114.3
Collection of the City of Calgary

149. Robert Murray (1936–)
*Preliminary Drawing of the Saskatoon City Hall
Fountain Sculpture*, 1960
Charcoal on paper
48.2 x 62.2
Collection of the Mendel Art Gallery, Saskatoon.
Gift of the artist, 1965

150. W.C. McCargar (1906–1980)
Untitled, 1960
Pen, ink and watercolor on paper glued to board
45.0 x 54.0
Collection of Jack Severson, Regina

151. Henry G. Glyde (1906–)
Afternoon Off, Lethbridge, n.d.
Watercolor on paper
25.5 x 36.0 (sight)
Collection of the City of Lethbridge

152. Illingworth Kerr (1905–1989)
Back Alley, n.d.
Oil on canvas
75.9 x 91.1
Collection of the Glenbow Museum, Calgary

153. A.C. Leighton (1901–1965)
City Buildings, n.d.
Oil on canvas
76.2 x 61.0
Collection of the Leighton Foundation, Calgary

154. A.C. Leighton (1901–1965)
Early Calgary, n.d.
Watercolor on paper
40.6 x 29.8
Collection of the Leighton Foundation, Calgary

155. Bartley Robilliard Pragnell (1907–1966)
Three Sketch Books, n.d.
Graphite on paper
Collection of The University of Lethbridge,
Lethbridge. Gift of the Pragnell family, 1989

B. PHOTOGRAPHS

All photographs are black and white, modern
gelatin silver prints, 20.3 x 25.4 cm, unless
otherwise indicated.

156. William McFarlane Notman (1857–1913)
CPR Machine Shop, Winnipeg, Manitoba, 1884
Courtesy of the McCord Museum of Canadian
History, Montréal. Notman Photographic Archives.
1586

157. William McFarlane Notman (1857–1913)
CPR Station, Winnipeg, Manitoba, 1884
Courtesy of the McCord Museum of Canadian
History, Montréal. Notman Photographic Archives.
1425

158. William McFarlane Notman (1857–1913)
Indian Head Station, Saskatchewan, 1884
Courtesy of the McCord Museum of Canadian
History, Montréal. Notman Photographic Archives.
1383

159. William McFarlane Notman (1857–1913)
Main Street, Winnipeg, Manitoba, 1884
Courtesy of the McCord Museum of Canadian
History, Montréal. Notman Photographic Archives.
1412

160. William McFarlane Notman (1857–1913)
Moose Jaw, Saskatchewan, 1884
Courtesy of the McCord Museum of Canadian
History, Montréal. Notman Photographic Archives.
1381

161. William McFarlane Notman (1857–1913)
Rosser Avenue, Brandon, Manitoba, 1884
Courtesy of the McCord Museum of Canadian
History, Montréal. Notman Photographic Archives.
1390

162. William McFarlane Notman (1857–1913)
Medicine Hat, NWT, 1884
Courtesy of the McCord Museum of Canadian
History, Montréal. Notman Photographic Archives.
1375

163. William McFarlane Notman (1857–1913)
*Assiniboine Flour Mill and Elevator, Portage la
Prairie, Manitoba*, 1884
Courtesy of the McCord Museum of Canadian
History, Montréal. Notman Photographic Archives.
1393

164. William McFarlane Notman (1857–1913)
Winnipeg, Manitoba, from the Parliament Buildings,
1884
Courtesy of the McCord Museum of Canadian
History, Montréal. Notman Photographic Archives.
1613

165. William McFarlane Notman (1857–1913)
Brandon, Manitoba, 1884
Courtesy of the McCord Museum of Canadian
History, Montréal. Notman Photographic Archives.
1389

166. William McFarlane Notman (1857–1913)
Calgary, NWT, c. 1884
Courtesy of the McCord Museum of Canadian
History, Montréal. Notman Photographic Archives.
1372

167. William McFarlane Notman (1857–1913)
Calgary, NWT, from Bow River Bridge, c. 1884
Courtesy of the McCord Museum of Canadian
History, Montréal. Notman Photographic Archives.
1371

168. William Pearce (n.d.)
*Blood Indians and Whites at the North-West Company
Land Title Office, Lethbridge, Alberta*, 1885
Courtesy of the Glenbow Archives, Calgary. NA
1322-10

169. William McFarlane Notman (1857–1913)
Main Street, Winnipeg, Manitoba, 1887
Courtesy of the McCord Museum of Canadian
History, Montréal. Notman Photographic Archives.
1617

170. William Hanson Boorne (1859–1945) and
Ernest G. May (n.d.)
Calgary, NWT, from the North, c. 1887
Courtesy of the McCord Museum of Canadian
History, Montréal. Notman Photographic Archives.
1134

171. William Hanson Boorne (1859–1945) and
Ernest G. May (n.d.)
Edmonton, NWT, from Lower Ferry, c. 1887
Courtesy of the McCord Museum of Canadian
History, Montréal. Notman Photographic Archives.
1079

172. William McFarlane Notman (1857–1913)
*Indian Camp, Blackfoot Reserve, near Calgary,
Northwest Territories*, 1889
Courtesy of the McCord Museum of Canadian
History, Montréal. Notman Photographic Archives.
2157-8

173. Anonymous
*Calgary, Alberta, in 1890—A Business Block on
Stephen Avenue*, 1890
Courtesy of the McCord Museum of Canadian
History, Montréal. Notman Photographic Archives.
MP 1362 (6)

174. Anonymous
Private Residences in Calgary, Alberta, c. 1890
Courtesy of the McCord Museum of Canadian
History, Montréal. Notman Photographic Archives.
MP 1362 (2)

175. Taylor Signs
Lougheed Block 8th Avenue between Centre and 1st Street West, Calgary, Alberta, 1890–91
Courtesy of the Glenbow Archives, Calgary. NA 3795–1

176. William McFarlane Notman (1857–1913)
Main Street and City Hall Square, Winnipeg, Manitoba, 1897
Courtesy of the McCord Museum of Canadian History, Montréal. Notman Photographic Archives. 3058

177. Lewis B. Foote (1873–1957)
L.B. Foote Photographer Wpg. Taking a Birds-Eye View of the City, 1906
Courtesy of the Manitoba Provincial Archives, Winnipeg. L.B. Foote Collection. N8478

178. Anonymous
Lethbridge Business Area, 1907
Vintage silver print
18.0 x 120.0
Collection of the Glenbow Archives, Calgary. PE–14–1

179. Hamly Press Ltd.
Panoramic View of Old-Edmonton, 1909
Vintage silver print
30.5 x 203.2
Collection of the Provincial Archives of Alberta, Edmonton. 81.399

180. Peter McKenzie (c. 1880–1965)
Laying of the Corner-Stone, Regina, October 4, 1909
Courtesy of the Saskatchewan Archives Board, Regina. R–A 2273

181. Edgar Rossie (1875–1942)
11 Avenue, Looking East, Regina, Saskatchewan, c. 1910
19.0 x 50.7
Courtesy of Mick West, Regina

182. Edgar Rossie (1875–1942)
McCallum & Hill Development of Lakeview. View from Legislative Building, Regina, c. 1910
19.0 x 50.7
Courtesy of Mick West, Regina

183. J.W. Wilson Co., Toronto and Regina
View of Moose Jaw from Robin Hood Mill, 1911
Vintage silver print
25.0 x 157.5
Collection of the Moose Jaw Art Museum, Moose Jaw.

184. Peter Schawang (n.d.)
Panoramic View of Winnipeg, July 21, 1911
Courtesy of the Manitoba Provincial Archives, Winnipeg. Box 30/32 N9081

185. Edgar Rossie (1875–1942)
Residential District S. Regina After Cyclone June 30/12, 1912
19.0 x 50.7
Courtesy of Mick West, Regina

186. Anonymous
Untitled (Board of Trade promotion, Saskatoon), c. 1912
Courtesy of the Local History Room, Saskatoon Public Library, Saskatoon

187. Ole Voldeng and Eric Bolton (n.d.)
Edmonton, Alberta, October 1913
Vintage silver print
22.2 x 186.5
Collection of the Provincial Archives of Alberta, Edmonton. 83.494/2

188. Lewis B. Foote (1873–1957)
Center-Piece of the Pediment, Manitoba Legislature, c. 1913
Courtesy of the Manitoba Provincial Archives, Winnipeg. L.B. Foote Collection. N2127 527

189. Anonymous
Rumley Oil-Pull Tractor and Legislative Building, Regina, c. 1913
Courtesy of the Saskatchewan Archives Board, Regina. R-A 2302

190. Lewis B. Foote (1873–1957)
Recruiting Drive, Trenches at Main Street and Water Avenue, 1916
Courtesy of the Manitoba Provincial Archives, Winnipeg. L.B. Foote Collection. N2972 2310

191. Anonymous
Maquette for Golden Boy and Dome, Manitoba Legislative Building, c. 1916
Courtesy of the Manitoba Provincial Archives, Winnipeg. N9716

192. Lewis B. Foote (1873–1957)
Kennedy Street Legislative Building, Winnipeg, May 2, 1917
Courtesy of the Manitoba Provincial Archives, Winnipeg. L.B. Foote Collection. N2126 526

193. Lewis B. Foote (1873–1957)
Statuary Group "Art" Before Positioning Above the Colonnade of the Manitoba Legislative Building, c. 1918
Courtesy of the Manitoba Provincial Archives, Winnipeg. L.B. Foote Collection. N9121 2407

194. Anonymous
Statuary Group "Industry" Before Elevation to the Dome of the Manitoba Legislative Building, c. 1918
Courtesy of the Manitoba Provincial Archives, Winnipeg. N13936

195. Lewis B. Foote (1873–1957)
Winnipeg General Strike. Crowd at Corner of William Avenue and Main Street, June 21, 1919
Courtesy of the Manitoba Provincial Archives, Winnipeg. L.B. Foote Collection. N2771 1705

196. Lewis B. Foote (1873–1957)
Winnipeg General Strike. Crowd at Portage and Main Street, June 21, 1919
Courtesy of the Manitoba Provincial Archives, Winnipeg. L.B. Foote Collection. N2267 1701

197. Lewis B. Foote (1873–1957)
Winnipeg General Strike. Inspector Proby's Mounted Force Approaching the Corner of Portage Avenue and Main Street, June 21, 1919
Courtesy of the Manitoba Provincial Archives, Winnipeg. L.B. Foote Collection. N2756 1690

198. Lewis B. Foote (1873–1957)
Interior of the Rotunda and Dome of the Legislative Building, Winnipeg, June 1920
Courtesy of the Manitoba Provincial Archives, Winnipeg. L.B. Foote Collection. N8969

199. Anonymous
War Memorial in Prince Albert Saskatchewan, designed by Marguerite Taylor, c. 1920
Courtesy of the Manitoba Provincial Archives, Winnipeg. N–4697

200. William John Oliver (1887–1954)
William John Oliver photographing Calgary from the roof of the Palliser Hotel, c. 1925
Courtesy of the Glenbow Archives, Calgary. NA-4868–19

201. William John James (1870–1944)
Group Portrait—Confederation Celebration (Prince Albert, Saskatchewan), 1927
20.3 x 95.8
Collection of the Mendel Art Gallery, Saskatoon. Gift of the Prince Albert Historical Society Archives, 1987

202. William John James (1870–1944)
North Star Service Station, Prince Albert, Saskatchewan, c. 1927
20.3 x 45.5
Collection of the Mendel Art Gallery, Saskatoon. Gift of the Prince Albert Historical Society Archives, 1987

203. John W. Gibson (1872–1959)
Saskatoon Industrial Exhibition, 1928
24.4 x 68.0
Courtesy of the Glenbow Archives, Calgary. 287

204. Anonymous
Paris Building, Winnipeg, c. 1928
Courtesy of the Manitoba Provincial Archives, Winnipeg

205. John W. Gibson (1872–1959)
Lloydminster, Sask. $1,000,000.00 Fire, August 19, 1929
24.0 x 73.7
Courtesy of the Glenbow Archives, Calgary. N.E. 3–634

206. John W. Gibson (1872–1959)
Untitled (Spadina Crescent, looking north, Saskatoon, Saskatchewan), c. 1930
28.0 x 86.6
Courtesy of the Glenbow Archives, Calgary. 334

207. Lewis B. Foote (1873–1957)
Unemployed at the Parliament Buildings, Winnipeg, 1931
Courtesy of the Manitoba Provincial Archives, Winnipeg. L.B. Foote Collection. N4910

208. McDermid Studios
Hunger March, Market Square, Edmonton, December 21, 1932
Courtesy of the Alberta Provincial Archives, Edmonton. A. 9214

209. Anonymous
Daynaka family, Edmonton, 1933
Courtesy of the Glenbow Archives, Calgary. ND–3–6343

210. Wilfred West (1895–1970)
First C.C.F. Convention, Regina, Saskatchewan, July 1933
13.0 x 25.5
Courtesy of Saskatchewan Provincial Archives, Regina West's Studio Collection. R-D341

211. McDermid Studios
Demonstration of the Unemployed, Edmonton, October 1933
Courtesy of the Glenbow Archives, Calgary. NC–6–13068A

212. McDermid Studios
Relief Kitchen, Edmonton, November 1933
Courtesy of the Glenbow Archives, Calgary. ND–3–6523A

213. McDermid Studios
"On to Ottawa Trek," C.P.R. Station, Medicine Hat, June 10, 1935
Courtesy of the Alberta Provincial Archives, Edmonton. 5150

214. McDermid Studios
"On to Ottawa Trek," C.P.R. Station, Medicine Hat, June 10, 1935
Courtesy of the Alberta Provincial Archives, Edmonton. 5146

215. Dick Bird (1892–1986)
Demonstration of Strikers at Market Square prior to Regina Riot, 1935
Courtesy of the Saskatchewan Archives Board. R–A27560

216. McDermid Studios
Men Laying Tar Sands on 107th Street, Edmonton, October 1937
Collection of the Glenbow Archives, Calgary. ND3–5228A

217. Anonymous
Billboard, Saskatoon, c. 1940
Courtesy of the Local History Room, Saskatoon Public Library, Saskatoon. B8284

218. Leonard Hillyard (1891–1975)
Victory Bond Float on 2nd Avenue, Saskatoon, c. 1940
Courtesy of the Local History Room, Saskatoon Public Library, Saskatoon. A1075

219. Harry Pollard (1880–1968)
Calgary, c. 1940
Courtesy of the Provincial Archives of Alberta, Edmonton. Pollard Collection. P.4719

220. Leslie G. Saunders (1895–1968)
Blizzard, c. 1942
27.2 x 35.4
Collection of the Mendel Art Gallery, Saskatoon. The Jessie S. Saunders Gift, 1981

221. John W. Gibson (1872–1959)
Untitled (view of Saskatoon), 1948
24.6 x 95.0
Courtesy of the Glenbow Archives, Calgary. NE–3–349

222. Anonymous
Bus Depot, Saskatoon, c. 1950
Courtesy of the Local History Room, Saskatoon Public Library, Saskatoon. 8225

223. Leslie G. Saunders (1895–1968)
Untitled (gas station), c. 1950
27.9 x 35.6
Collection of the Mendel Art Gallery, Saskatoon. The Jessie S. Saunders Gift, 1981

224. Anonymous
Barr Colonists, Saskatoon, n.d.
Courtesy of the Local History Room, Saskatoon
Public Library, Saskatoon

225. Anonymous
Legislative Building, Regina, n.d.
Courtesy of the Saskatchewan Archives Board,
Regina. R–B7947

226. Anonymous
*Interior View of Dome and Mural, Legislative Building,
Regina*, n.d.
Courtesy of the Saskatchewan Archives Board,
Regina. R–B2744–3

C. PROMOTIONAL MATERIAL

227. *Main Street, City of Winnipeg, Manitoba*, 1881
Published by H. A. Strong
14.0 x 22.0 (folded)
Collection of the Glenbow Archives Library, Calgary

228. *Winnipeg from St. Boniface Ferry Landing*, 1882
Modern photograph of a steel engraving from
Picturesque Canada, Vol. 1, P. 286
Courtesy of the Local History Room, Saskatoon
Public Library, Saskatoon

229. *The Canadian Pacific Railway. Traversing the
Great Wheat Region of the Canadian Northwest*,
c. 1883
Printed by the American Bank Note Company
Letterpress and wood engraving on paper
111.5 x 75.0
Collection of Canadian Pacific Limited, Montréal.
GR874A

230. *The Dominion Illustrated: The Calgary Special*,
1890
Published by Dominion Illustrated Publishing Co.
36.0 x 27.0
Collection of the Glenbow Archives Library, Calgary

231. *Main Street Views*, 1892
Published by C.E. Steele
14.0 x 22.0 (folded)
Collection of the Glenbow Archives Library, Calgary

232. *The Leader Inaugural Number, Regina,
Saskatchewan, September 1, 1905*
Published by Leader-Times Co.
35.0 x 27.0
Collection of the Glenbow Archives Library, Calgary

233. *Souvenir Book of Moose Jaw*, 1905
Published by W.G. MacFarlane
18.0 x 23.9
Collection of the Moose Jaw Art Museum,
Moose Jaw

234. *Regina City*
Modern photograph of an advertisement
reproduced in *The Regina Morning Leader*,
June 11, 1906
Courtesy of the Saskatchewan Archives Board,
Regina. R–A1241

235. *Lakeview! Lakeview!*
Modern photograph of an advertisement
reproduced in *The Regina Morning Leader*,
October 10, 1906
Courtesy of the Saskatchewan Archives Board,
Regina. R–B2487

.36. *Competition for Legislative and Executive
Building at Regina, Saskatchewan*, c. 1907
Modern photograph of a blueprint by Cass Gilbert
(1858–1934)
Courtesy of the Saskatchewan Archives Board,
Regina. R–B 247–13

237. *Front Elevation, Proposed Legislative and
Executive Building, Regina, Saskatchewan*, c. 1907
Modern photograph of a blueprint by Jean
O. Marchand (1872–1936) and Stevens Haskell
(1871–1913)
Courtesy of the Saskatchewan Archives Board,
Regina. R–B 248–1

238. *Regina Commercial Souvenir*, 1910
Published by Greater Regina Club
24.0 x 16.0
Collection of the Glenbow Archives Library, Calgary

239. *Saskatoon from the South Bank of the
Saskatchewan, Canada*, c. 1910
Screened china plate
19.0 diameter
Collection of the Saskatchewan Western
Development Museum, Saskatoon

240. Wedgwood Company
Untitled (view of Moose Jaw, Saskatchewan, with
the launch *Edith*), c. 1910
Screened, handpainted china plate
25.0 diameter
Collection of the Moose Jaw Art Museum,
Moose Jaw

241. *Calgary Alberta: The Manufacturing, Jobbing and
Commercial Centre of the Canadian West*, 1911
Published by the Jennings Publishing Company
15.0 x 24.0
Collection of the Glenbow Archives Library, Calgary

242. *Prince Albert, Saskatchewan's Coming
Manufacturing Centre*, 1911
Published by Canadian Promotion Co. Winnipeg
8.5 x 11.5 (folded), 8.5 x 92.0 (unfolded)
Collection of the Local History Room, Saskatoon
Public Library, Saskatoon

243. *Saskatoon Saskatchewan, The Wonder City*,
1911
Published by Canadian Promotion Co., Winnipeg
8.5 x 11.5 (folded), 8.5 x 108.0 (unfolded)
Collection of the Local History Room, Saskatoon
Public Library, Saskatoon

244. Thomas H. Mawson (1861–1933)
Calgary, Past, Present and Future, 1912
32.0 x 26.0
Collection of Glenbow Archives Library, Calgary

245. *Regina before & after the cyclone, June 30, 1912*
Published by P.T. Evans and K.L. Fenney
16.5 x 26.5
Collection of the Prairie History Room, Regina
Public Library, Regina

246. *Regina Tornado, June 30, 1912*
Photographer: Edgar Rossie
18.0 x 25.0
Collection of the Prairie History Room, Regina
Public Library, Regina

247. *Factoria: Means Dollars*
Modern photograph of an advertisement
reproduced in *The Saskatoon Daily Star*,
December 9, 1912
Courtesy of Government Publications, University
of Saskatchewan, Saskatoon

248. *Saskatoon*, 1912
Published by the Saskatoon Board of Trade
13.5 x 20.0
Collection of the Local History Room, Saskatoon
Public Library, Saskatoon

249. *Calgary Brewing and Malting Company*, c. 1912
Lithograph on paper
84.0 x 54.0
Collection of the Glenbow Archives, Calgary

250. *Untitled* (South Railway Street, Regina),
c. 1912
Photolithograph on paper
Collection of the Saskatchewan Archives Board,
Regina

251. Anonymous
Untitled (view of Regina, looking north at the pro-
posed Grand Trunk Hotel from the Legislative
Building), c. 1912
Published by Novelty and Art Painting Company
Photolithograph
17.5 x 71.0
Collection of the Regina Plains Museum, Regina

252. *Calgary: the Gateway to the Women's West*,
June 12, 1913
Published by the Calgary Women's Press Club
39.0 x 28.0
Collection of the Glenbow Archives Library,
Calgary

253. Photolithograph of *Their New Home: A Family
of English Immigrants Arriving at a Western Town* by
C.W. Jefferys, 1913, reproduced on the cover of
Canadian Grocer 27 (18 April 1913)
Collection of Robert Stacey, Toronto

254. *Town Topics "Edmonton Industrial and
Investment Number,"* 1913
Printed by Edmonton Printing and Pub. Co.
35.0 x 26.0
Collection of the Glenbow Archives Library,
Calgary

255. *Factoria: (nuf sed)*
Modern photograph of an advertisement
reproduced in *The Saskatoon Daily Star*,
February 24, 1913
Courtesy of Government Publications, University
of Saskatchewan, Saskatoon

256. *Factoria: The Keystone of Prosperity*
Modern photograph of an advertisement
reproduced in *The Saskatoon Daily Star*,
February 19, 1913
Courtesy of Government Publications, University
of Saskatchewan, Saskatoon

257. *Re-Establish Him/It's up to us/Buy Victory Bonds*,
c. 1915
Lithograph on paper
90.5 x 60.8
Collection of the Saskatchewan Archives Board,
Regina

258. *Saskatoon Western Canada*, 1919
Published by the Saskatoon Board of Trade
26.0 x 18.0
Collection of the Glenbow Archives Library, Calgary

259. *Our Winnipeg Store*, c. 1920
Enamel on tin
22.5 x 17.7 x 12.3
Collection of Cecilia Côté, Saskatoon

260. W. Adams & Co.
Souvenir of Moose Jaw, c. 1920
Screened china plate
25.0 diameter
Collection of the Moose Jaw Art Museum,
Moose Jaw

261. Anonymous
Zion Methodist Church, Moose Jaw, Canada, c. 1920
Screened china plate with gilt
21.2 diameter
Collection of the Moose Jaw Art Museum,
Moose Jaw

262. *Untitled* (artillery shells, Calgary), 1940
Modern photograph of Hook Sign Company
billboard
Courtesy of the Glenbow Archives, Calgary.
NA–4072–14

263. *Untitled* (Sweet Caporal advertisement,
Calgary), 1940
Modern photograph of Hook Sign Company
billboard
Courtesy of the Glenbow Archives, Calgary.
NA–4072–39

264. *Untitled* (painted signs on Calgary building),
c. 1940
Modern photograph for Hook Sign Company
Courtesy of the Glenbow Archives, Calgary.
NA–4072–76

265. Photolithograph of *Prairie City in 1940* by
Ernest F. Lindner in *Contemporary Art of the
Western Hemisphere*
Published by International Business Machines
Corporation, 1941
Courtesy of the Mendel Art Gallery Library,
Saskatoon

266. Photolithograph of *Back Stage* by Leslie
G. Saunders in *The Sheaf Literary and Art
Supplement*, 1943
Published by the University of Saskatchewan,
Saskatoon
Courtesy of the Mendel Art Gallery Library,
Saskatoon

267. Photolithograph of a Douglas C-4 Skymaster
flying over Edmonton in *Canadian Geographical
Journal*, Vol. XXXIII No. 6, December 1946
Courtesy of the Mendel Art Gallery Library,
Saskatoon

268. *Edmonton Canada—Oil Centre*, 1950
Published by the City of Edmonton
28.0 x 21.0
Collection of the Glenbow Archives Library, Calgary

269. *Regina 50 Years of Progress, 1903–1953*, 1953
Published by Western Printers Association
30.0 x 23.0
Collection of the Glenbow Archives Library,
Calgary

270. Photolithograph of *Calgary, in the Foothills* by
A.C. Leighton in *Cities of Canada*, exhibition
catalogue published by The House of Seagram,
1953
Courtesy of the Mendel Art Gallery Library,
Saskatoon

271. Photolithograph of *Edmonton, Skyline of the
North* by Charles F. Comfort in *Canadian
Geographical Journal*, Vol. L, No. 1., January 1955
Courtesy of the Mendel Art Gallery Library,
Saskatoon

272. Modern photograph of a mural by William Perehudoff in the waiting room of the STC bus depot, Saskatoon, 1955
Courtesy of William Perehudoff, Saskatoon

273. Photolithograph of *Prairie Village* by Kenneth Campbell Lochhead in *Edmonton Journal,* July 19, 1957
Courtesy of the Mendel Art Gallery Library, Saskatoon

274. *Aladdin Homes "Sold by the Golden Rule,"* n.d.
Published by Aladdin Homes Limited, Toronto, Ontario, Catalogue No. 51
26.8 x 21.0
Courtesy of the Mendel Art Gallery Library, Saskatoon

275. *Calgary/The City Phenomenal,* n.d.
Published by Canadian Promotion Company
9.0 x 12.0
Collection of the Glenbow Archives Library, Calgary

276. *C.P.R. Transcona,* n.d.
Published by W. Grassie
28.0 x 19.0
Collection of the Glenbow Archives Library, Calgary

277. *Picturesque Calgary,* n.d.
Published by the Herald Company
22.0 x 31.0
Collection of the Glenbow Archives Library, Calgary

D. POSTCARDS

278. *Post Office, Regina, Sask.,* 1909
Chromolithograph postcard
14.0 x 9.0
Collection of Neil Richards, Saskatoon

279. *Eaton's Store, Winnipeg, Man.,* 1910
Chromolithograph postcard
8.8 x 13.7
Collection of Neil Richards, Saskatoon

280. *City Hall and Union Bank of Canada, Winnipeg,* c. 1910
Chromolithograph postcard
9.0 x 14.0
Collection of Neil Richards, Saskatoon

281. *Victoria Park, Regina, Sask.,* c. 1910
Chromolithograph postcard
9.0 x 14.0
Collection of Neil Richards, Saskatoon

282. *A Few of Winnipeg's Handsome Buildings,* 1912
Chromolithograph postcard
13.9 x 9.0
Collection of Matthew Teitelbaum, Toronto

283. *C.N.R. Station and Board of Trade Building, Saskatoon, Sask.,* c. 1912
Chromolithograph postcard
9.0 x 14.0
Collection of Neil Richards, Saskatoon

284. *Post Office, Lethbridge, Alberta,* 1939
Chromolithograph postcard
9.0 x 14.0
Collection of Neil Richards, Saskatoon

285. *Crescent Park, Moose Jaw, Canada,* n.d.
Chromolithograph postcard
9.0 x 14.0
Collection of Neil Richards, Saskatoon

286. *"The Fort Garry," (Grand Trunk Pacific's New Hotel, Winnipeg, Man., Canada),* n.d.
Chromolithograph postcard
13.6 x 9.0
Collection of Neil Richards, Saskatoon

287. *Hotel Qu'Appelle, Regina, Sask. (Grand Trunk Pacific Railway),* n.d.
Chromolithograph postcard
13.1 x 8.6
Collection of Neil Richards, Saskatoon

288. *Post Office, Moose Jaw, Sask.,* n.d.
Chromolithograph postcard
8.8 x 13.8
Collection of Neil Richards, Saskatoon

289. *River St. Looking West, P.A, Sask.,* n.d.
Black/white postcard
8.5 x 13.7
Collection of Neil Richards, Saskatoon

290. *Souvenir Folder of Regina,* n.d.
10 double-sided postcards, c. 1913
10.7 x 15.3 (closed); 111.3 x 15.3 (open)
Collection of the Saskatchewan Archives Board.
R-A 8744

291. *Traffic Bridge, Saskatoon, Sask.,* n.d.
Chromolithograph postcard
8.2 x 14.0
Collection of Neil Richards, Saskatoon

292. *21st Street Looking East, Saskatoon, Sask.,* n.d.
Black/white postcard
9.0 x 14.0
Collection of Neil Richards, Saskatoon

293. *Union Station, Winnipeg, Man.,* n.d.
Chromolithograph postcard
13.8 x 8.8
Collection of Neil Richards, Saskatoon

E. MAPS

294. *Bird's-Eye View of Winnipeg,* 1884
Published by Mortimer and Co. Ltd.
Color lithograph on paper
74.0 x 101.0
Collection of the Glenbow Archives Library, Calgary

295. *Map of Arcola, Assiniboia,* 1902
Published by the CPR
Pen and colored pencil on paper
29.0 x 39.0
Collection of the Glenbow Archives Library, Calgary

296. *Street Map of the City of Calgary,* 1913
Published by E.A. Victor
Engraving on paper
79.0 x 91.0
Collection of the Glenbow Archives Library, Calgary

297. *Official Plan—City of Saskatoon, June 1, 1914*
Published by the Saskatoon Board of Trade
Photolithograph on paper
120.6 x 90.0
Collection of the Local History Room, Saskatoon Public Library, Saskatoon

F. FILM

298. Leonard Hillyard (1891–1975)
Broadway Bridge Construction, c. 1932
19:20 min., 16 mm dubbed to video
Courtesy of the Local History Room, Saskatoon Public Library, Saskatoon

Photographic credits:
A.K. Photos Saskatoon (Grant Kernan) : pp. 6, 11, 24, 28, 33, 34, 35, 38, 42, 43, 47 (top), 59, 62, 65, 68, 72, 73, 77, 79, 80, 82, 86, 89, 91, 94, 95, 96, 97, 101, 103, 104, 112, 115, 122, 126, 139, 142, 143, 145, 148, 152, back cover
Art Gallery of Windsor, Windsor: p. 74
Canadian Pacific Limited, Montréal: p. 14
Centre Canadien d'Architecture/Canadian Centre for Architecture, Montréal: p. 50
Concordia University, Leonard & Bina Ellen Art Gallery, Montréal: p. 75
Glenbow Collection, Calgary: pp. 21, 26, 29, 32, 39, 46, 54, 78, 81, 84/85, 87, 90, 98/99, 106, 111, 134
McCord Museum of Canadian History, Montréal. Notman Photographic Archives: pp. 12, 13, 15, 18, 22, 23, 27
Manitoba Provincial Archives, Winnipeg: pp. 44, 45, 53, 55, 56, 57, 58 (top), 64, 71 (top and bottom), 110, 124, 130, 133
Mendel Art Gallery, Saskatoon: p. 69
National Archives of Canada: pp. 20, 25
National Gallery of Canada, Ottawa: pp. 2, 58, 63, 67
Provincial Archives of Alberta, Edmonton: pp. 40, 41
Saskatchewan Archives Board, Regina: pp. 49, 52, 70, 132
Saskatoon Public Library, Saskatoon, Local History Room: p. 88
University of Alberta Archives, Edmonton: p. 47 (bottom)
University of Saskatchewan, Saskatoon, Government Publications: pp. 30, 31
Mick West, Regina: p. 36/37
Winnipeg Art Gallery, Winnipeg (Ernest Mayer): pp. 61, 66, 93, 125
Winnipeg Art Gallery, Winnipeg (Sheila Spence): pp. 17, 76, 83, 100, 118

Curator's note: While preparing the exhibition catalogue, the Mendel Art Gallery has made every effort to ensure the accuracy of all aspects of the publication, including photographic credits and reproduction rights. Because of the nature of some of the promotional material and photographs, we were not always able to list complete credits. Addenda will appear in subsequent editions.

Design: McKay Goettler & Associates, Saskatoon, SK
Color separations: TrueColor Graphics Ltd., Saskatoon, SK
Printer: D.W. Friesen and Sons, Altona, MB

Printed and bound in Canada
93 94 95 96 97 / 5 4 3 2 1

Interleaves (pp. 1, 109, 131 & 153): 89. Margaret Shelton, *East Calgary,* 1940

Front Cover: 99. Henry G. Glyde, Detail of *The Exodus,* 1941

Back Cover: 240. Wedgwood Company, *Untitled* (view of Moose Jaw, Saskatchewan, with the launch *Edith*), c. 1910

Printed in Canada

Contents

"If you've got it, flaunt it."

figures ... the sentiment "Nothing ... nothing gained." For those who have better things to do with their time than concoct pithy bon mots, the guiding principle should no doubt be "If it ain't broke, don't fix it." And that's where *Clichés and Platitudes for All Occasions* comes in. Whether you go to the cultur-ally familiar tried-and-true or to enlightenment borrowed from foreign shores, you'll have access to succinct, relatable sound bites for every conceivable situation. Everything under the sun has been experienced by someone before and turned into a quip that stands ready to be committed to your memory—if it's not there already.

Introduction

PREPARING TO SAY WHAT'S ALREADY BEEN SAID

Throughout life, we are continu-ally called upon to provide advice, perspective, and the odd nugget of wisdom. Coming up with intel-ligent insights for so many circum-stances, however, can prove draining. It's a common misperception that creativity matters in human interac-tions—in a time when most of our undesirable work is outsourced, why think of something original to say when you can avail yourself

of both the knowledge of others and the experience of the ages?

It's most likely the artists and English teachers among us who have painted the word "clichéd" in so unflattering and pejorat light. These individuals, how comprise only 0.88 percent American population; it ca follow that most of us sub the words of the great En nalist and philosopher G terton: "Platitudes are t] they are true." Such say not stand the self-refle time if there were not proverbs: in Spain, a platitude characterized as "a short sentence based on a long experience," and the Arabs note that "a proverb is to speech what salt is to food."

Do You Have "It"?

Can anything be more cliché than It, whether the It bag or the It girl? The term originated in 1927 when silent-film starlet Clara Bow was touted as epitomizing the liberated, sexy Jazz Age "It Girl" for her role in the box-office smash It, based on the novel by Elinor Glyn. According to Glyn, "To have 'It,' [he or she] must have that strange magnetism which attracts both sexes . . . Conceit or self-consciousness destroys 'It' immediately."

the notion "Mind your own busi-ness," but he or she who is ashamed to ask is ashamed to learn—and it is therefore your duty to comment on others' strengths and foibles.

Fortunately, your insights into what may be sensitive areas will carry a wallop that is simultane-ously greater and less offensive when they are expressed as clichés

or platitudes. And if the words you speak are intended to bolster or compliment, their recipients will be more likely to believe them if they are cloaked in the wisdom of the ages.

A cliché is like a mirror, reflecting its target. Just as people love to gaze at themselves, so do they appreciate observations that speak to their personal appearance, age, intelligence, and character. Each of us would like to believe that we are unique, and clichés perform the improbable magic of describing special qualities while being universally applicable. Best of all, the concise wisdom of clichés can prompt dramatic changes in perspective or persona—and, if the $11 billion self-help industry is any indication, all roads lead to Rome.

Personal Appearance

Beauty will not season your soup.

———•·•———

A gem, unless polished, does not glitter.

———•·•———

You can never be too rich or too thin.

———•·•———

He who dyes his beard deceives
no one but himself.

———•·•———

Beauty is only skin deep, but
ugly goes all the way through.

———•·•———

There's many a good cock
come out of a tattered bag.

———•·•———

No one is free who is a slave to the body.

———•·•———

Beware of him who squints
or has red hair.

A peacock has too little in its
head, too much in its tail.

———•—•———

If you've got it, flaunt it.

———•—•———

Never choose your women or
your linen by candlelight.

———•—•———

It is a great affliction to be
too handsome a man.

———•—•———

Beauty is in the eye of the beholder.

———•—•———

A big nose never spoiled a handsome face.

———•—•———

He who loves a one-eyed girl thinks
one-eyed girls are beautiful.

———•—•———

Curly hair, curly thoughts.

———•—•———

A fat woman is a quilt for the winter.

15

Good things come in small packages.

Blonds have more fun.

Even the devil was handsome at eighteen.

The longer the hair, the smaller the brain.

Handsome is as handsome does.

A smiling face is half the meal.

Beauty is a fading flower.

Age

There's many a good tune
played on an old fiddle.

He who lives long lives well.

A man is as old as he feels,
a woman as old as she looks.

―――――――

A prodigy at ten, a genius at twenty,
an ordinary man at thirty.

―――――――

Motion drawing to its end is swifter.

―――――――

You can't teach an old dog new tricks.

Wasted on the Young

Clichés have their day in the sun before, in
many cases, it sets. Phrases that were once
common knowledge but are no longer recog-
nized are known as "generational clichés."
For example, in a survey conducted by scholar
Gary A. Olson, respondents under 30 years
old recognized only 51 percent of common
clichés. Platitudes that didn't make the cut
included "filthy lucre," "going to wrack and
ruin," and "many a slip between cup and lip."

Youth is wasted on the young.

———•———

A young puppy does not fear the tiger.

———•———

You're only young once.

———•———

What you break in youth
you feel in old age.

———•———

No man can call back yesterday.

———•———

Life begins at forty.

———•———

Youth has a beautiful face, old
age a beautiful soul.

———•———

Soon ripe, soon rotten.

———•———

It is safer to irritate a dog
than an old woman.

Age but tastes, youth devours.

The aged forget, but the
young know nothing.

The frog forgets his days as a tadpole.

Youth cannot be stored for the winter.

Intelligence

There is no cure for stupidity.

He that is too smart is surely done for.

A little knowledge is a dangerous thing.

He who knows he is a fool
is not a big fool.

Ignorance is bliss.

A Mute Point

Watch your words lest you commit a malapropism, the substitution of similar-sounding—but incorrect—words into well-known sayings. Named after a theater character, Mrs. Malaprop, for her patterns of speech, malapropisms can be very amusing but taint one's credibility. According to a recent British survey, top verbal bloopers include "one foul swoop" ("*fell* swoop"), "nip it in the butt" ("*bud*"), and, of course, "mute point" ("*moot*").

Ignorance may not kill you, but
it does make you sweat a lot.

Whatever you do not
understand, you admire.

Great minds think alike.

A good head does not want for a hat.

Knowledge is power.

He who is ashamed to ask, is ashamed to learn.

The frog of the well knows nothing of the sea.

The bullfrog knows more about rain than the almanac.

Search for knowledge though it be in China.

In a world of fools, intelligence is a fatal handicap.

Do not jump high under a low ceiling.

When the blind lead the blind, both shall fall into the ditch.

The fox knows many things, but the hedgehog knows one big thing.

* * *

Genius is as tender as a skinned cat.

* * *

The fat man knoweth not what the lean man thinketh.

* * *

It's not rocket science.

Good Character

A clear conscience is a good pillow.

* * *

Do right and fear no man.

* * *

Honesty is the best policy.

* * *

Fortune favors the brave.

* * *

A good horse cannot be of bad color.

Better poverty than a
home without virtue.

One volunteer is worth two pressed men.

Honor is better than honors.

Kindness begets kindness.

A clean hand never needs washing.

Great modesty often hides great merit.

Virtue is its own reward.

What lies behind us and what
lies ahead are tiny matters
compared to what lies within.

If your conduct be noble,
you will be a king.

He who has no courage must have legs.

If you lie down with dogs you
will get up with fleas.

A guilty conscience needs no accuser.

Pride goeth before a fall.

Maternal Protection

Urban speech has capitalized on our sensitivities to mother-directed pejoratives, producing the "yo' mama" call-and-response contest of ever-escalating, ever-wittier barbs. Formal putdown matches date at least to the eighth century, when Arab poets publicly traded words; in the Middle Ages, Scots held "flyting" competitions. Today, "yo' mama" is such a classic that you needn't even finish the sentence—just let the cliché do its job.

Be as hard as the world requires
you to be, and as soft as the
world allows you to be.

———•———

He that can compose himself is wiser
than he that composes books.

———•———

Still waters run deep.

———•———

Actions speak louder than words.

———•———

To err is human, to forgive divine.

———•———

'Tis better to give than to receive.

———•———

A good example is the best sermon

———•———

There is no right way to
do a wrong thing.

———•———

If you can't be good, be careful.

A leopard does not change its spots.

After one vice a greater follows.

He who excuses, accuses himself.

Vipers breed vipers.

No medicine can cure a vulgar man.

To wash a pig is to waste
both water and soap.

A bully is always a coward.

If you're not part of the solution,
you're part of the problem.

Nothing is more contagious
than a bad example.

There's no rest for the wicked.

———•———

What happens in Vegas stays in Vegas.

———•———

A liar ought to have a good memory.

———•———

There is no honor among thieves.

———•———

Misery loves company.

———•———

Fewer possess virtue than
those that feign it.

———•———

Nobody's perfect.

THE MATERIAL WORLD

When all that glitters isn't gold

BECOMING SUCCESSFUL REQUIRES more than stars in our eyes; it requires ambition, perseverance, time management, hard work, and most of all, money. In keeping our eyes on the prize, however, we can lose sight of life balance—and therein lies the rub.

Clichés about the material world support us from commencement

Tip: It's a Win-Win

Love it or hate it, the workplace and its corporate-speak provide scads of clichéd material. How would we describe our business life without "results driven" or "paradigm shift"? Maximize cliché fun at your next meeting by downloading buzzword bingo cards and, with coworkers, secretly marking off the expressions as they're uttered. When one of you gets bingo, clear your throat to signify your win—then collect the low-hanging fruit.

speeches ("Go forth and . . . ," "Dare to dream," "Today is the first day of the rest of your life") to the workplace ("Win-win," "Get on the same page," "Think outside the box") to our own wallets ("Penny wise, pound foolish," "Money makes the world go 'round," "Easy come, easy go"). According to ResumeDoctor.com, based on a

survey of 160,000 resumés, 12.6 percent of job seekers used the term "communication skills," 7.2 percent "team player," and 4.2 percent "detail oriented." Since most of these people presumably got jobs, it's clear that clichés will carry you far in the outside world.

When it comes to material concerns, the proverbs and platitudes that you apply to yourself and others will tend either toward idealism or realism, depending on the situation. Generally those starting out in the real world receive pie-in-the-sky encouragement, while those who have been working and earning for a while prefer confirmation that it is indeed a dog-eat-dog world. Whether it's appropriate to focus on life's ups or its downs, money talks—and so will you.

r

ond.

ump high.

ses to the top.

tured, nothing gained.

When one door closes,
another door opens.

Don't bet more than you
can afford to lose.

Work

Many hands make light work

Too many cooks spoil the br[oth]

All work and no play m[akes]
Jack a dull boy.

If you want someth[ing]
done, ask a busy p[erson]

Don't bite the hand th[at]

The customer is

A chain is only as strong
as its weakest link.

It's not what you know,
it's who you know.

Hope for the best and
prepare for the worst.

A job is fine, but it interferes
with your time.

Ambition

It's better to be a big fish in [a]
pond than a little fish in

Ambition and flea

Cream

No

Work expands to fill the time available.

You can't make an omelet
without breaking some eggs.

———•◆•———

If you are not the lead dog,
the view never changes.

———•◆•———

Not to go forward is to go backward.

———•◆•———

He who climbs up is easily
seized by the heels.

Your Words Could Be More

Renowned mid-twentieth-century minimalist
architect Mies van der Rohe is synonymous
with his famous utterance "Less is more."
Comedian Rodney Dangerfield is remembered
for "I don't get no respect," and celebrity
chef Emeril Lagasse will forever be linked with
his emphatic "Bam!" No lesser light than Paris
Hilton even trademarked "That's hot." Seek to
have your own words memorialized—speak in
original catchphrases and hope they catch on!

A person who misses a chance
and the monkey who misses
its branch can't be saved.

———•◦•———

The smaller the lizard, the greater
its hope of becoming a crocodile.

———•◦•———

A turtle makes progress when
it sticks out its neck.

———•◦•———

Better to live one day as a tiger
than a thousand years as a sheep.

———•◦•———

If you can make it here, you
can make it anywhere.

———•◦•———

The harder you fall, the
higher you bounce.

———•◦•———

A good buttock finds
a bench for itself.

Every man is the architect
of his own fate.

———•••———

There's always room at the top.

———•••———

If you would be pope, you
must think of nothing else.

———•••———

Don't let the bastards get you down.

Perseverance

When the going gets tough,
the tough get going.

———•••———

Diligence is the mother of good luck.

———•••———

The early bird catches the worm.

———•••———

All things are difficult
before they are easy.

Gather No Moss

The music world has long recognized the lasting power of a good proverb. Hank Williams's 1949 song "Lost Highway," which contains the line "I'm a rolling stone," and Muddy Waters's 1950 "Rollin' Stone" reportedly provided inspiration for Bob Dylan's 1965 "Like a Rolling Stone." In 2004, Dylan's hit was named the "Greatest Song of All Time" by *Rolling Stone* magazine; the number-two song was "Satisfaction" by—wait for it—The Rolling Stones.

Never put off until tomorrow
what can be done today.

He that would eat the fruit
must climb the tree.

Practice makes perfect.

Idle hands are the devil's playground.

A little hard work
never hurt anyone.

———•◦•———

A lazy man's garden
is full of weeds.

———•◦•———

Rome wasn't built in a day.

———•◦•———

Without perseverance,
talent is a barren bed.

———•◦•———

Work now, play later.

———•◦•———

Dry pants catch no fish.

———•◦•———

Work and you will be strong;
sit and you will stink.

———•◦•———

Any job worth doing
is worth doing well.

Slow and steady wins the race.

———•·•———

I rest, therefore I rust.

———•·•———

He is not a good mason
who refuses any stone.

———•·•———

If at first you don't succeed,
try, try again.

———•·•———

Where there's a will, there's a way.

———•·•———

Rest is good after the work is done.

———•·•———

He is deserving
who is industrious.

———•·•———

Play in summer, starve in winter.

———•·•———

No pain, no gain.

Time

You can rest when you're dead.

———•·•———

Pace yourself and
you will live longer.

———•·•———

Time is money.

———•·•———

Good things come to those who wait.

———•·•———

Patience is a virtue.

———•·•———

Haste makes waste.

———•·•———

You snooze, you lose.

———•·•———

Time is of the essence.

———•·•———

Don't cross the bridge
until you come to it.

The one in a hurry is always late.

———•———

Better late than never.

———•———

Take time to stop and smell the roses.

———•———

Great bodies move slowly.

———•———

Creaking wagons are long in passing.

———•———

Time and tide wait for no man.

———•———

A handful of patience is
worth a bushel of brains.

———•———

There are only so many hours in the day.

———•———

Quick and well seldom go together.

———•———

Take your time.

Money

With money in your pocket, you
are wise and you are handsome—
and you sing well too.

———•◦•———

Penny wise, pound foolish.

———•◦•———

Better poor with honor
than rich with shame.

Got Clichés?

According to *Advertising Age*, the ten best
slogans—now clichés—of the twentieth
century were:

1. Diamonds are forever (De Beers)
2. Just do it (Nike)
3. The pause that refreshes (Coca-Cola)
4. Tastes great, less filling (Miller Lite)
5. We try harder (Avis)
6. Good to the last drop (Maxwell House)
7. Breakfast of champions (Wheaties)
8. Does she . . . or doesn't she? (Clairol)
9. When it rains it pours (Morton Salt)
10. Where's the beef? (Wendy's)

Money makes the world go 'round.

———•———

Neither a borrower nor a lender be.

———•———

Riches, like manure, do no
good until they are spread.

———•———

Money can't buy happiness.

———•———

A penny saved is a penny earned.

———•———

A purse without money
is called leather.

———•———

Money is the root of all evil.

———•———

Put your money where your mouth is.

———•———

Where there is money,
there will be friends.

Don't count your chickens
until they've hatched.

———•—•———

You can't squeeze blood from a turnip.

———•—•———

A fool and his money are soon parted.

———•—•———

He that has no silver in his purse
should have silver on his tongue.

———•—•———

Money doesn't grow on trees.

———•—•———

Easy come, easy go.

———•—•———

Buyer beware.

———•—•———

You can't take it with you.

Work

Many hands make light work.

———•••———

Too many cooks spoil the broth.

———•••———

All work and no play makes
Jack a dull boy.

———•••———

If you want something
done, ask a busy person.

———•••———

Don't bite the hand that feeds you.

———•••———

The customer is always right.

———•••———

A chain is only as strong
as its weakest link.

———•••———

It's not what you know,
it's who you know.

survey of 160,000 resumés, 12.6 percent of job seekers used the term "communication skills," 7.2 percent "team player," and 4.2 percent "detail oriented." Since most of these people presumably got jobs, it's clear that clichés will carry you far in the outside world.

When it comes to material concerns, the proverbs and platitudes that you apply to yourself and others will tend either toward idealism or realism, depending on the situation. Generally those starting out in the real world receive pie-in-the-sky encouragement, while those who have been working and earning for a while prefer confirmation that it is indeed a dog-eat-dog world. Whether it's appropriate to focus on life's ups or its downs, money talks—and so will you.

Hope for the best and
prepare for the worst.

———•———

A job is fine, but it interferes
with your time.

Ambition

It's better to be a big fish in a small
pond than a little fish in a big pond.

———•———

Ambition and fleas both jump high.

———•———

Cream always rises to the top.

———•———

Nothing ventured, nothing gained.

———•———

When one door closes,
another door opens.

———•———

Don't bet more than you
can afford to lose.

A bad workman blames his tools.

———————

There's no such thing
as a free lunch.

———————

Never send a boy to do a man's job.

———————

Keep your shop and your
shop will keep you.

———————

Make hay while the sun shines.

———————

If you pay peanuts,
you get monkeys.

———————

As the job, so the clothes.

———————

If it ain't broke, don't fix it.

———————

Work expands to fill the time available.

LOVE

When it's all you need

LOVE HAS COMPLEX, CONFLICTING dynamics—one minute you are at the highest heights and next you are in the depths of despair. It's not surprising, then, that clichés about love reflect its roller coaster of emotions. Whether it's the tumult of courtship, the feverishness of sex, the ups and downs of marriage, or the agony of breakups, sharing tales of love—blissful or

To Love or Not to Love

How do we know that "the course of true love never did run smooth"? Because Shakespeare said so. The bard's reflections on love and life permeate the English language. Even his characters are synonymous with romance— think Romeo and Juliet. Whether "Parting is such sweet sorrow" or "If music be the food of love, play on," Shakespeare's words are an example of those that become cliché because they're brilliant rather than merely overused.

dreadful—is a human common denominator.

Love is perhaps one of the greatest inspirations for clichés and platitudes, in no small part because popular music, the poetry of our time, devotes so much attention to the subject. With the goal of producing a song whose message

could be understood by multiple nationalities, John Lennon wrote "All You Need Is Love." Movies share this focus. "Love means never having to say you're sorry," from the 1970 film *Love Story*, has entered the vernacular as a platitude. As testament to the phrase's influence, Lennon himself countered, "Love means having to say you're sorry every fifteen minutes."

Whether you use clichés to pitch woo, write wedding vows, or comfort heartbroken loved ones, whether you and yours identify as Romeo or Juliet, Napoleon or Josephine, or Scarlett or Rhett, the words in this chapter are proof that everything from throbbing lust to wrenching torment has been felt before. In the end, all's fair in love, war, and clichés and platitudes.

Courtship

Love and foolishness differ from
each other only in name.

Faint heart never won fair lady.

A good rooster crows proudly
in any henhouse.

Love is like butter;
it's good with bread.

A good man is hard to find.

Every Jack has his Jill.

You can catch more flies with
honey than with vinegar.

Coffee and love are best
when they are hot.

A man in love mistakes a
pimple for a dimple.

———•◆•———

Opposites attract.

———•◆•———

Love is blind.

———•◆•———

Why buy the cow when you
can get the milk for free?

———•◆•———

Happy's the wooing
that is not long a-doing.

———•◆•———

The heart wants what it wants.

———•◆•———

As men are, so you must humor them.

———•◆•———

Love teaches asses to dance.

———•◆•———

When you go to dance, take heed
whom you take by the hand.

Choose your love, then love your choice.

—————

Love enters man through his eyes,
woman through her ears.

—————

A heart is a lock: you need
the right key to it.

—————

The man who does not love
a horse cannot love a woman.

—————

Always a bridesmaid, never a bride.

—————

Love conquers all.

Sex

Make love, not war.

—————

After sexual intercourse,
every animal is sad.

Love is one thing, lust another.

———•—•———

Below the navel there is
neither religion nor truth.

———•—•———

Love or fire in your trousers
is not easy to conceal.

———•—•———

When the heart is full of lust,
the mouth is full of lies.

Harlequintessential

Clichés don't have to be words. In the billion-dollar romance novel industry, certain formulas are endlessly recycled: the naive virgin whose innocent love tames the playboy, the feisty heroine whose pluck earns the intrepid adventurer's respect, or the perplexed woman whose brutish love interest suddenly reveals himself. For a visual cliché, consider Fabio, the overmuscled, overhaired, overchested model for hundreds of romance book covers.

Frequent kisses end in a baby.

Desires are nourished by delays.

A lame man copulates best.

A traveled woman is like a
garden trespassed by cattle.

Stopping at third base adds no more
to the score than striking out.

Lust is a knife that cuts to the bone.

Strangers' meat is the greatest treat.

Different strokes for different folks.

To fill a valley is easier than
to satisfy a man's desire.

Maidens say no and
do it all the same.

———•·•———

The husband is always
the last to know.

———•·•———

If one won't, another will.

———•·•———

Size matters.

Marriage

All's fair in love and war.

———•·•———

To marry once is duty, twice is
folly, and the third time madness.

———•·•———

A second wife is like a wooden leg.

———•·•———

He who does not honor
his wife, dishonors himself.

Tip: The Happiest Day

There's nothing more awkward than a wedding toast falling flat. Don't leave life's most important public speaking engagement to chance. Open up with a cliché, interject a cliché, and end with a cliché. A few to try: "May you live each day like your last, and each night like your first," "May you remember the two secrets to a happy marriage: a short memory and a good sense of humor," and "May all your ups and downs be in the bedroom."

A wedding lasts a day or two,
the misery forever.

———

If the wife wears the breeches,
the husband rocks the cradle.

———

Marriage is a battlefield and
not a bed of roses.

———

A good husband makes a good wife.

A good wife makes a good husband.

———•·•———

Matrimony and macaroni—
if they are not hot, they are not good.

———•·•———

Husbands are in heaven
whose wives scold not.

———•·•———

Marry in haste, repent at leisure.

———•·•———

The most difficult mountain
to cross is the threshold.

———•·•———

Marrying is easy, but
housekeeping is hard.

———•·•———

The only cure for love is marriage.

———•·•———

Wedlock is like an eel basket—
those who are out of it want to get in,
and those who are in want to get out.

Love the one you're with.

There's more to marriage than
four bare legs in bed.

Love makes a house a home.

When husbands and wives agree
with each other, they can dry
up the ocean with buckets.

The honeymoon is over.

Breakups

You can't force a square
peg into a round hole.

Parting is such sweet sorrow.

Better to have loved and lost than
never to have loved at all.

The jar will long retain the odor
of that which once filled it.

———•◦•———

Sooner be hated than forgotten.

———•◦•———

The worst ache is the present ache.

———•◦•———

Time heals all wounds.

———•◦•———

We know the worth of a thing
when we have lost it.

———•◦•———

Better to be alone than in bad company.

———•◦•———

A broken hand works, but
not a broken heart.

———•◦•———

Short love brings a long sigh.

———•◦•———

The flounder does not return
to the place it left when disturbed.

There are plenty of fish in the sea.

———•—•———

It is misery enough to have
once been happy.

———•—•———

Hell hath no fury like
a woman scorned.

———•—•———

New love drives out old.

———•—•———

Better a tooth out than
one always aching.

———•—•———

There's a thin line
between love and hate.

———•—•———

You have to kiss a few frogs
before you find a prince.

———•—•———

The grass is always greener
on the other side.

A man's heart is as changeable
as the skies in autumn.

———◆———

A woman's heart is as
changeable as the eyes of a cat.

———◆———

Don't get mad—get even.

———◆———

Love hurts.

Broken Hearts Club

They say whatever doesn't kill you makes you stronger, but now there's scientific proof that if you suffer a broken heart, it may be the end of more than just a relationship. According to a study conducted by Johns Hopkins University, stress hormones can form in otherwise healthy people in response to emotional trauma, actually causing the symptoms of heart failure. "Love hurts" may be a cliché, but it's also medical fact.

FRIENDS AND FAMILY

When you can't live with them or without them

DOROTHY SAID IT BEST: "THERE'S no place like home." Whether this home is positive or negative depends on the individual, but regardless, friends, family, and community have made us who we are—for better or worse.

In a time when the nuclear family is itself a cliché, we need our friends more than ever, and in many cases,

Boyz II Bubblegum

Describing buddy boy bands such as the Backstreet Boys, Salon.com's Janelle Brown identified these essentials: "the cute blond guy, one with curly hair, the dark one with big dimples, the guy with the funny facial hair, and the less cute, but really sensitive, guy," not to mention that all looks and moves come from the same playbook. Less scripted are the riches—while some bands never earn their keep, 'N Sync raked in $87 million on its 2001 tour alone.

friends are our chosen family; after all, you can pick your nose and you can pick your friends, but you can't pick your family. In some cases, however, relatives are loving and supportive. There are as many types of families as there are families. As Leo Tolstoy wrote, "Happy families are all alike, but each unhappy family is unhappy in its own way."

Fortunately, there are universally applicable clichés for both happy and unhappy households.

It's difficult to keep a clear head when parents irritate us, children throw tantrums, friends let us down, or the neighbors' tree blocks our view. For this reason, a pocket full of platitudes will serve you in good stead. Proverbs and clichés are nothing if not familiar, and what is the root of "familiar"? Why, "family," of course.

Different cultures have varying perspectives on the ties that bind, but all of them point to the necessity, unavoidability, and care and feeding of these relationships. Just as good fences make good neighbors, the well-chosen cliché can make you a good friend, relative, or citizen.

Friends

They are rich who have true friends.

———•••———

A man is known by the
company he keeps.

———•••———

Make new friends, but
keep the old; one is silver
and the other's gold.

———•••———

A good friend is worth more
than a bad brother.

———•••———

One always has strength
enough to bear the misfortunes
of one's friends.

———•••———

A friend in need is a friend indeed.

———•••———

Correct your friend secretly
and praise him publicly.

Loyalty is more valuable than diamonds.

———•—•———

Eat and drink with a friend,
but have no business
transaction with him.

———•—•———

Friends, if often used, wear out.

———•—•———

If a friend is honey,
do not try to eat all of him.

———•—•———

The time to make friends
is before you need them.

———•—•———

If you have a good friend,
you don't need a mirror.

———•—•———

Fall out not with a friend for a trifle.

———•—•———

Keep your friends close and
your enemies closer.

He who speaks ill of you in your
absence fears you in your presence.

The enemy of my enemy is my friend.

All are not friends who smile on you.

He is an ill companion
that has a good memory.

A fair-weather friend
changes with the wind.

A friend to all is a friend to none.

With friends like that,
who needs enemies?

It takes one to know one.

Man's best friend is his dog.

Family

Blood is thicker than water.

In time of test, family is best.

Don't teach your grandmother
to suck eggs.

There's a dirty spoon in every family.

Tip: Mixing and Matching

In the 1980s, comedian Rich Hall penned a
series of bestselling books featuring "snig-
lets," defined as "words that don't appear
in the dictionary, but should." They included
neologisms such as "timefoolery," the practice
of setting the alarm clock ahead to fool your-
self into waking up earlier. Employ this method
to make custom platitudes, combining two or
more clichés into a new one, such as "Blood is
thicker than water under the bridge."

Govern a family as you would
cook a small fish—very gently.

———•◦•———

A mother-in-law, like a yucca
tree, is useful underground.

———•◦•———

You can't go home again.

———•◦•———

Rich kin are close kin.

———•◦•———

Much kindred, much trouble.

———•◦•———

Love your relations, but
live not near them.

———•◦•———

A bad branch harms the tree.

———•◦•———

Remember where you come from.

———•◦•———

Mules make a great fuss about
their ancestors being horses.

Hyena and dog cannot share an abode.

Charity begins at home.

Likeness causes liking.

Go to friends for advice; to women for pity; to strangers for charity; to relatives for nothing.

Home is where the heart is.

There's nothing so funny as folk.

What's bred in the bone will come out in the flesh.

A family divided against itself will perish together.

Familiarity breeds contempt.

Benevolent Dictators

Parents don't ask—they *tell*. Psychologist Robert Jay Lifton calls many of the maxims that fly out of parents' mouths "thought-terminating clichés," "language of the totalist environment" intended to distill human problems into reductive, definitive, and memorable phrases. Some examples? "Life is unfair," "Because I said so," and "Do as I say, not as I do." If you're a child, these sayings will chafe, but to a parent, they're invaluable.

Whoever is ashamed of his
family will have no luck.

———•◆•———

In the time of need the
pig is called uncle.

———•◆•———

Confide in an aunt and
the world will know.

———•◆•———

Of what use are pedigrees?

Be it ever so humble, there's
no place like home.

———•◦•———

The apple doesn't fall far from the tree.

———•◦•———

Don't shit where you sleep.

Parenting

There's no love like a mother's love.

———•◦•———

Children are a poor man's wealth.

———•◦•———

Good parents, happy marriages;
good children, fine funerals.

———•◦•———

Great oaks from little acorns grow.

———•◦•———

Good seed makes a good crop.

———•◦•———

Like father like son.

Bring up a raven and it will
peck out your eyes.

———•—•———

Count your blessings.

———•—•———

To a mother a bad son does not exist.

———•—•———

Praise the child and you
make love to the mother.

———•—•———

Other people's harvests are always
better, but not their children.

———•—•———

He's a chip off the old block.

———•—•———

Father knows best.

———•—•———

Just wait 'til your father gets home.

———•—•———

An ounce of mother is
worth a ton of priest.